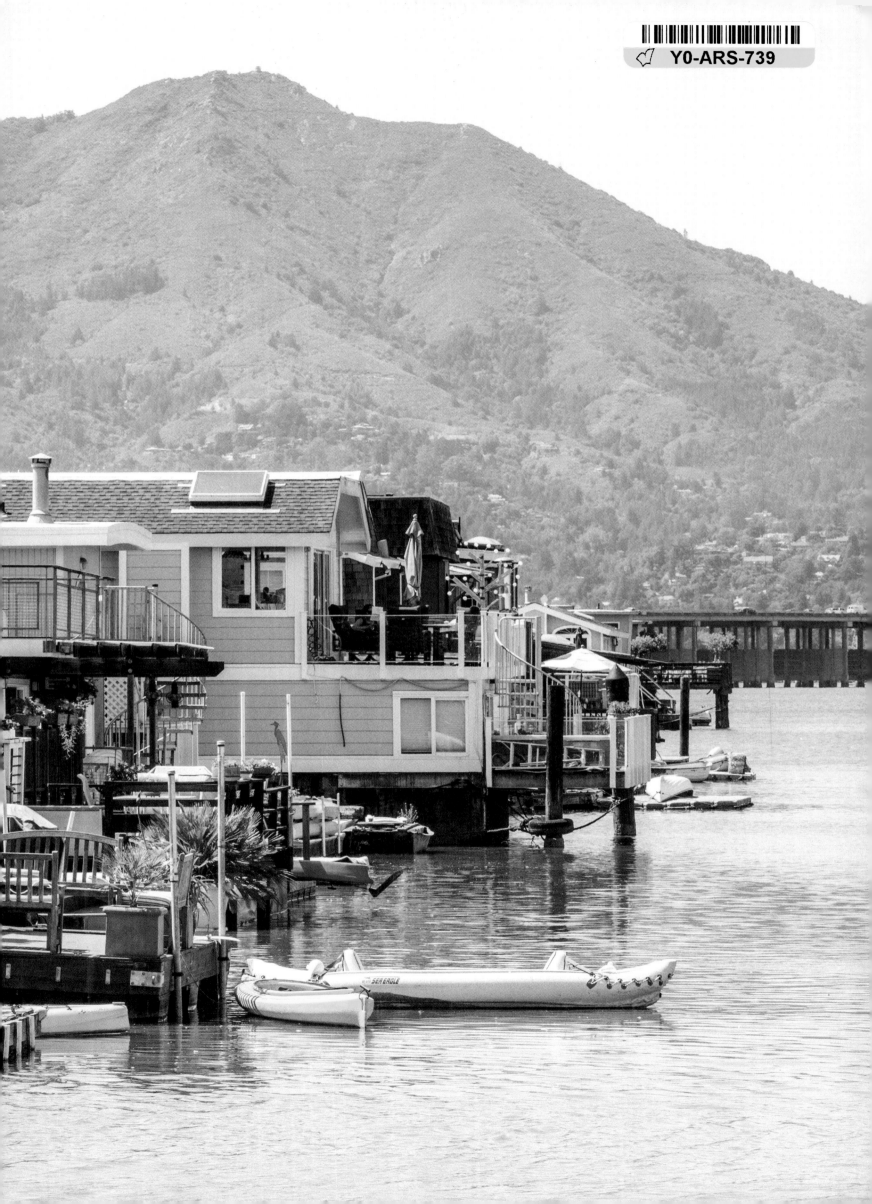

FLOATING IN SAUSALITO

Text
LARS ÅBERG

Photo
LARS STRANDBERG

KERBER PHOTO ART

CONTENTS

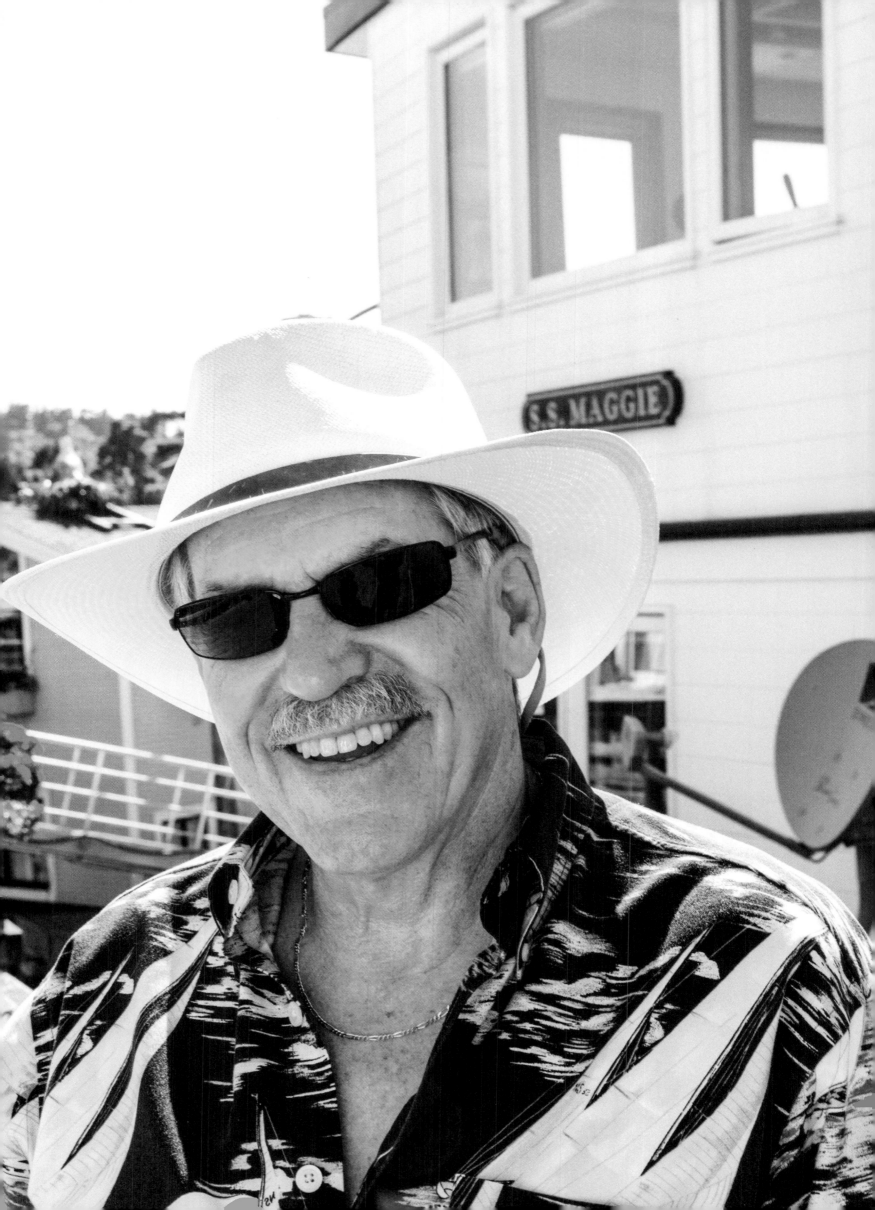

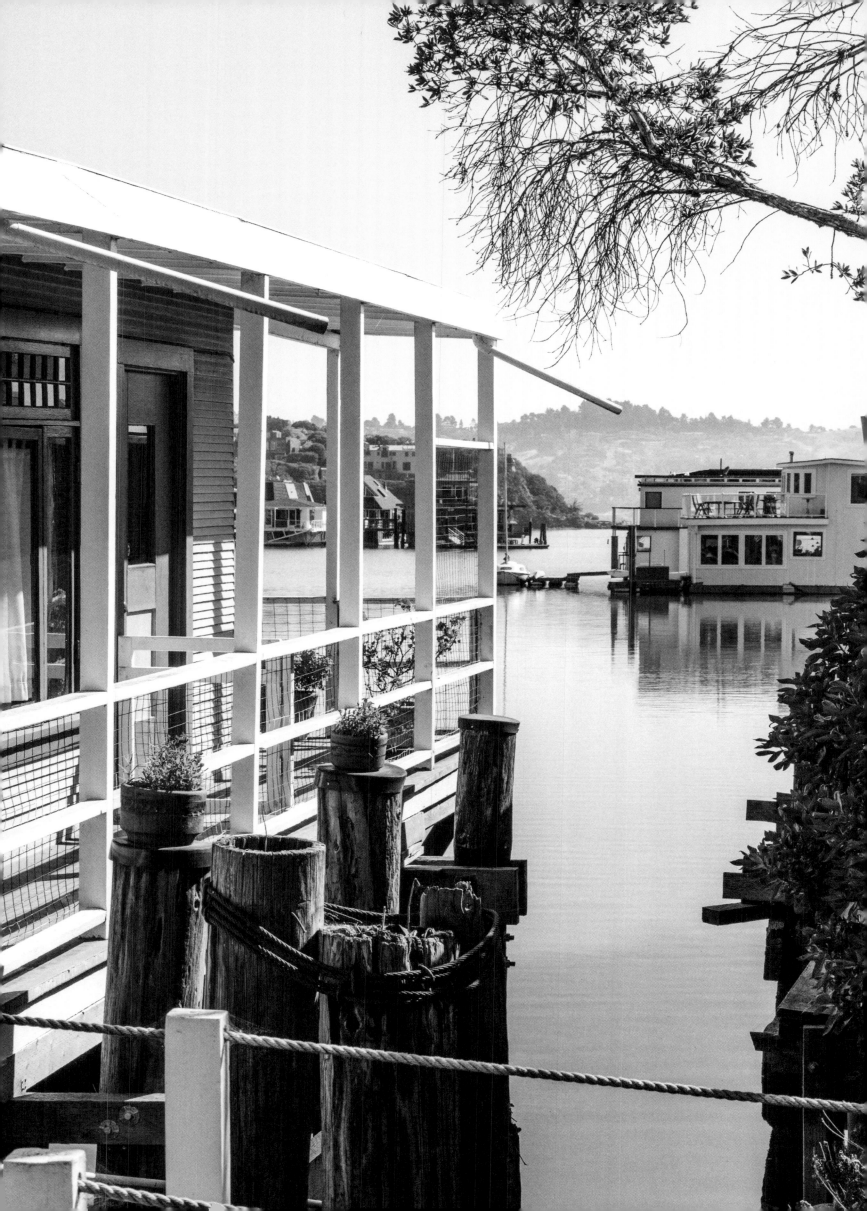

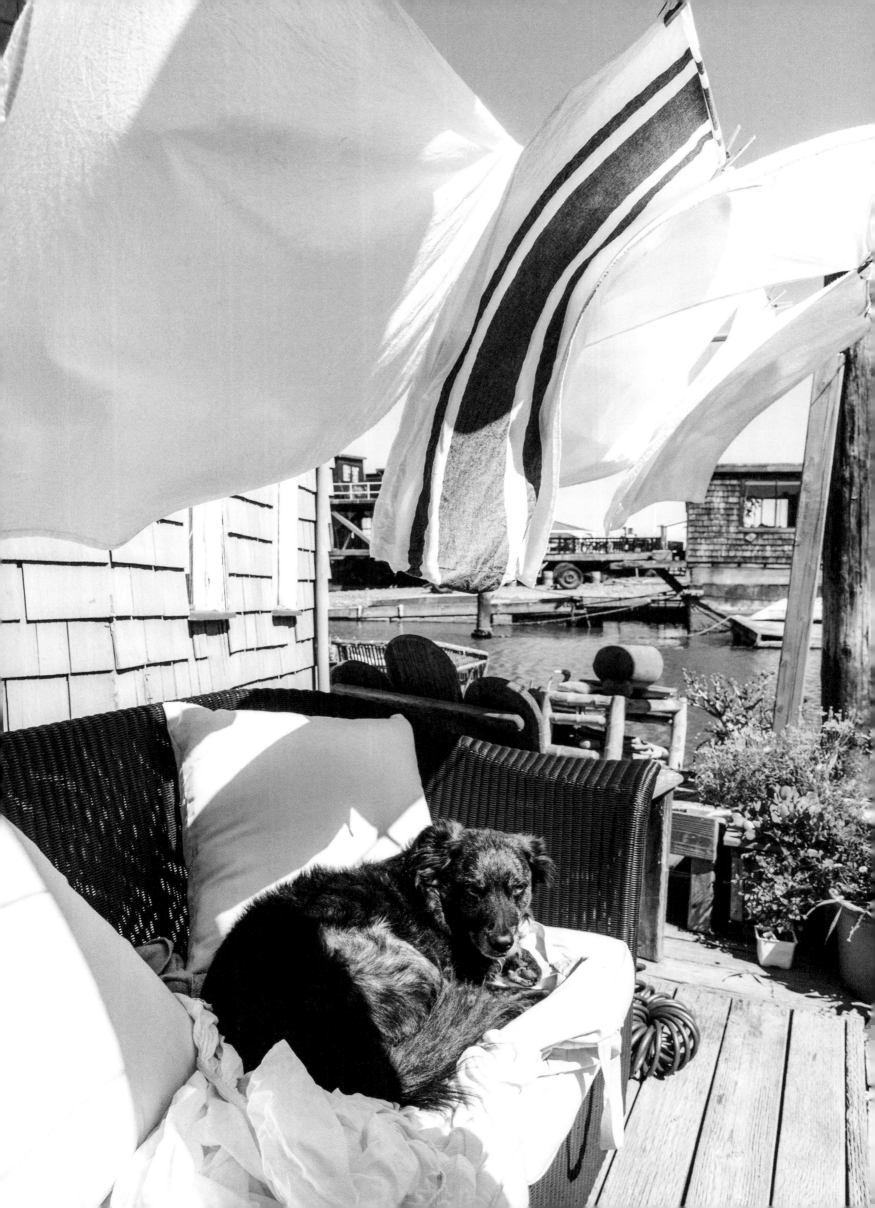

The Very First
Breakfast in Town

It's all designed to confuse a simple breakfast mind. Fred's Place on the Bridgeway thoroughfare in Sausalito was once upon a time opened by a German immigrant and is nowadays run by a Chinese family with Mexican kitchen staff. The menu is Swedish-Italian, which may sound like an attempt at colonizing an entire continent in one strike. What does that mean, really? The explanation is simple with a logic of its own: if you add unspecified vegetables to the supposedly Swedish toast, patty, egg, cheese & caramelized onion specialty, according to Fred's you'll get something that is genuinely Italian.

The regulars here do not necessarily bother too much with what is floating and bobbing a couple of minutes' drive away. Breakfast is all about routine and repetition; regular coffee with regular local news. Yeah, there is a waterfront, everybody knows that, but Liberty, no, haven't heard too much about that particular dock.

It may very well be a different kind of breed out there, with dwellings unknown to the caramelized onion folks, without or with their vegetables.

Out there, they may walk on water, and even live on it.

They may have created the largest houseboat community in the whole of the United States.

The Outskirts
of The No-Good
Mainstream

It was in the 1960s that they came here to live on a shoestring and to party on the outskirts of that no-good, mainstream, conformist, 9-to-5 society. Janine Boneparth arrived much later, with a healthier budget that would buy her an upscale houseboat, but she still does her part to save the world, wearing peace earrings and picking up plastic litter from the ground each day as an environment-friendly gesture. There is a legacy at work here; a whisper carried on the salty winds, words that were once spoken in a hippie dream.

Decks and docks and, yes, dreams: wooden ships, cottages nailed to barges, shacks of the shotgun type, bulging flowerpots, luxurious and meticulously decorated homes, colliding colors and angles, rafts connected by haphazard walkways, electric wiring hanging perilously close to the water's surface...

Some days, as the sun sets with a reddening apricot radiance, this may look like an Indochinese riverfront with rickety structures from salvaged materials piling up against one another, making use of whatever drifts by and has not yet sunk. Then turn your head just a few degrees and you are in pastel plastered Suburbia, where trimmed planters abound and design magazines knock on doors. Having made this their place on earth, the hippies and the upper middle class professionals now share the brackish tidal waters of Richardson Bay just north of San Francisco and they will all tell you that this is about feeling good, feeling free, and finding an attractive lifestyle off the beaten track.

Sausalito, the small coastal town on the northern side of the Golden Gate Bridge leading out of the city, is home to more than 400 houseboats; an impressive fleet and a vibrant floating homes community.

Once driven by notions about ecstasy and withdrawal from the rules and regulations of the mainstream, and the need for inexpensive housing, the place is becoming more

gentrified by the day while insisting that the term "alternative" still has a ring to it.

This stretch of shoreline, sheltered from the Pacific wind and pretty much secluded, had been used during World War II as a shipyard for landing vessels, cargo ships, and submarine chasers. The abandoned mudflats, filled with scrap, barges and recyclable materials, then caught the eye of the countercultural dropouts looking for rent-free, unpretentious quarters.

It was a peaceful occupation of what had just recently been military land.

Now you will encounter the lawyers and doctors and retired literature professors, who appreciate the relaxed and somewhat different lifestyle, the younger office workers who commute to the city on a local ferry, and some of the old-timers who fought for a hard-to-find Utopia. Today's mix on the docks is fascinating, but the gentrification also generates mixed feelings, of course. There is an ongoing project aimed at moving some of the unstable and unsafe home-built boats with their totems and junk sculptures to new, more secure spots, integrating them into this separate world of real estate agents and interior decorators.

While these changes take place, the whole neighborhood still appears like a small universe of its own, filled with luscious plants, cozy breakfast decks and a myriad of imaginative boat names.

The Return to
The Wonderful Times

A walk along Issaquah Dock offers an ambience rich with well-tended foliage and blossoms, the result of meticulous care that would make most landlubbers envious.

Pots and vines are abundant. Showroom homes with concrete hulls share the space with homegrown plywood wrecks and assorted models of gingerbread work. In every shrub there is a garden frog, on almost every fronting a stylized pelican or lizard.

Several of the modern houseboats resemble moored villas. Flo Sherwood is watering the plants on her sun deck while describing how she and her husband Jack moved here more than ten years ago. They are truly enjoying their retiree life on the water.

"The first thing we did was open the entire wall facing the bay and the boats on the next pier and put in huge windows."

Out front, on the dock, floral arrangements jostle with the sort of animal sculptures made from wood or rusty sheets that inhabit the entire neigborhood. In this oasis of theirs, Jack Sherwood sits working on his third novel. The second one was, unsurprisingly, set in a fictional town with houseboat docks. To him, moving here was is like a return to a bygone era, when he was a younger professor teaching at radical universities and flower power became synonymous with San Francisco. He came through Ann Arbor and Harvard before arriving to the west coast.

"The sixties were a wonderful time in academia," he sighs.

Flo taught group dynamics at Stanford Business School, the kind of subject the students – fondly, she assures us – would define as "touchy, feely stuff". Her favorite excursions these days take her to Esalen at Big Sur, an exclusive retreat with spectacular Pacfic views that describes itself as "a global network of seekers devoted to the belief that we are all capable of the extraordinary".

Jack points to the Gate Six Co-op over yonder as the true bearers of the underground

spirit. That's the part of the community with the dissident legacy. Those are the folks that outsmarted the cops and would not let themselves be intimidated. They just needed to fix the sewage and clean up the bay. One of the guys who lives there now has a bathtub that looks like a temple.

"We have a very relaxed and alternative atmosphere," Jack Sherwood says and smiles underneath his straw hat. "People care for each other. One of our neighbors has Alzheimer's disease and there's fourteen of us who take turns to assist him. If one should have Alzheimer's, this is the place to have it."

Welcoming visitors to this aquatic small town, cacti and elephant grass mingle with brightly colored plants. There is greenery covering railings and terraces. Coffee tables and lounge chairs sit scattered on the decks and wobbling bridges. The pace is relaxed, the noise from traffic on the hillside highway conveniently remote.

The flowers in Flo Sherwood´s hat are exactly what you would expect. There is a certain niceness to all things here that is self-evident.

At the far end of one of the docks resides The Train Wreck, a home aware of its magazine appeal, having been built around an old mahogany railcar from the 1880s that was cut in half, thus creating a sharp angle. It is one of twelve remaining Pullman cars of this type and it was used on the old railroad line from San Francisco up to coastal Oregon. Even today, the windows look across the bay toward the city lights on the other side of the Golden Gate.

"The boat came up for sale on a Saturday night," says owner Henry Baer, a retired dentist. "I got here Sunday morning and made an offer after ten minutes. And I'm the kind of guy who can't even decide which shirt I'm gonna wear!"

Baer and his wife Renée, who is an interior decorator, belong to the new tribe of settlers in the floating gardens of Sausalito. They thoroughly appreciate the communal lifestyle and the location of their home, which demands that they take a long walk from the parking lot and run into all kinds of neighbors.

With her dogs Inga and Otto, Lovise Mills practises a more compact version of living aboard a tiny vessel that has been gradually renovated. Both the surface and the interior were full of graffiti when she first moved in. Now it is a well-functioning base for her small gardening and landscaping business.

Before the most recent financial crisis Lovise did well with moneyed clients sporting Porsches and nannies and their own private chefs. The market has recovered somewhat lately; a lot of people want to make something nice out of their backyard, but simply do not have either the patience or the ability.

Hers is a tale of two countries. A Danish woman worked in a San Francisco restaurant and when the place caught fire an American firefighter came to the rescue.

And so Lovise was born here, but her teenage years were spent in the idyllic green landscape of the Danish island of Bornholm. She still travels back each summer to her family home. It is a journey between two seas and two different types of vegetation.

"I once studied in Lisbon to become a fashion designer. But it wasn't me. Those elbows were much too sharp."

So now Lovise Mills lounges in one of the chairs on the trembling walkway that encircles her houseboat. When the evening sun travels past the hillside to the west, the floating homes and gardens of the bay are covered in a shimmer the color of lions on the savannah.

It is a hippie dream with a golden lining.

Few individuals perhaps embody it better than Janine Boneparth, who moved in quite recently with her shades and silvery moviestar hair. Her sea bungalow plays in a different league than the boat next to it, The Evil Eye, whose tenant Larry Moyer has been around for a very long time with his retired hurry-scurry and assorted bookcases and pots and plants and a thousand memories and stories to tell. However, Janine Boneparth still participates in more rallies than most people did in the 1960s.

Flower power, of course, never really died.

The Charm of
The Small Town

Upwards of 7,000 individuals nest in Sausalito, and with an environmental cap on further development this is pretty much the way it will stay in the years to come. More often than not, Democrats are sent to offices of political significance. Tourists come for the scenic views and crowd into gift shops and coffee houses; it is a California version of quaint and quiet which leaves you relaxed if not totally excited.

It is nice. It is laid back. It is comfy. It is rare to find such a lovable spot so close to a major city. It is a town you could grow old in with your homegrown vegetables sprouting in the backyard.

Downtown, there is a No Name Bar, where waterfront musicians are regulars. If you are an eccentric, a piano waits to be played down by the marina, at The Seahorse. You will hear all kinds of songs there, from lullabyes to Laura Nyro tunes, as local heroes pound the keys at the far end of the shiny dance floor. A birthday party bursts in and bursts out, local IPA's in hand. A soft wind is waltzing outside, occasionally pushing the sea breeze through the saloon door.

Of course, indigenous people were around long before the town was founded in 1868. One branch of the Coast Miwok had lived here, but the native group was displaced when European settlers showed up. A Spanish advance party in 1775 reported back to their main ship, describing friendly locals, plentiful wildlife and an abundance of timber.

But it would be another half-century before William Richardson, a Mexican citizen born in England, began the actual development by establishing his Ranch Saucelito, a reference to willow trees. In 1838 he received a huge land grant that made him both a seaside and a bayside landlord. The bay was given Richardson's name. A small town

then rooted itself within sight of San Francisco, but it remained isolated since any journey on land would require a long detour. When the first post office opened in 1870 the spelling had changed to Sausalito.

In a newspaper article from 1918, in the San Franciscan Call Bulletin, Richardson's son Stephen, then 87 years old, recalled his childhood days in the area:

"My early life in Sausalito was perhaps the happiest time of life. A horse trail ran from San Rafael to Sausalito, very much the same as the main highway goes today. The country was entirely untouched by man, and the wild oats grew shoulder high, in spite of the great herds of wild animals browsing in the fields."

Stephen Richardson remembered the bay as a fairyland of enchantments with water clear as crystal.

"The stillness was unbroken save for the shrill piping of the myriad shorebirds, and elk with huge branching horns, graceful antlered stags, and huge grizzly bears stood statuesque on the hillsides."

The Sisterhood of Safety

Her cat Monster is blind, but manages to stay out of the water. Michele Affronte has been part of the houseboat community for more than twenty years and her home is the aptly named Bateau de Rêve – the Dream Boat.

I came in 1991 from Los Angeles. I lived at the beach, Venice Beach, and I wanted to move up here because of the recession. I was selling real estate down there and I couldn't really make money any more. I came here and I wanted water so I bought my first house boat. I lived there for several years and when the real estate market got better I moved to land and bought a few houses and sold them, just to make money, and then came back and bought this one some ten years ago. And I love it!

What makes this place special?

I don't really have too many friends at all on land. My whole life is based on these houseboats. The social life here is something you're not gonna find anywhere else. Here's a bunch of women that are like sisters. We're in and out of each other's houses, we share dinners, everything, and I think that's hard to find these days, because people usually go home and close their door and that's it. But I also like being out on the bay a lot, with my pedal boat and my kayaks. It's really just a very special, nurturing place. And it's safe, you never have to lock your doors. That's another good thing about living here, you don't have to worry. Nobody will ever break into your car. There is zero crime.

Isn't someone who works in real estate an outsider here?

There is no tension, because I'm not the typical real estate person at all. I befriend all my clients and bring in people that I know will fit into the community. If I sell someone a house I'll give them a party and introduce them to the community. I know everybody. I baby-sit everyone's cats and dogs. I'm one of the supporters of the community. I donate money all the time.

How can you tell if the buyer will fit into the community?

If they complain about the walk on the walkway, if they ask if there are parties and tell me they are very quiet people, then I will advise them that maybe they shouldn't live here. I mean, we're ten feet apart from each other. I can tell right away. If they're not liberals, they will not fit in at all. They won't be invited to any parties!

How do you know if they are liberals?

We talk. We talk about it. Republicans don't even tend to look at houses here. They want the conservative house and the elegant street and things like that.

But some of the houses here are very elegant, too.

Yes, they are. That is a change. It's happened mostly in the last ten years. But the kind of people that are coming are still not the conservative type. The ones who come and spend all the money are very ecclectic and interesting people who own homes all over the world. My next door neighbors, husband and wife, are doctors. They do all this pro bono work in Africa all the time helping children. They only live here part-time. There's a lot of people like that around. Retired professors, that's the kind of people who'll move here.

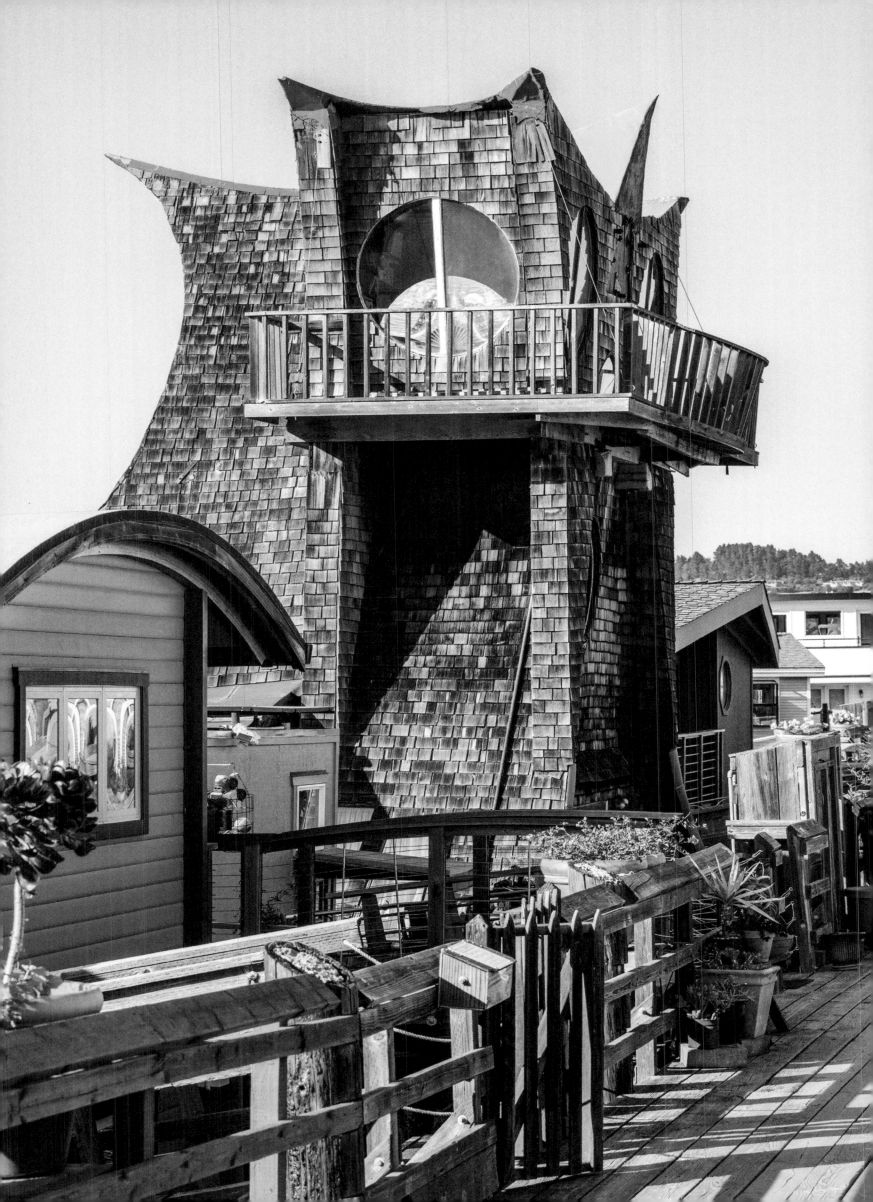

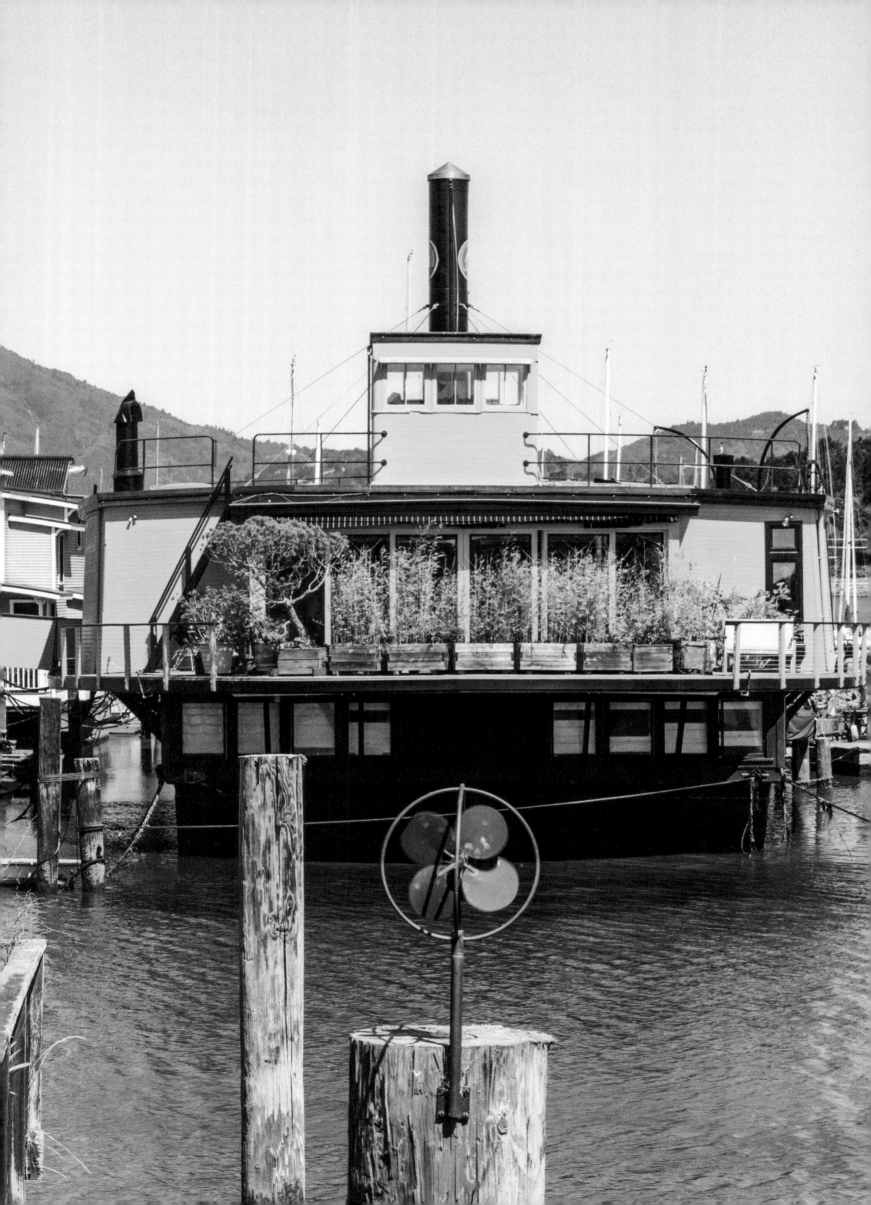

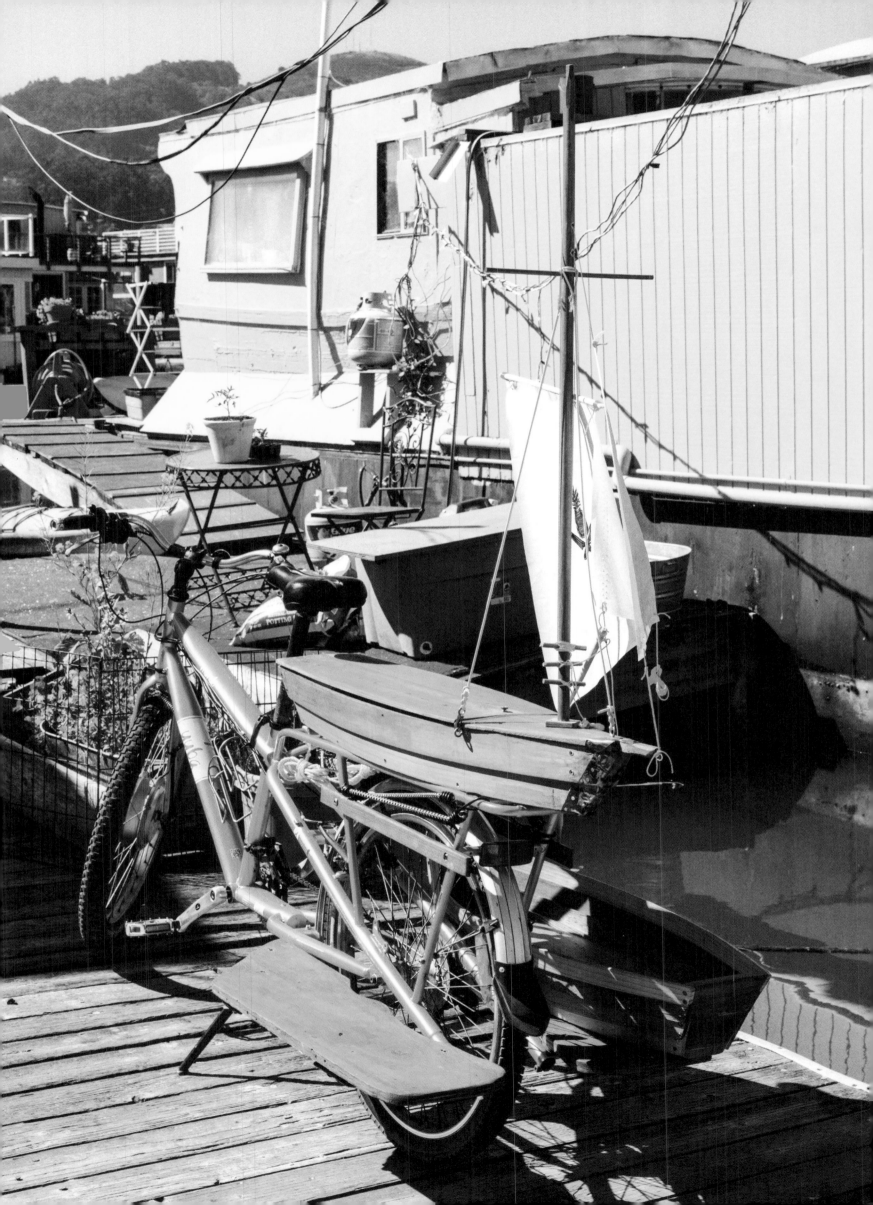

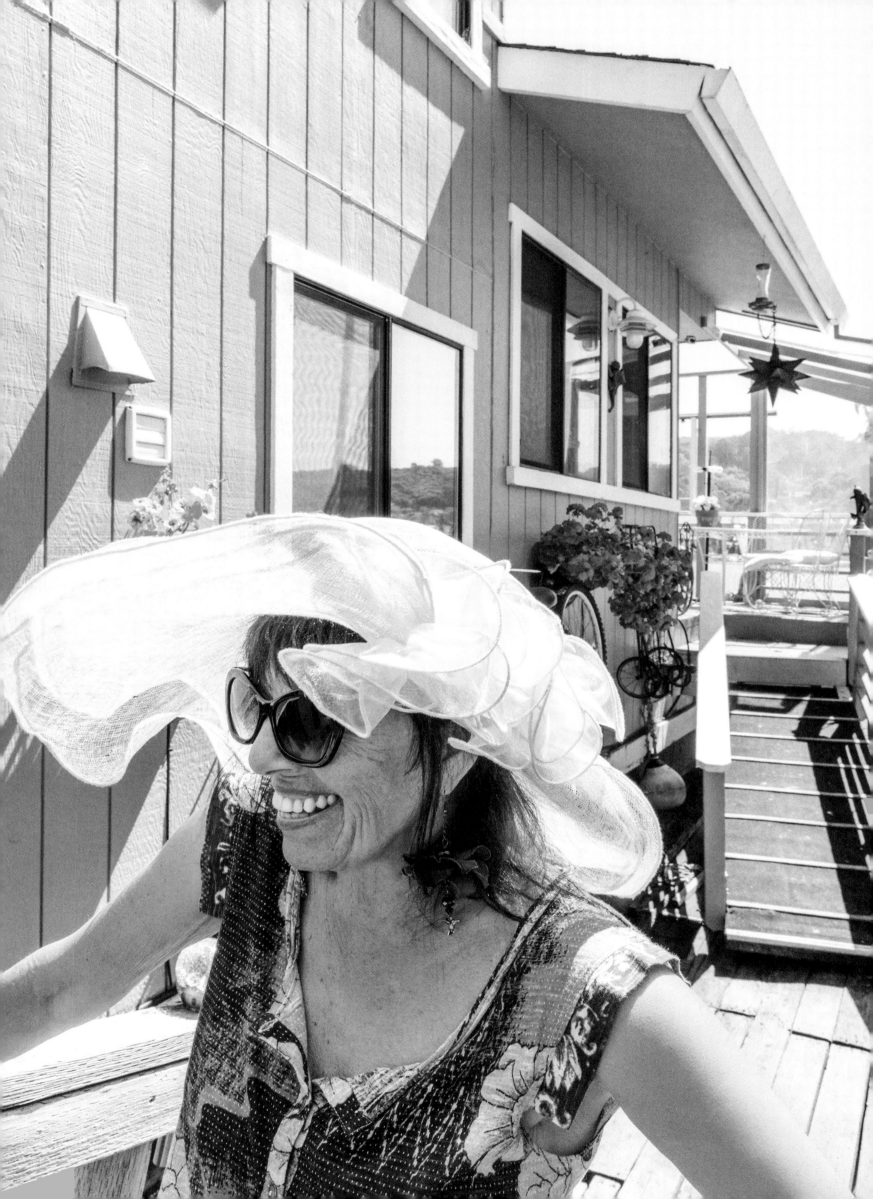

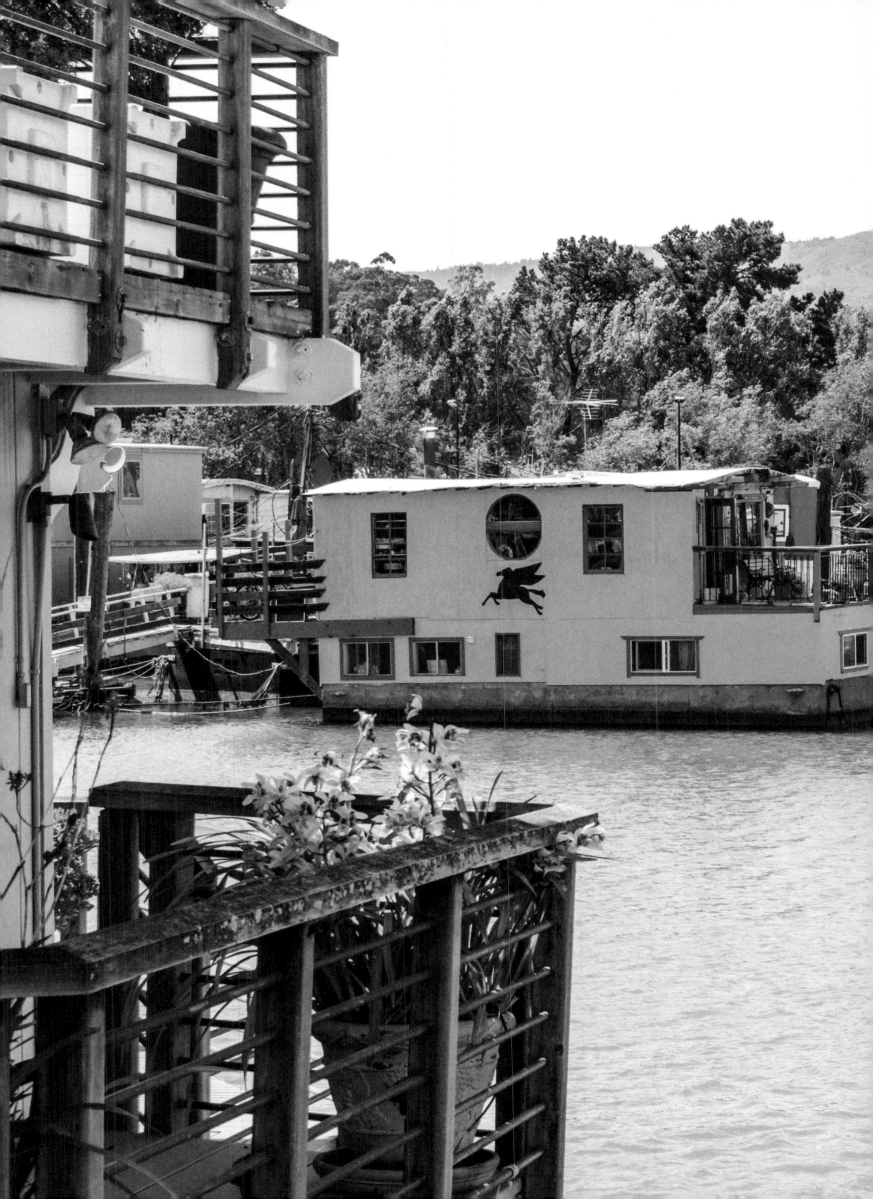

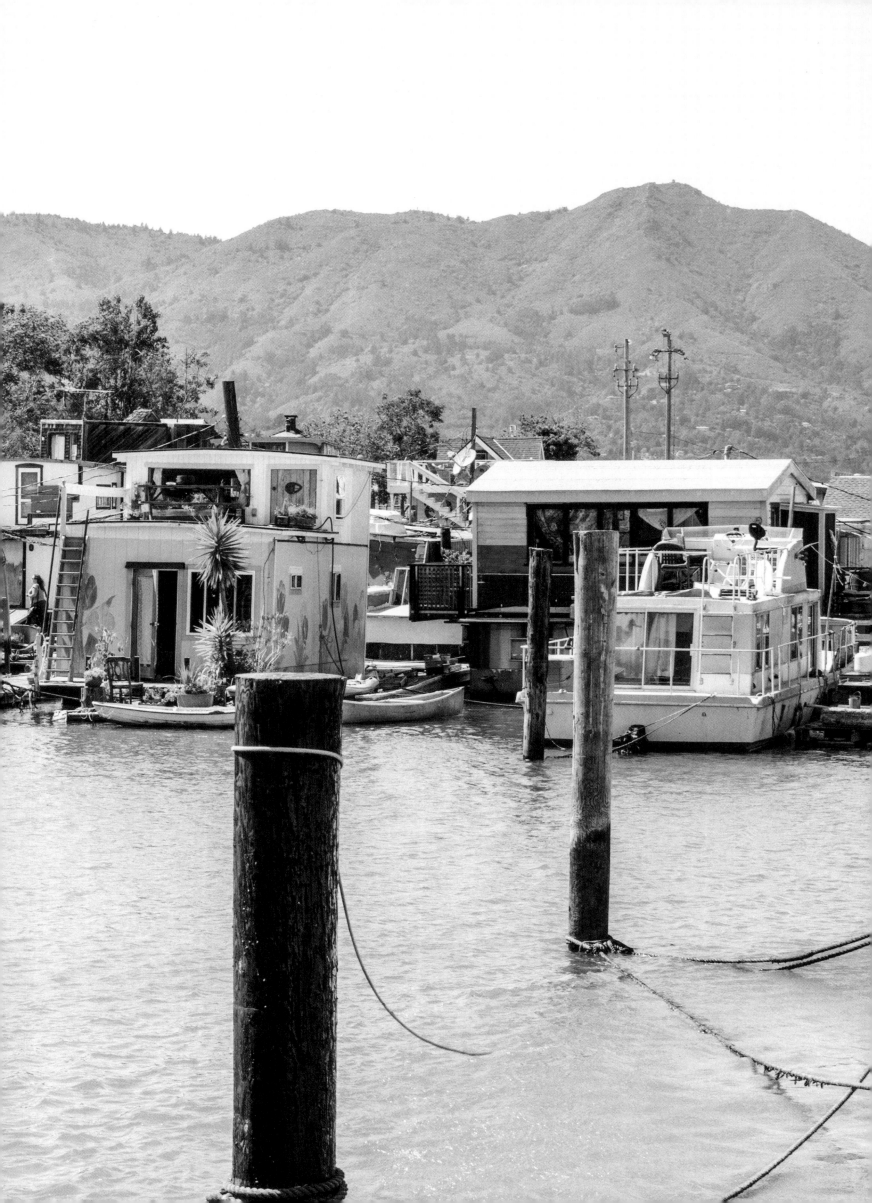

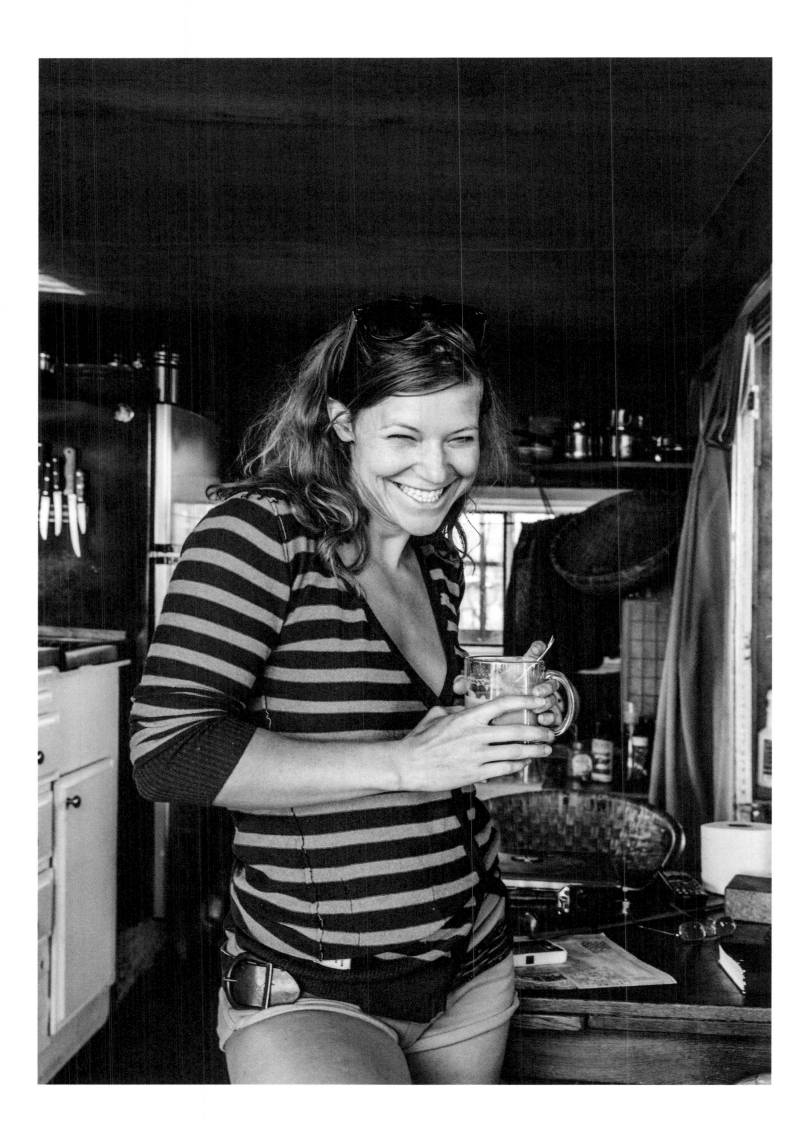

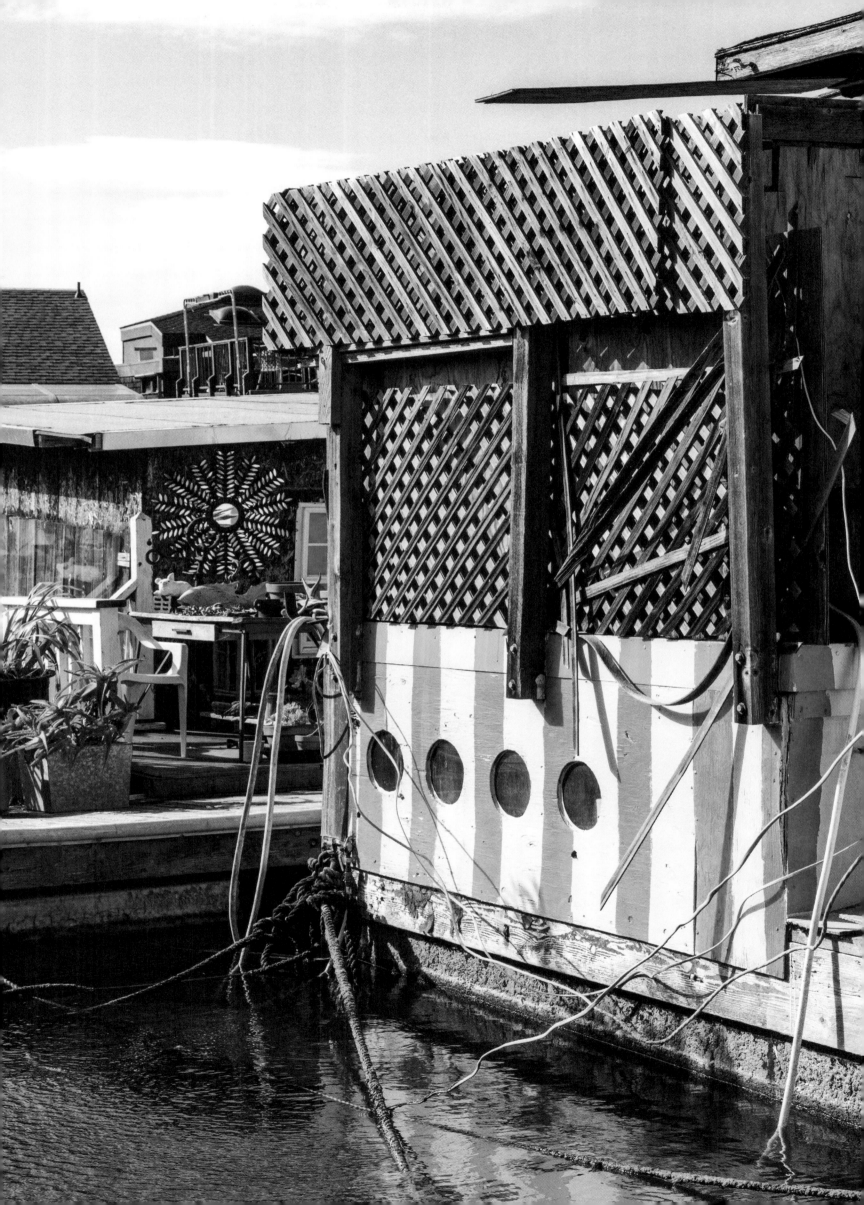

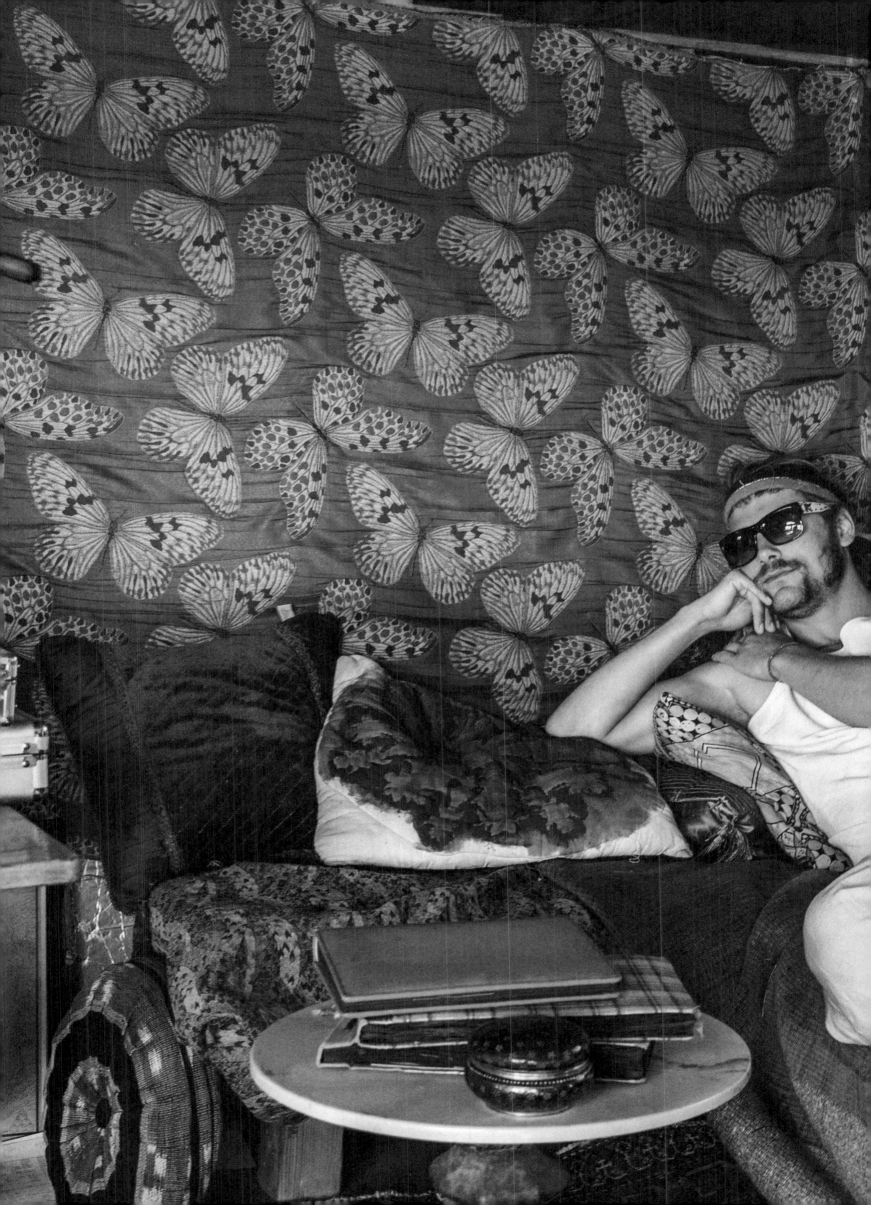

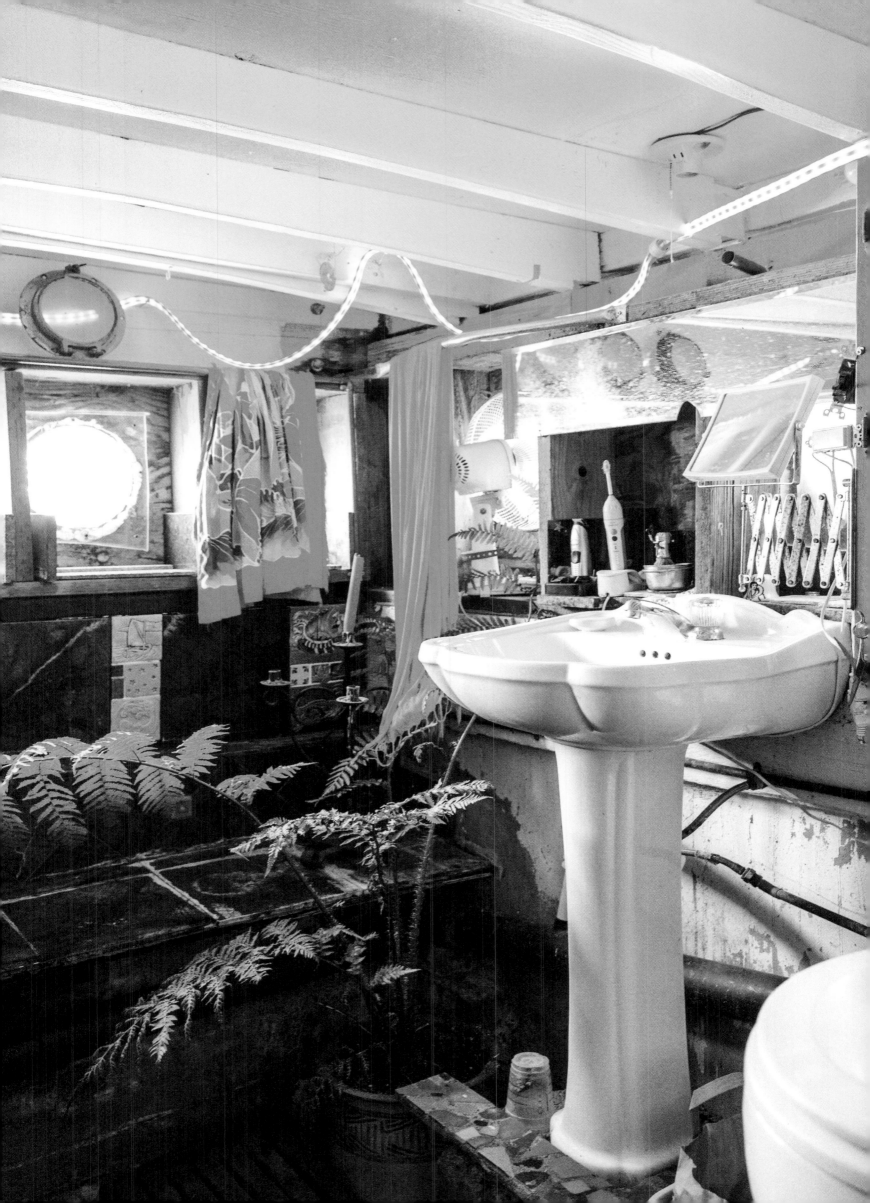

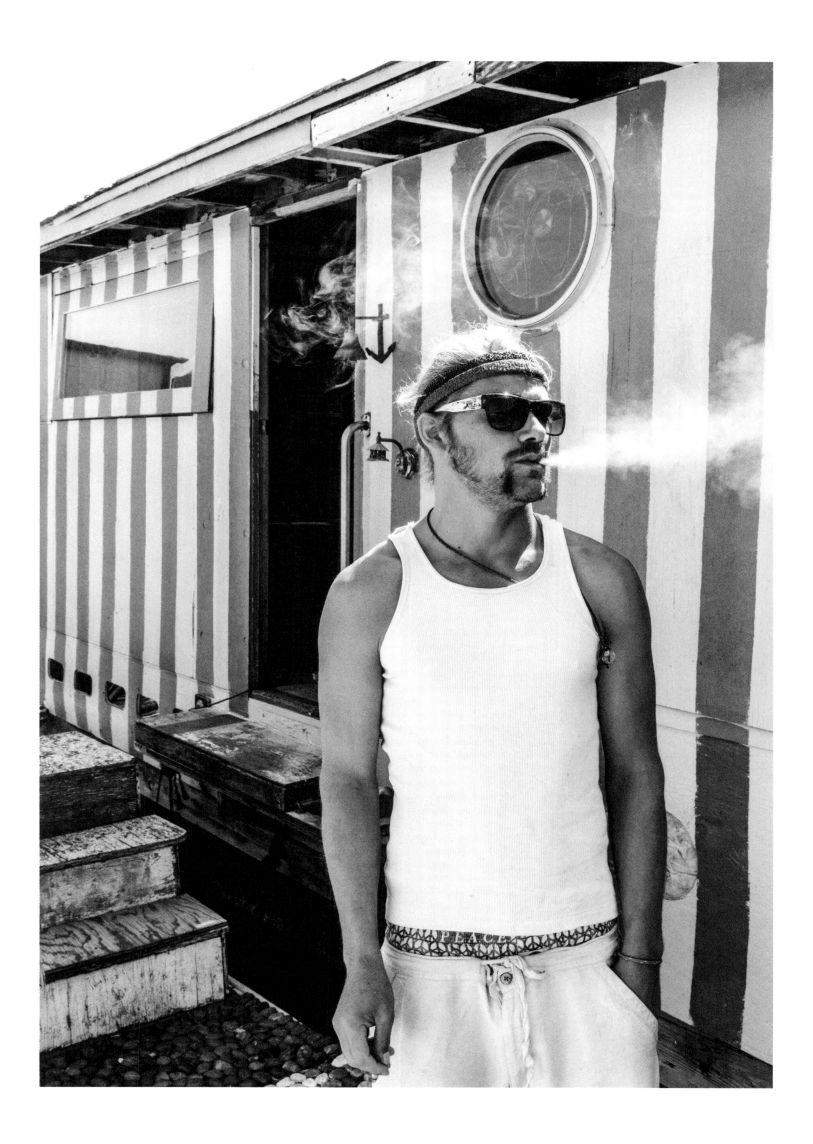

The Whole of
The Earth

The paths have not always been straight or paved. The Dorathea, with a pair of windows looking like narrowly set eyes, or observant camera lenses, is a flat-bottomed tugboat owned by a man named Michal Venera. He was born in Prague, escaped on foot from old-time Czechoslovakia through Yugoslavia into Austria and eventually found himself on a Greyhound bus crossing the American continent, going west. He slept in the streets of San Francisco, took up work as a fisherman and has now made a career for himself as a commercial photographer while living house-boat life with his son.

In contrast, S/S Maggie, a short distance away, shines like a silver spoon.

She came from a sail powered tradition, but was equipped with a small steam engine when she carried light cargo between Monterey and Fort Bragg on the Mendocino Coast a hundred years ago or more. The three story schooner then became home to numerous residents, who did not pay enough attention to prevent her from eventually taking in water and landing on the bottom of the bay. All hope seemed to be gone, but extensive restoration in the 1990s provided S/S Maggie with a new hull and a changed appearance.

The present owner Connie Ruben leads the way through the former wheel house, which is now a dining room, and down to the engine room that has been converted into a spacious bedroom with the old beams humming and wooden pegs serving as tributes to the craftmanship of early boatbuilders. In the bow room, there is a bed and a bath. The neatness is reflected in polished hardwood floors.

We sit in deck chairs absorbing the almost cruiser-like atmosphere of this moored nautical residence, the light from the white exterior walls forcing Connie Ruben to search for her sunglasses.

She spends half the year in Calgary up in Canada; in the snow, in the wind, in the mining business, in a universe quite separate from this. Her husband Peter continues to catch every opportunity to bring his bicycle to Europe for different professional

races up and down Mediterranean mountain roads, though these days it seems to be mainly for the satisfaction of remaining alert.

You will, on these docks where boats are where the hearts are, hear countless stories about persistency bordering on obstinacy. Dennis and Aggie Bayer bought their boat in 1976 for $7,500. It then sank twice. Returning to the surface they created a paper model of the sort of houseboat they wanted, and moved in eight years later. Marybeth Thompson's home nearly broke away like a wild horse one stormy night and had to be hauled back through a collective neighborly effort. In more ragged parts of the community, half-rotten, junk-filled remnants of vessels await their owners' decision to begin restoration. Some continue to hesitate because of the costs and dwell on it while living a more comfortable life in some faraway prairie state.

For Lauren Petterson the move to Sausalito was a dream come true. Her husband had not totally vetoed life on a boat, but he was opposed to the idea of living on a berthed one without an engine. His father had moved from small town Sweden to America in the 1930s. Sitting still did not seem like a family trait. But when the husband passed away some ten years ago, Lauren Petterson took the leap.

Despite their kinship to mobile homes, these constructions rarely move. They sit anchored to their hulls of concrete. The only houseboat here with a motor is Stewart

Brand's and Ryan Phelan's tugboat Mirene. Built in Oregon in 1912 as a cannery schooner, she sixty years later became a derelict houseboat in Sausalito's Dredgetown. Brand and Phelan acquired the hulk for a fair price in 1982 and over a three-decade period they transformed the wreck into a home and a boat that actually floats and sails.

Brand had helped organize the Trips Festival, combining rock music and light shows in mid-60s San Francisco, and became a countercultural household name when he published the Whole Earth Catalog, a series of back-to-the-garden, back-to-the-country tool reviews for a do-it-yourself generation opting out of materialistic conventionalism.

The catalog could also be read as a manual for establishing yourself on the Sausalito waterfront.

Stewart Brand used to hang out with Ken Kesey, the author and LSD test pilot, and his Merry Pranksters collective, and actually got an acid test graduation diploma signed by Neal Cassady. In Tom Wolfe's novel "The Electric Kool-Aid Acid Test", Brand is bouncing down the hills of San Francisco in a pickup truck awaiting the imminent release of Kesey from a local jail. "Two more things they are looking at out there are a sign on the rear bumper reading 'Custer Died for Your Skins' and, at the wheel, Lois's enamorado Stewart Brand, a thin blond guy with a blazing disk on his forehead too, and a whole necktie made of Indian beads. No shirt, however, just an Indian bead

necktie on bare skin and a white butcher's coat with medals from the King of Sweden on it."

Three years before NASA provided humanity with the pictures from above, Brand used to walk around with the button slogan, "Why haven't we seen a photograph of the whole Earth yet?".

Like many other off-the-grid Californians, Brand then became a cyberculture pioneer, tuning hippie minds into computer space. He initiated an early Hackers Conference, came up with the online forum The Well, and was instrumental in creating the Long Now Foundation, which takes to yet another level the Iroquois notion that one should always plan for the well-being of humans seven generations ahead.

The ecology-minded Brand has written extensively on the topic of global resources and human footprints, and emphasizes the fact that life on water reduces his personal problems with earthquakes and wildfires. He has, however, been criticized for a futuristic belief in the blessings of technology. For example, he argues that urbanization is green, as is nuclear energy, something his old Native American pals would certainly object to, and his statement that "the romantic nature-is-perfect approach is just horse exhaust" suggests that he may have shed some layers of skin since the earliest communal days.

The Brutal Side
of Beauty

The creative resourcefulness associated with today's boat community also has its precedents, such as the ark Crystal Palace which in the late nineteenth century was built around four retired cable-cars placed on a floating platform. The Belvedere arks, sitting on the eastern side of Richardson Bay, across from Sausalito, even had an annual waterlife celebration in the 1890s called "Night in Venice", with fireworks and yachts lit up by electricity as darkness fell. Images from that period show relaxed bathing scenes, women with high-collar dresses and wide summer hats in row boats, and social deck gatherings beneath Chinese lanterns.

As local resident Phil Frank found out when researching his book "Houseboats of Sausalito", this floating homes history stretches back even longer, at least to the 1880s.

Houses on boats offered affordable quarters for some of the manual laborers, who had come from the east to flock into northern California and the Pacific Northwest looking for fortune, a new identity, or simply a decent job. Demasted with new roofs, these homes on the water were often reminiscent of prairie cabins and if you didn't see the poles or the pilings, the image created was that of a small town helplessly floating downstream after a horrendous rainfall. Water is elusive. Living on it, surrounded by it, your privacy is also invaded by it. Your exterior is damaged and there is always the threat of leakage through rust or other weaknesses. It keeps you alert, it forces you to take into account the brutal side of beauty.

In the bay, the stationary vessels move with the eight feet tide, rising twice daily and landing on the mudflats in between. A man, who just recently moved into a modern Sausalito houseboat, describes how he and his wife spent several sleepless nights haunted by the wails of unknown underwater creatures before realizing that the sound came from the ropes scuffing against the pilings as the water stirred according to plan.

San Francisco was devastated by the 1906 earthquake and the ensuing fire. People with houseboats as second homes would move onto them permanently. As a bridge system was established in the Bay Area, with the Golden Gate Bridge opening in 1937, ferryboats lost their function. Some of them found a retirement home in Sausalito. By the early 1950s a small group of arks on hulls had come together at Gate Six, by the rail tracks near Waldo Point. One of them was rumored to use a piano as its anchor.

Before the bridge era, Sausalito had been the terminus of the Northwest Pacific Railroad and the ferryboats going back and forth to San Francisco and the East Bay. Now, even the old county road through town, Water Street, had to adapt and its name was changed to Bridgeway.

Landfill always is an option for expanding communities, and Sausalito has held such aspirations. Frowning at privately owned houseboats parked on public water that could possibly become public streets, city planners would look at new opportunities. For a while, the very existence of Richardson Bay was questioned. Though it has not happened yet, there are documents that show underwater demarcation lines and even a theoretical street system where you can imagine yourself walking, or swimming, down Eureka, Pescadero or Teutonia.

Houseboat life was not always soaked in sunshine and roses even though many of the historical photos offer weekend smiles and relaxed groups of individuals leaning on railings. The City of Sausalito disliked some of the structures that showed up on its shores and several were burned and destroyed around 1950. Slightly to the north, the ark owners along Corte Madera Creek found their boats crushed by bulldozers after the State Lands Commission denied them further occupancy in the mid-1960s.

Once a continent without fences, America had become a territorial battlefield with land its most valued asset. Sausalito would soon have this conflict at its doorstep and on a scale not seen before on the waterfront.

The Spirit
of Bohemia

People came journeying from afar to see what was happening in San Francisco in 1967, during the Summer of Love. A few of them proceeded to Sausalito, creating a makeshift, make-do community. Homes were constructed from debris, driftwood, cardboard sheets, old planks, whatever was available nearby. Some were designed to look like birds, others emulated pirate ships.

For a brief period of time, the squatter gathering was pretty much a secret. If you are searching for a life on the fringes of today's society you will probably have to trek into the wide open spaces of Wyoming or dig into deserted mining towns in northern Nevada. The visionary architect Paolo Soleri, who passed away in 2013, tried to create an alternative small town, Arcosanti, commencing from scratch in the Arizona desert, but because he turned down a Disney offer to transform it into a theme park the funding remained smallish and construction has crawled forward at a very slow pace.

In Sausalito, the bohemian spirit is still present, but it is fair to say that the original occupation has been taken over and occupied by a new era, which places much more value on material things. Just as with Soleri, who viewed Suburbia as a soulless place without urban qualities or human connections, essentially a rallying-point for emotional hermits, the fringe has become hip, symbolically coveted and fashionable. Dirty old factories change into loft apartments. Junkyards are altered into canal promenades.

It did not take long for the countercultural slogans to be turned on their heads and used in commercials for cars and soda pop.

The anchor-outs were the most peripheral; they lived on the outskirts of the outskirts. The residents on these boats never cared too much for permits and paper work. Their Billy The Kid approach provided the waterfront with a touch of mysticism. Whatever went on was almost out of sight.

The few who still sit out on Richardson Bay are reminders of the outlaw era, seemingly adrift and unattached to society in general and, more specifically, its neat Sausalito neighborhoods.

The physical foundation of the community is a mixture of mud and salvaged scrap from the Marinship facility, to a great extent built on dredgings from the bay, which swiftly closed down its massive World War II shipyard operation once the Germans and the Japanese had been defeated. A lot of building material was left on the shore;

the only thing missing was an idea about its future use. As squatters and freewheelers floated in, this was soon taken care of. A rent-free commune materialized with wild architecture and untreated sewage.

It is hard to imagine the present-day houseboat community without taking into account the role of the Arques family. Beginning in the early twentieth century, Camillo Arques operated a number of boatyards in Sausalito. Wooden barges for both commercial and military purposes were the main products. A veritable fleet of abandoned vessels was also assembled by his son Donlon Arques, a motley collection of abandoned submarine chasers and almost Jurassic period ferryboats. These came in handy later when the 1960s outcasts showed up.

As the United States entered World War II the need for cargo ships had been enormous. In March 1942, initial work began on the Marinship, hidden in Richardson Bay shadowed by Mount Tamalpais. A new wartime community was hastily created around the

shipbuilding, with plans made for 1,500 apartments, a school, and a community center. After the war, Donlon Arques took care of the leftover materials, playing around in what was essentially a waterfront junkyard. This was a period of transition; instead of production and repair work, recycling dominated. Arques acquired surplus ships, equipment, and more land on the water. He rented boats to artists and ex-soldiers and was soon in control of much of the vacated Marinship property.

Tugs and sub chasers and boathouses were floated from other positions to come and sit at Gate Six in Sausalito. Arques had the good instinct of surrounding himself with young guys, who wanted to learn the boatbuilding trade and become part of his scrap and repair business. The emptied shipyard buildings could be reused as work spaces as newcomers moved in.

And without anyone having mapped out any plans, a social experiment grew from scratch on this nowhere land.

The Parade of Waterfront Celebrities

A few of the old ferryboats became prominent features in the alternative marine landscape. Others were scrapped, like The Issaquah which disintegrated in the late 1950s, but would later give name to the most park-like of the modern docks.

The Charles Van Damme was an impressive ferryboat with room for 45 automobiles. Decommissioned in the late 1950s and towed to Gate Six it spent its retirement years as a restaurant and, incarnated as The Ark, as a hangout place and waterfront home for rock bands. With its new name painted boldly on the port side, the former ferry, complete with paddle wheel and steam stack, was a social hub for the houseboaters until it was demolished in 1983.

A mound of dirt now sits where The Ark used to harbor groups such as Moby Grape and Big Brother and the Holding Company. There are still imaginative concert posters to be found with the likes of Steve Miller, Santana, Sir Douglas Quintet and West Coast Pop Art Experimental Band, but many of these big names did not actually show up at Gate Six. One reason may have been that the bands did not get paid. Those who did perform in the wee hours would however get treated to a huevos rancheros breakfast.

Several music and movie personalities parade through the memoirs and fragmented reminiscences that have been published through the years. The Quicksilver Messenger Service lead guitarist may have strolled past the flea market with Cher, and there have been sightings of Bill Cosby, Jefferson Airplane, The Smothers Brothers, Bill Graham, the concert promoter, and even a young Pam Tillis, of later country music fame.

You can no doubt also find mentions of John and Yoko. And the legend would

never be complete without Bob Dylan lurking in a shady corner.

In all likelihood Jerry Garcia had a smoke or two on the waterfront. Interviewed in a 1972 book, Garcia declared that his band, the Grateful Dead, "is not for cranking out rock and roll, it's not for going out and doing concerts or any of that stuff. I think it's to get high... I'm not talking about unconscious or zonked out, I'm talking about being fully conscious."

Writing in Boom Magazine in 2012, editor and lecturer Peter Richardson found the core of the Dead's long-lasting appeal in the band's utopian devotion to ecstasy, mobility, and community. Garcia had called the band's extensive touring and traveling culture his generation's "archetypal American adventure" and according to drummer Mickey Hart, the Grateful Dead were in the transportation business: "We moved minds."

Thus, they were the epitome of the hippie ethos and became an inevitable part of the Sausalito soundtrack.

The Sound of Flute Tunes in The Air

The Vallejo, a side-wheel ferry built already in 1879, became home to Brtish-born Zen philosopher and writer Alan Watts and, in a separate part of the ship, the cosmopolitan collage artist Jean Varda, who in 1943 had convinced Henry Miller to move to Big Sur, a connection that would also lead to a close friendship with another well-known author, Anaïs Nin.

Varda moved to Sausalito in the late 1940s, entertaining large groups of friends on board and throwing costume parties that became quite famous. For many years The Vallejo was an influential midpoint in the social life of the floating community. One of Varda's birthday parties was described in Phil Frank's book as "singing and dancing with everyone dressed in exotic costumes and Varda arriving with great fanfare on his sailboat, The Sakri, decorated with pennants and flowers".

There was long hair blowing in the wind and tender flute tunes in the air.

Another gathering point was The S/S Lassen, an old lumber schooner that was host to numerous artists' studios. Some of them also lived there. All kinds of media events took place on board, radio shows were broadcast and reporters showed up in search of quotable phrases. When city hall wanted to clean up the boatyard and get rid of The Lassen, its owner Donlon Arques, according to Frank, replied with great anger:

"I told the city 'you move that boat and I'll sue the hell out of you because you'll ruin my ways, and I have a lot of money in that ways'."

Before the hippie generation learned about the possibilities of these mudflats, artists would flock into Sausalito and some of the beatniks from San Francisco's North Beach came here for the summer. There is a slight, and somewhat odd, mention of the place in Jack Kerouac's "On the Road", by Sal Paradise, the book's narrator and protagonist: "I had just come through the little fishing village of Sausalito, and the first thing I said was, 'There must be a lot of Italians in Sausalito.'"

Other celebrities from the alternative scene, among them poet Allen Ginsberg and sculptor Sargent Johnson, also found their way to Sausalito, often invited by Jean Varda who liked to take them aboard his sailboat. Varda's flamboyant lifestyle must have been an attraction in itself; an artist's realization of the good stuff, an existence

filled with friends and party-goers. You could sense a certain kinship with the merry group of psychedelic pranksters that circled around Ken Kesey and who, in 1964, took off across America in a brightly painted bus named Further, with Neal Cassady at the wheel; a legendary magical mystery tour that later would inspire the most famous pop group on earth.

On a visit to Kesey's home in Oregon in the fateful month of September 2001, just shortly before the author passed away, he showed us the famous vehicle which stood half-buried, covered with moss, behind the main building. It was slowly sinking into the cultural foundation, like an old folk song with roots you can no longer trace.

The Kesey garden, with its coveted concealed object, is where the Grateful Dead played their dirge to a close circle of friends just after Jerry Garcia died. The Smithsonian Institute had for many years tried to convince Ken Kesey to hand over Further for inclusion in its historical collections, but he kept saying that the bus was gone and nowhere to be found.

His lips were still sealed when he, not unlike Chief Broom in "One Flew Over the Cuckoo's Nest", left this world one November day and disappeared across the meadows at Pleasant Hill.

The Unlimited Joy
of The Big Picture

A man comes home from work, walking up West Pier, soft soles on his shoes and earplugs hanging loosely around his neck.

"I'm so lucky," he says. "I'll take the ferry back and forth to the office in the city each day and I just sit there and revel. I cannot get over how people aboard can only stare at their smartphones in surroundings like these. I just relax, watch, enjoy, and let the music flow."

On the same dock, a magazine editor shows us his white-walled living room and work space, and tells us about the headache this environment may induce among insurance salespersons. His and his wife's house is insured against collisions with tank ships, a pretty unlikely event, but should they just sink into the mud where they sit there is no protection whatsoever.

With so much wooden structure around, fire is also something to watch out for. In this bay, there have been serious incidents and flames swallowing human quarters; even on water, surrounded by it, any vessel of this type could become a torch.

Many of the old houseboats were dramatic creations, not least The Madonna and Child, built by artist Chris Roberts, which rose above the other vessels at Gate Five with a church-like grandeur. The Owl, also envisioned by Roberts, and straight out of a children's book, was built around a dredge tower. Others had a rudimentary design, but very early on some may have had solar panels on the roof. Up until the mid-1970s, when the county began issuing building ordinances, the houseboats were primarily born out of fantasy and available resources. In contrast, a modern conventional

floating home such as the recently constructed Freedom does not push the limits of its rather pretentious name. It has replaced an old boat that caught fire and took the next door neighbor with it. Seventeen fire-engines were brought in to fight the dangerous winds of heat.

Most regular homes on land may hide behind street numbers, but the houseboat residents make up names to reflect the personality of their boats, or themselves. On the docks you will find Unlimited Joy, The Edge, Esperanza, Grey Goose, Green Heron, White Pelican, Painted Whale, Casa de Amor, Absolute Magic, The Louisiana Purchase, Mayflower, Bohdisattva, Chateau Bateau, Tranquility Base, By Storm, The Big Picture, and The Answer. Sweet Dreams is owned by two pilots.

The Roots
of Connection and
Disconnection

California is a hub in the modern world of communications, but a sense of artistic isolation at the end of the Pony Express trail prevailed in the Bay Area into the 1950s.

This spurred community and an obsession disguised as willfulness. Poet Lawrence Ferlinghetti opened his bookstore, which is still in the same location while all of the city's main bestseller chains have vanished. City Lights remains a place to cherish, a temple of enlightenment. Teenage girls from fly-over country can now be seen entering the premises to take wide-eyed Instagram photos of bookshelves that are actually filled with poetry instead of holiday souvenirs.

There was no place left to go, as Eric Burdon sang with conviction in the 1960s. Poet Gary Snyder, in Michael Davidson's "The San Francisco Renaissance", described the roots of connection and disconnection, this feverish need to come together in a cold-hearted, mean-spirited material world: "In the spiritual and political loneliness of America of the fifties, you'd hitch a thousand miles to meet a friend."

Hit the highway, get a ride, catch the Greyhound, fire up your motorcycle, conquer the curve. Go west if you're still young at heart. That's what they did: the cowboy bards, the outlaws shedding identities, the Beats, the flower children, the boatbuilders, the electronic frontier people. No place left to go.

In his seminal book "Invisible Republic", music journalist Greil Marcus recreates an almost archaic yet strangely present country: the old, weird America. Its songs come from a place without clocks or sense of time and its inhabitants, maybe crazy, sometimes wise, seem to be at work building a democratic structure where accidents or wickedness may strike at any time. The book begins as an investigation into Bob Dylan's "The Basement Tapes", but at the center of Marcus's story is "Anthology of American Folk Music", a classic collection of 84 songs compiled by a guy named Harry Smith and with themes related to incidents and moods during the Civil War years when

Americans were strangers to each other and the nation had no real contours. White music blends with black, blues with banjo, religious mania with evil machinations.

The sound is that of a different world, perhaps it's the third world or a fifth dimension, and it took some courage for Smith, a pencil-thin record collector without a permanent address, to release this material at a time, the 1950s, when America was being homogenized and suburbanized; always looking forward, never back.

Harry Smith would also make his way into bohemian circles in the Bay Area. A special kind of home could be carved out from this collected music and Greil Marcus calls the fictitious domicile Smithville. This place is imaginary, but within its borders there is also true exile, says Marcus when we visit him at his house in Berkeley.

"What is Smithville?" he asks and attempts an answer: "The town is simultaneously a seamless web of connections and an anarchy of separations: who would ever shake hands with Dock Boggs, who sounds as if his bones are coming through his skin every time he opens his mouth? And yet who can turn away from the dissatisfaction in his voice, the refusal ever to be satisfied with the things of this world or the promises of the next?"

The Dock
of The Bay

Bob Marley & The Wailers recorded their "Talkin' Blues" album at the Record Plant studio in Sausalito in 1973. But infinitely more famous is the story of how Otis Redding in 1967 wrote his hit song "(Sittin' on) The Dock of The Bay" while staying on one of the houseboats on the waterfront.

The light, airy feeling of the song, with whistling and waves rolling in, contrasted with many of Redding's other offerings, and you could detect both a geographic and a cultural leap from the South to the west coast; the same journey many African Americans had made in the previous decades looking for jobs in California factories and shipyards. Of course, the local myth grew when Otis Redding and his band then crashed to death in an airplane shortly after the song's recording.

As we walk past an upscale houseboat named The Music Box one of our informants indicates that this was the actual place where the song was born, but noone seems to know for sure.

Furthermore, there is a breezy kind of lounge tune by George Duke, not prone to disturb anyone with its "lovely Sausalito" lyrics, and all sorts of musicians – from Bobby Darin to Santana to Conor Oberst to Stephen Malkmus – have recorded songs referring to the place. In "Real Emotional Trash" by Malkmus and the Jicks, these are a couple of lines: "Down in Sausalito we had clams for dessert/He spilt some Chardonnay on your gypsy skirt." And this, on a slightly different note, is from "Sausalito (is the Place to Go)" by bubblegum pop group Ohio Express: "Cruisin' 'round 'round fell out of my boat/Swam around swam around started to float/Floated 'round 'round came in on the flow/There I found, there I found Sausalito."

Conor Oberst, in his tribute to the community, ponders the idea of staying here after he has brought his dreams and his girlfriend out west: "So we remain between these waves/Sheltered for all our years/While bikers glide by highway shrines/Where pilgrims disappear."

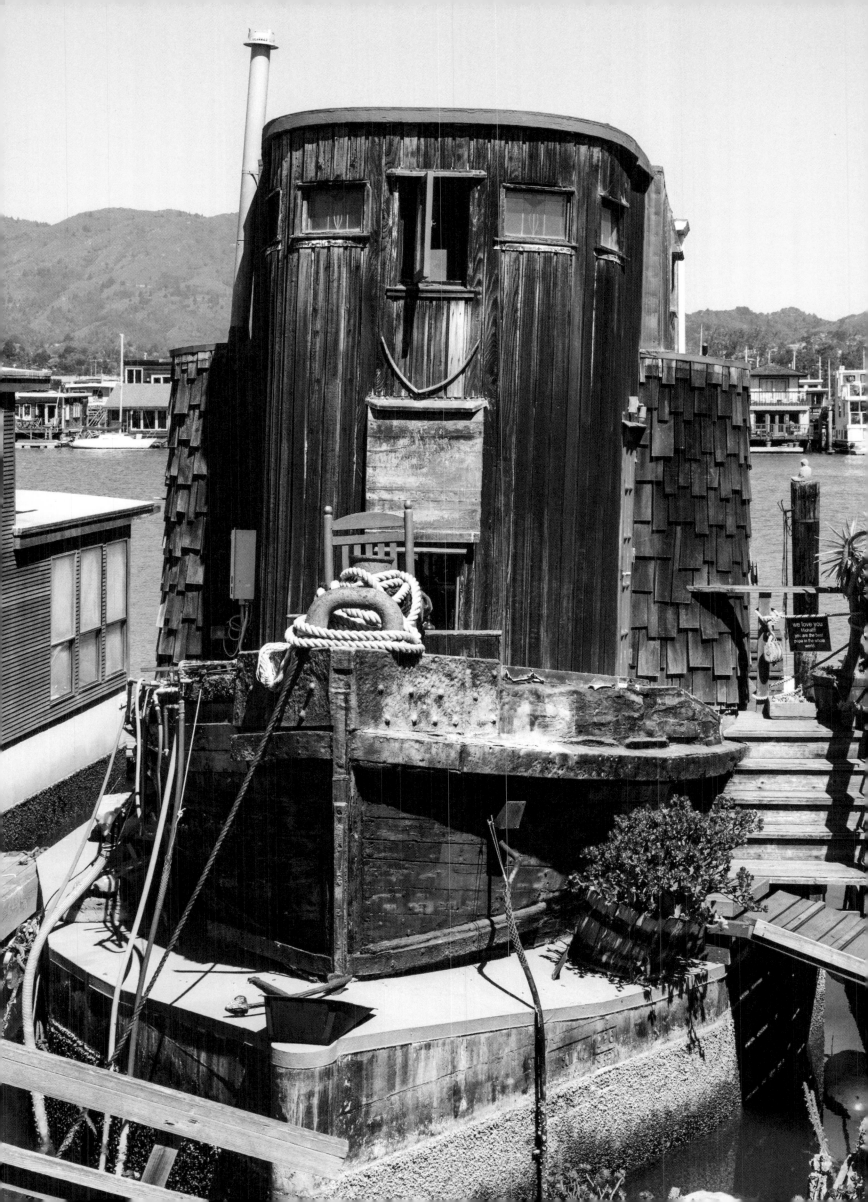

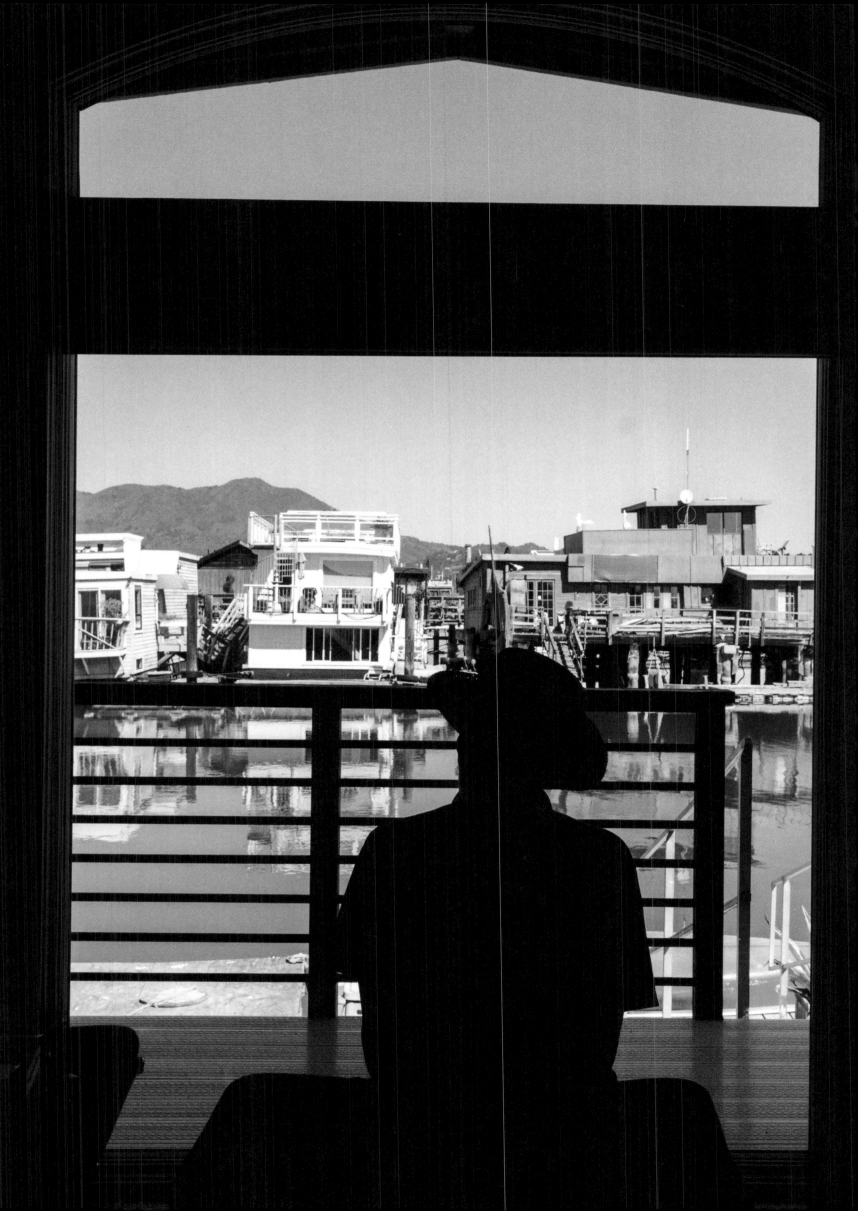

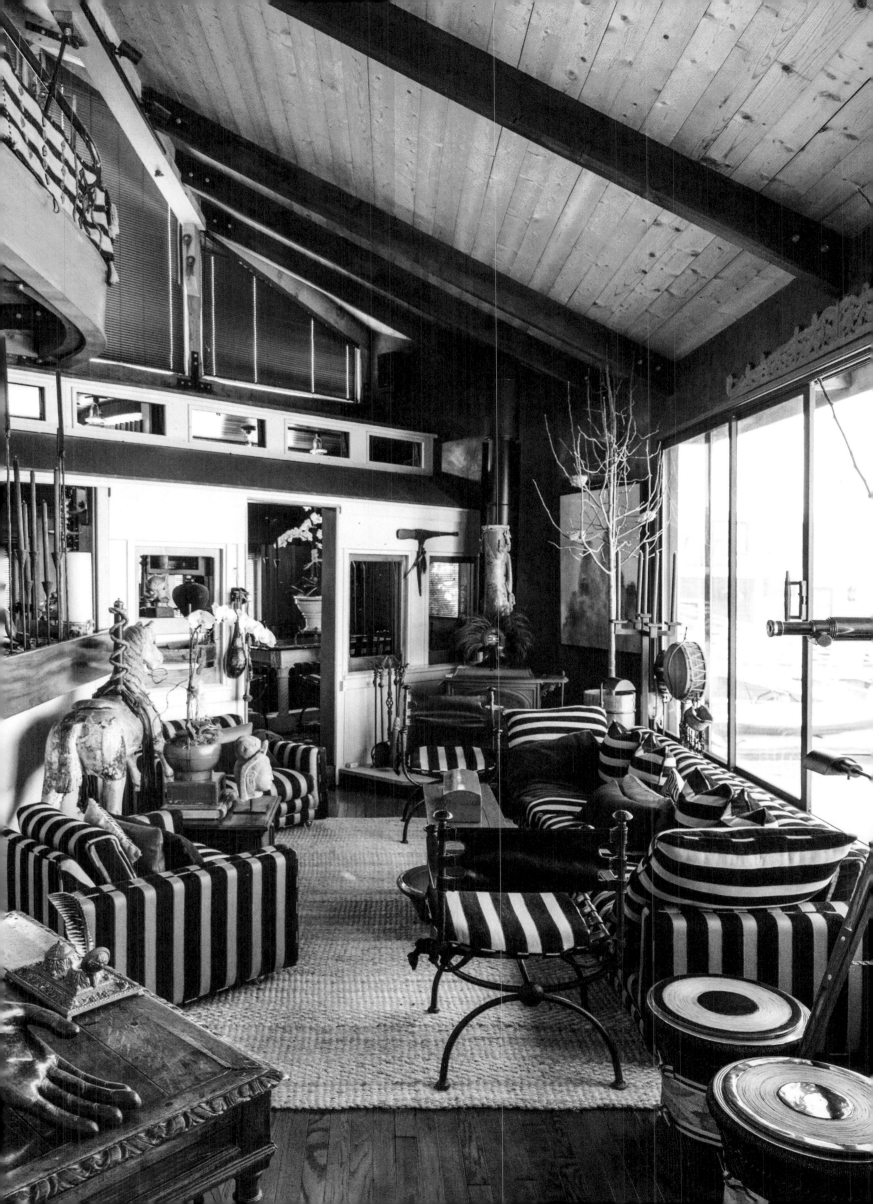

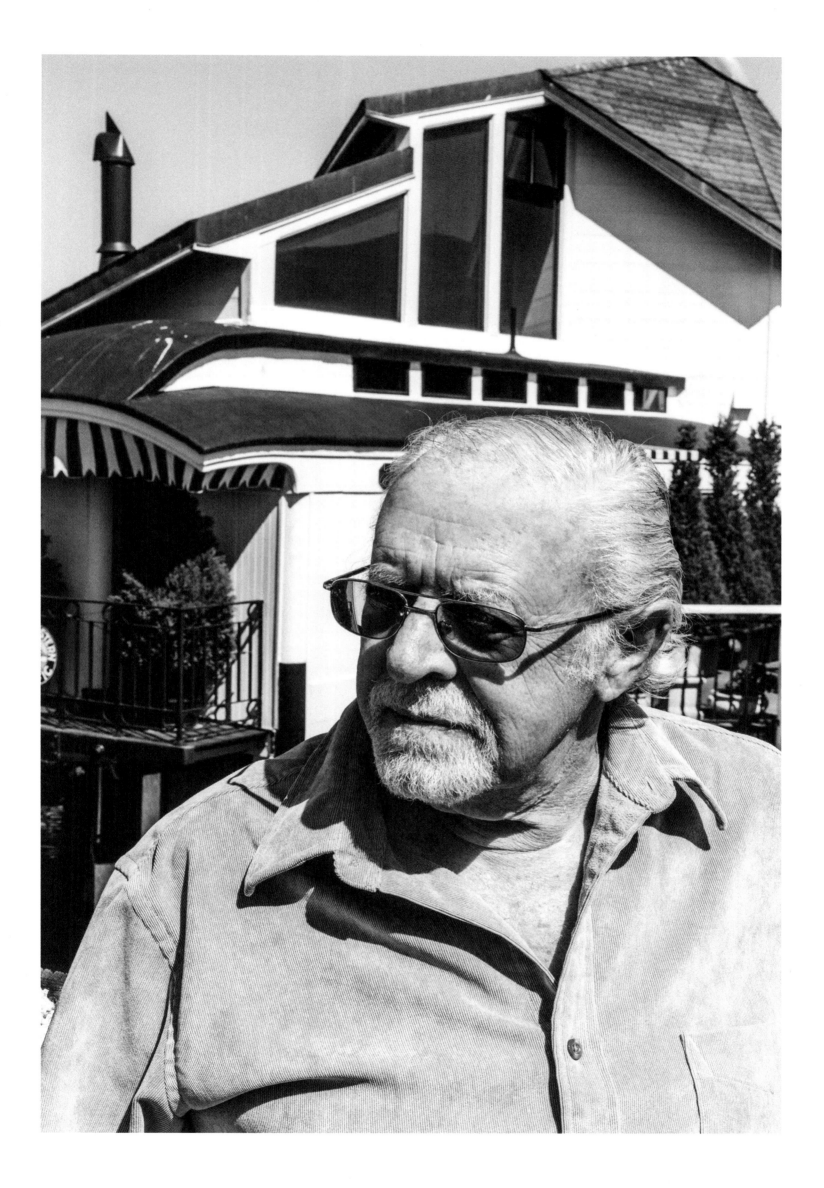

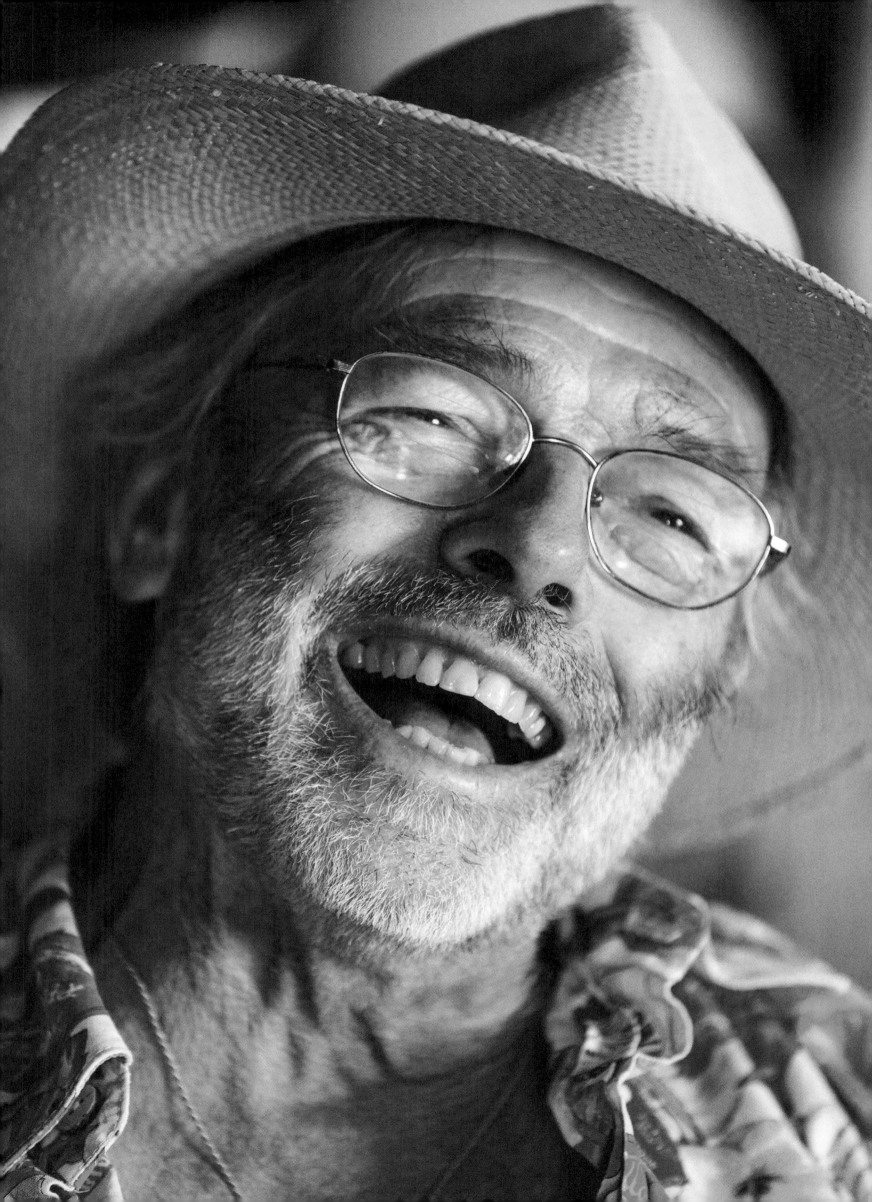

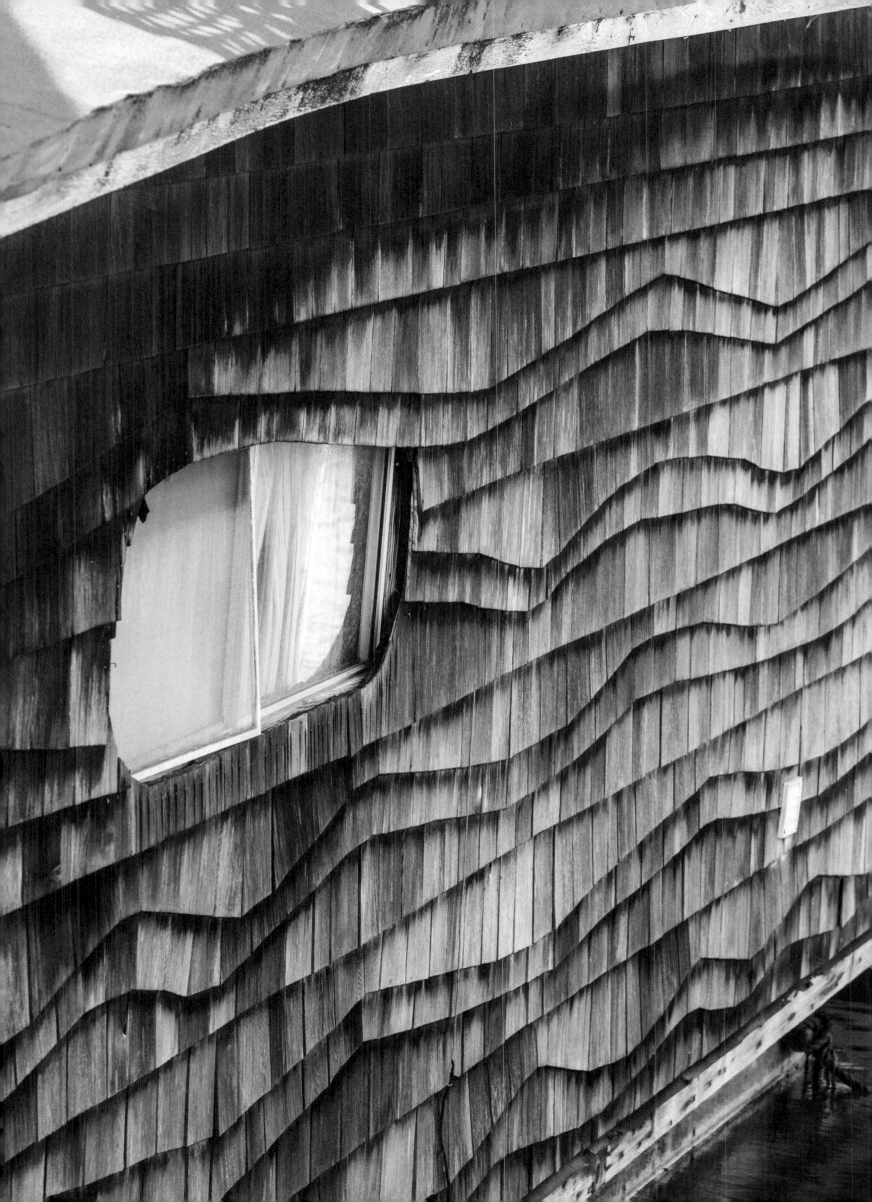

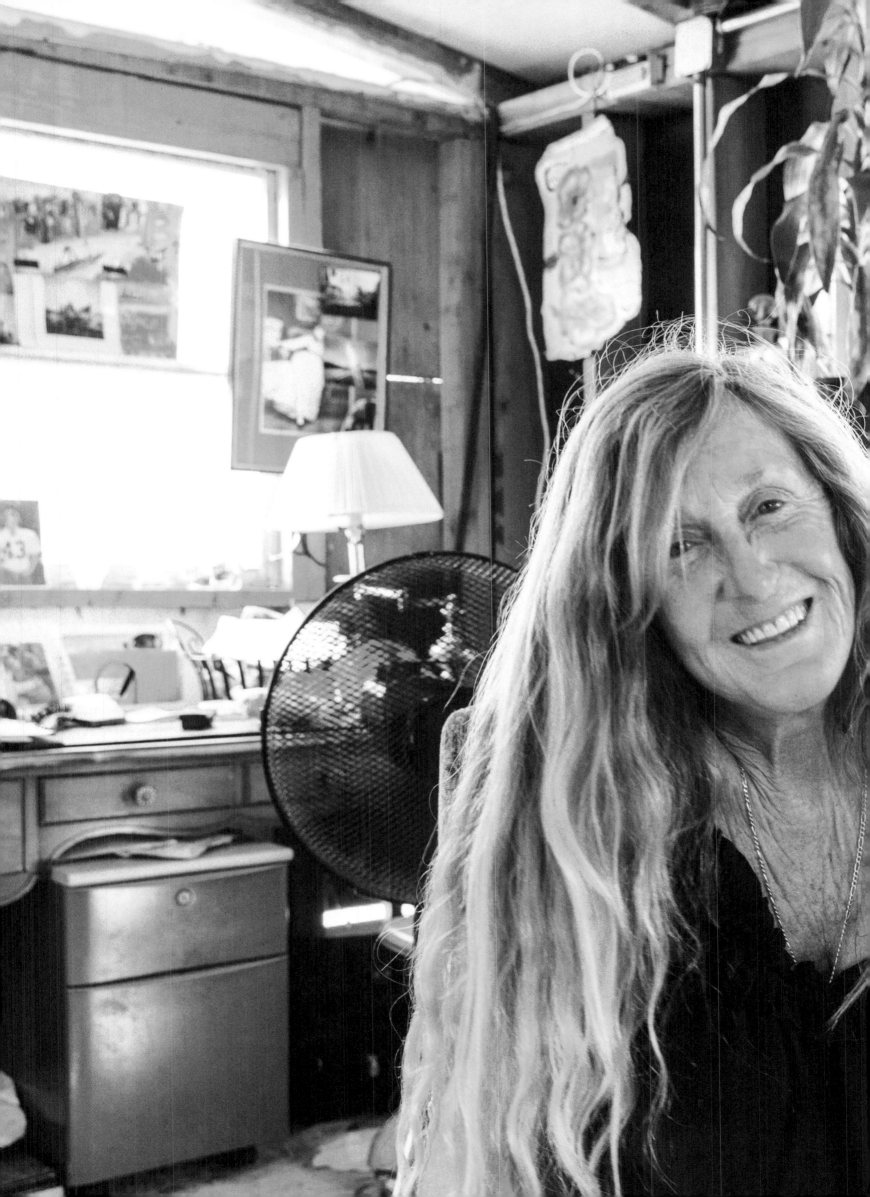

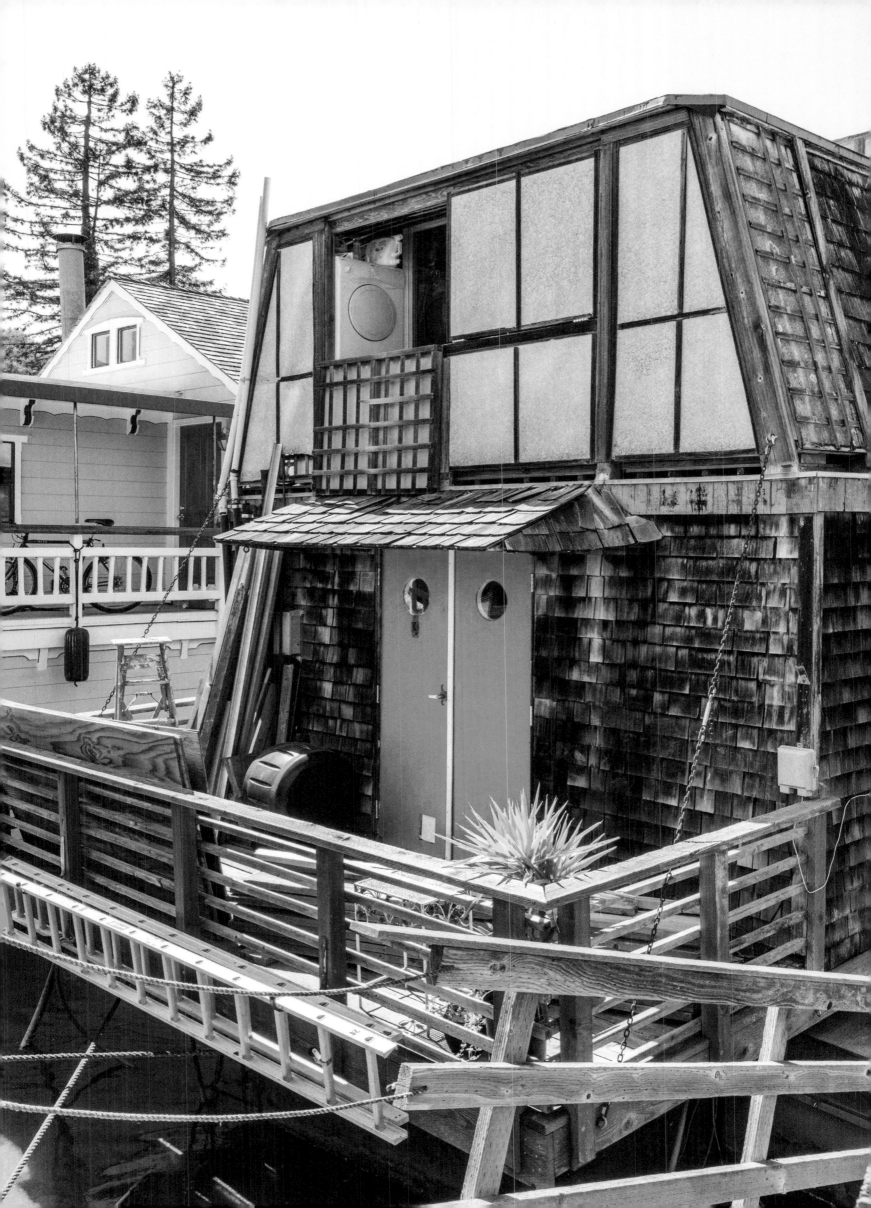

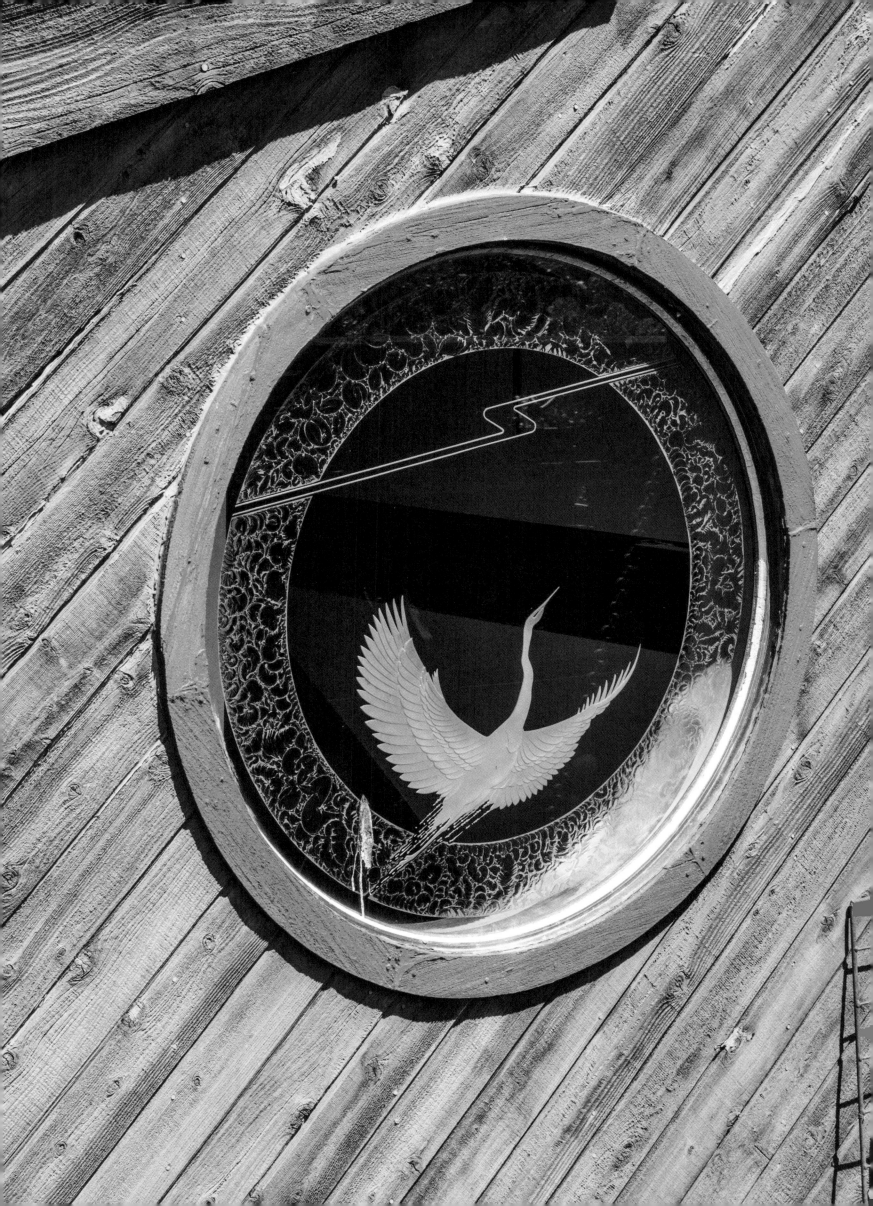

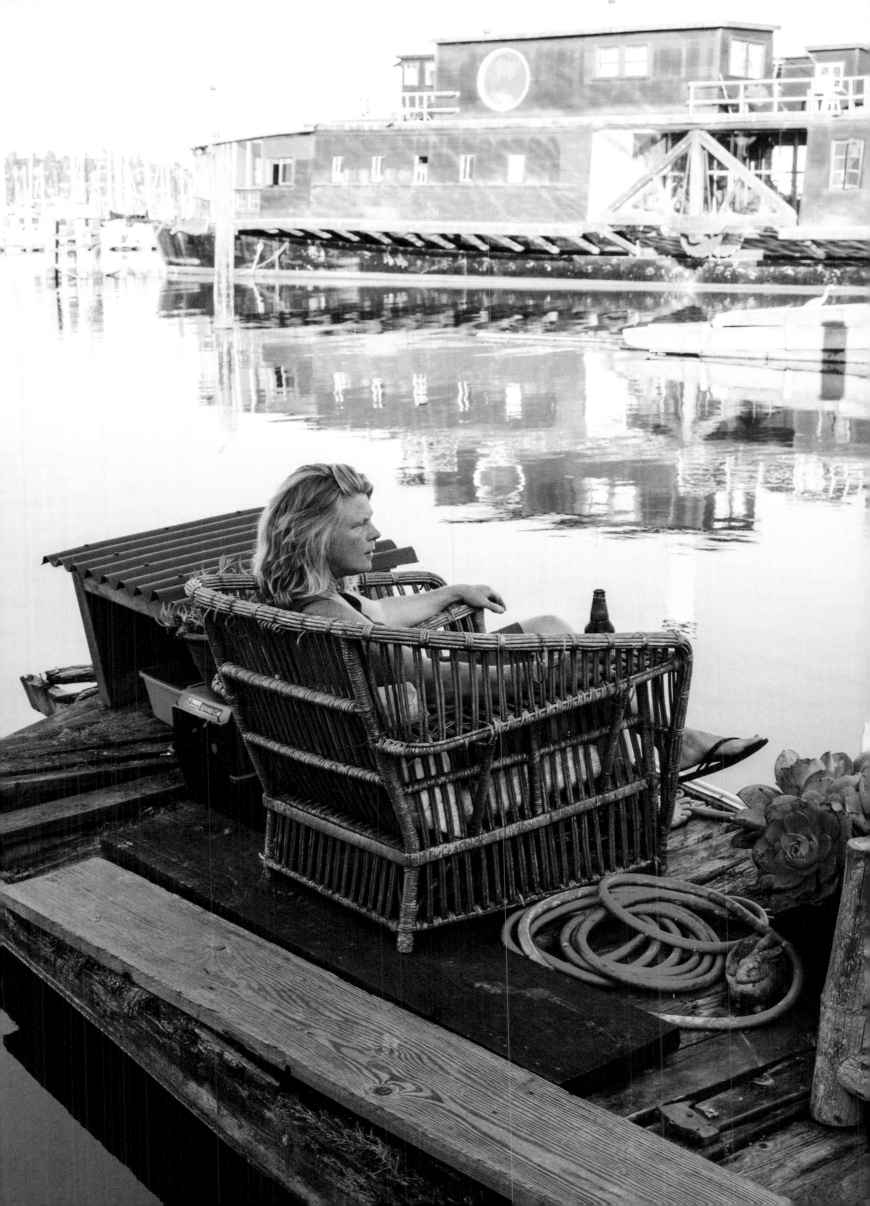

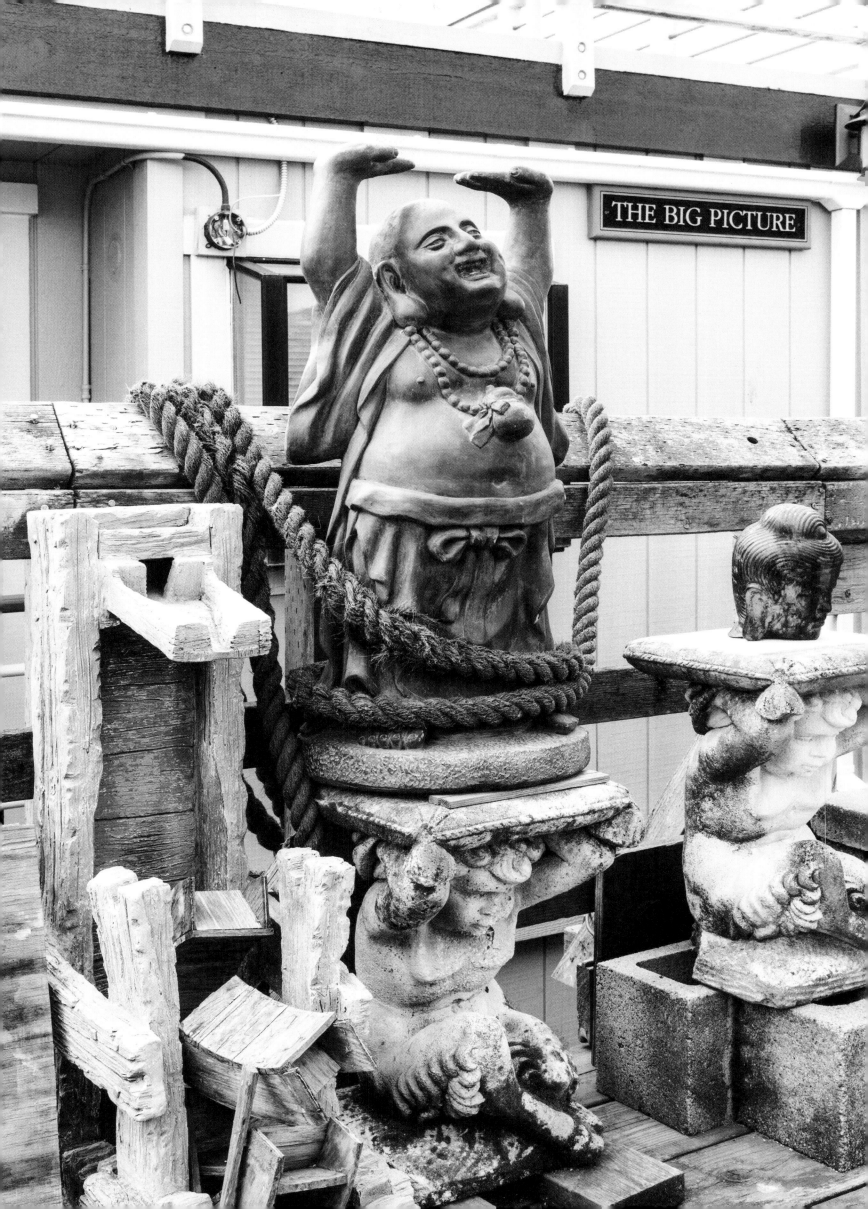

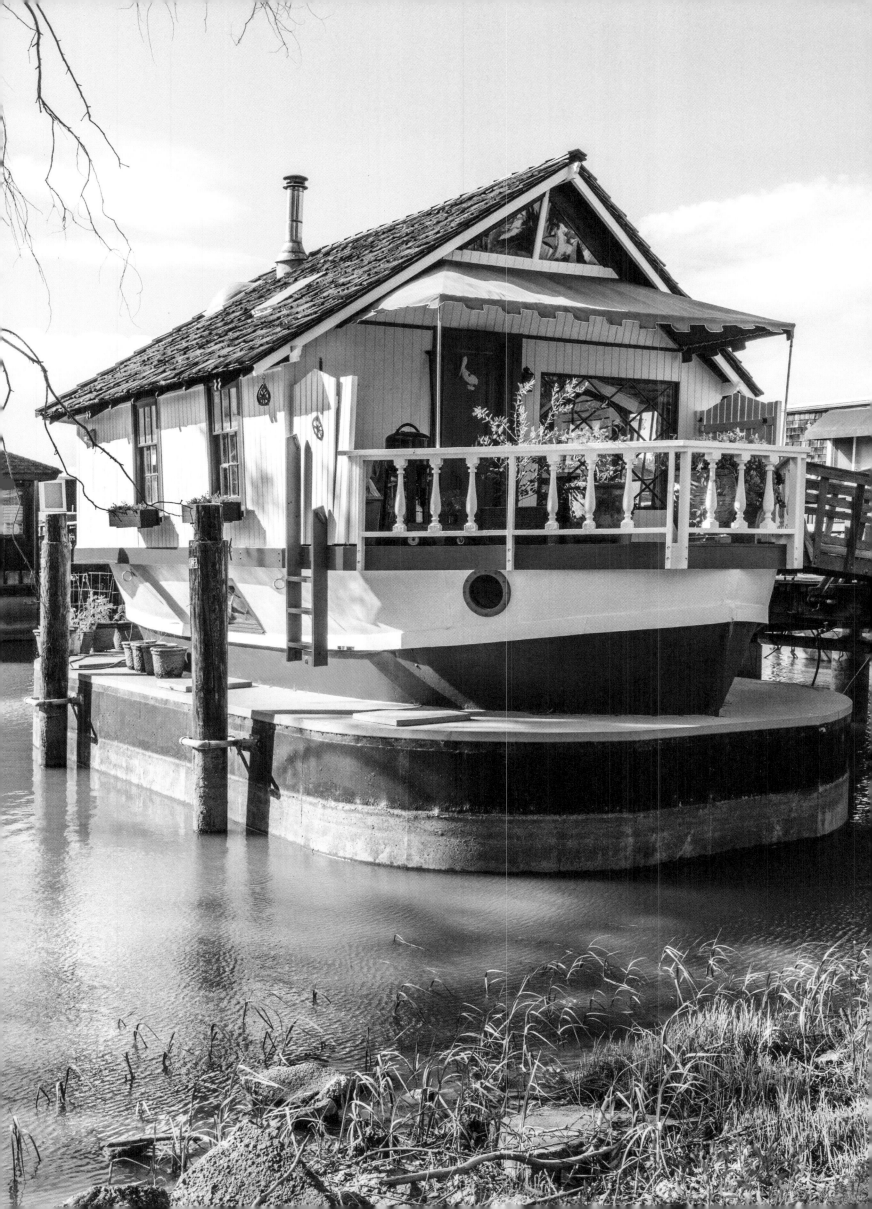

The Houseboat Wars

When local authorities decided to clean up the waterfront and relocate the residents in the name of development and progress, the confrontation was fierce. The survivors still dub it the Houseboat Wars. It was a classic struggle between the haves and the have-nots, but also between opposing lifestyles and world views.

At the onset of the clash, The Wall Street Journal relayed this dispatch from Marin County under the headline "Houseboat Dwellers In West Find They're On Troubled Waters":

"You spot them soon after you cross the Golden Gate from San Francisco and pass through this picturesque community. Old lifeboats, landing craft, submarine chasers, river scows, barges and ferryboats, numbering about 250 in all, stretch for a mile and a half along the shore of an inlet of San Francisco Bay. They're home to hippies, artists, engineers, doctors and lawyers.

On some of the boats, which are mired in mud, the self-styled 'working nonconformists' have built $40,000 apartments, designed with imagination and artistry. On others, the dwellers have put up jerry-built shacks. But taken together, the houseboats constitute an artistic community that is a welcome contrast to much of suburbia, proponents say.

Taken together, the place is an eyesore, opponents say.

In the view of some observers, it all shapes up as a battle between the free spirits of a community and the established elders, and the way it looks now it could be a real

confrontation. Officials of Marin County have told 36 of the houseboat dwellers that their boats will be demolished unless they are moved. The people won't go, which could mean trouble."

The newspaper also spoke to Donlon Arques:

"One person who is not too concerned, however, is D. J. Arques, a boat builder who owns many of the underwater lots that the underwater streets run to. Mr. Arques, whom county officials call 'the Howard Hughes of Sausalito' because of their difficulty reaching him, says he really doesn't have much control over his underwater lots. Squatters have moved on to his property, he says, 'and I don't pay any attention to them.' He concedes, however, that a few of them pay rent."

This happened as the 1960s had become the 1970s. Depending on who you talk to, the original houseboat days were visionary and festive or draped in a drug-crazed haze, which kept people going or ultimately took their lives.

In Marianne Dolan's film documentary "Houseboat Wars" from 2013 people dance in the dirt; in a frenzy they fall or throw themselves into the mud, immerse themselves in it. It's like watching an ancient ceremony without understanding its purpose.

The contrast between light and darkness is obvious. If some residents hold on to a dream there are also nightmarish streaks.

The producers of the movie speak of guns and drugs drifting into a funky paradise and of the arrival of developers with grandiose propositions to build hotels and condominiums. Evictions follow. Agitprop theater versus bulldozers. Then years of suits and counter-suits.

The confrontation was reenacted in the "Last Free Ride" film by Roy Nolan and Saul Rouda, which placed self-taught boatbuilder and musician Joe Tate at the center of events. He and his friends were scrounging for junk, an activity later to be renamed recycling. Tate's project was actually double; a boat, The Richmond, needed to be fixed and his rock band, The Redlegs, needed paid gigs. Tate the Sailor eventually seemed to be more on top of the game.

Saul Rouda, the film's narrator, defied the image of lazy layabouts and summarized the homesteader ethos of the hippie houseboaters:

"We paid for our independence with hard work."

The film exudes a rebel spirit that had already begun to fade. It ends with a sigh of dejection amid the dancing and the smiling.

"All is gone due to the forces of change and development."

In a piece by Jeff Costello, of Redlegs notoriety, in The Anderson Valley Advertiser in August 2013, the crux of the matter was described this way: "A lot of valuable real estate was going to waste... The shipyard was a treasure trove of junk, boats and barges in all possible conditions, a still-functioning marine ways. In the eyes of the square, 'normal' Americans, it was a mess. To the creative, i.e. 'abnormal' brain, it was a wonderland of seemingly unlimited potential."

If you managed to look beyond the actual appearance of the waterfront property with its war-time leftovers and pirate-like occupants, and if your inclinations were primarily financial, this was a space with great profit possibilities. Several gambits were used to deal with the unwanted homesteaders; Costello identifies building codes, sewage problems and complaints about disturbances of the view from the Sausalito Hills.

"The real, always unspoken reasons were the anarchy factor and more to the point, money. Millions of dollars awaited those who would develop the property and start collecting rent and selling wildly expensive 'floating homes' built on concrete barges and tied up to nice, neat, orderly docks."

As with other similar attempts to live alternatively, ambitions, ideas and reasons collide. You get a motley crew with different ways of defining freedom and just as many varying personal motives for showing up. Some have nothing to lose, others most everything.

The Rock'n'Roll
Ouwtlaw
of The Waterfront

One day there is a birthday party on South Pier. It is the month of May and margaritas are shared beneath a friendly, well-lit sky while summer dresses and loose fit Hawaiian shirts flock around the object of celebration, Jack Sherwood, who now enters his ninth decade. It's like a garden party without the lawn. Joe Tate is there, of course, and with him the other members from the residential band The Gaters, who will soon have people dancing to tunes that everyone knows by heart; Creedence, Eagles, Steve Miller, anything Californian with an ageing tinge.

A few days later, Joe Tate sits down in the living room of his Becky Thatcher houseboat to recapitulate his own waterfront story.

The first houseboat I ever had was about a hundred feet over that way, and I lived there between 1967 and 1969, something like that. And then I got a little Chinese junk that I started sailing. Around that time I formed a rock'n'roll band that we called The Redlegs. We became the de facto outlaws of the waterfront.

I'm originally from St. Louis, but emigrated to California in 1964. It wasn't so much the attraction of this state as the revulsion I felt for St. Louis. I was majoring in physics and math and I was interested in nuclear physics, and came out here to go to graduate school at the University of California at Berkeley. I went down to the registrar's office and when I got there they were having this Sproul Hall demonstration. It was the beginning of the Free Speech movement, which in short then morphed into the whole anti-war movement. I was there on that day, and you couldn't get into Sproul Hall. The whole place was blocked, there were demonstrating students all over, thousands of them. And Mario Savio was up on top of a police car giving a speech!

You know, I was just transfixed by the whole thing. I started hanging out, met some musicians there, smoked some pot. And I got into a rock band that very day, and that's when I dropped out.

I had already started having misgivings about nuclear energy and stuff because

people were protesting the bomb tests. It was just about then that the moratorium started, in 1964. They ended atomic testing because of public protest. Even politicians were starting to realize what the dangers were.

So I thought, do I really want a future in nuclear physics? And the answer was no.

In that very moment I got into a rock'n'roll band called Red Shepherd and the Flock. Red was a really great singer and we had lots of gigs. We played all the time, six days a week for a couple of years.

Somehow we got stranded in Fort Collins, Colorado, but you know, we survived that. Some bar gave us a gig and we played for a week to get enough money to get out of town. Red Shepherd later on got the lead role in "Hair" in LA. It was a lot of fun working with him, he was a great character.

Anyway, I decided there wasn't gonna be any more rock bands and I moved over here to Sausalito. No nuclear power, no more rock'n'roll. But then we had these parties where we started to play music, we had our electric guitars and stuff. Just some sessions on this big old potato barge. At the time, there was a guy named Joseph Brannan, we called him Joey Crutch, and he's a drummer and he moved into the neighborhood. I heard him playing and went over to jam with him. Then I thought of Kim Kerry,

whom I had just gotten to know. He grew up here, right in this very spot where we're at now, maybe over that way twenty feet. I said, Kim, can you come over and jam with me and Joey Crutch? He said okay, and so we had a little trio going. It just sounded great, we rocked out. And then of course Maggie Catfish joined us and we formed The Redlegs, against my better judgement!

Had you left all your professional ambitions behind at that point?
Oh yeah, I was very much a bum. A waterfront bum. I didn't know what I was gonna be doing. Get odd jobs in a boatyard, paint some boat or something like that. Waterfront work men is what we called ourselves.

What did the place look like when you moved here?
There was this tower right here, just about where The Owl is now. It never did get complete. The Becky Thatcher, the house we're in, was a pile driver so it had this big wooden structure on it. And there was this thing, the Tower, that was just built around the structure that was there. It was a sculpture and a home. We called it The Madonna. Eventually The Madonna burned down. All the exterior stuff put on there burned off first.

What's the story behind the name Redlegs?

We used to live out in a filthy place, it was really wet, and we wore blue jeans. The seams of our pants would run out. They kept coming out so somebody said: let's paint the seams. That's a standard way of preserving your sails, to paint them. So we used wet paint on our blue jeans without any real purpose in mind except to keep them going. There was a comedian, a local guy, and he asked about the people who lived in the Dry Locks and one guy said they're just a bunch of rednecks. And he said, no, they're not rednecks, they're redlegs. That's where the name came from. Isn't it silly? We were painting our pants, but what we were really doing was naming our band. Later on we found out that there were historical redlegs, such as the Redlegs of Kansas. They were either confederates or yankees, I've forgotten which group they were from, but they went on murdering their opponents. There was a lot of death and destruction caused by these Redlegs. There were also redlegs in Scotland, fierce mountain warriors that the English really feared. So basically the historical meaning of redlegs is terrorist. And we were pretty much that, anyway!

And you see what they did to our homes. They burned them down to the ground. They burned down the Tower, they burned down the Dry Locks, and they burned down

the Dredge. But they still haven't got rid of us. We're still here.

The fires were all on purpose. In the case of the Dry Locks they hired a guy. They gave him 50 dollars and he went out there and put gasoline all over everything and lit it on fire. Fifty bucks. City of Sausalito. In the case of the Dredge, the fire department came out in a boat and poured gasoline and diesel all over the place and then they went out in their fire boat and started firing flares into it.

In the case of the Tower we don't quite know what happened. We know there was a guy there that had a Jesus complex and he was gonna crucify himself. He supposedly had put some heated nails through his fingers and hands and in the process of doing that he caught the place on fire. We don't believe that story! That was the official line. I'm sure there was debauchery, but on the other hand there were people that wanted to see it destroyed. The county. And they did it. Somebody would get hired to come in and take care of business.

Why this anger and violence?

Well, this is America. Our culture is built on violence and injustice. Every political decision is made to create injustice. Because of that injustice they have to use violence to enforce it, that's what we live under. I'm not getting used to it. I'm still pissed off and I wanna do something about it.

What is the attitude toward this community nowadays?

See this parking lot they are building here? They're gonna pave all the way through all of that for half a mile going up this way. It's all gonna be like that. Those people living in shacks at the Co-op, they will all have to move over here on the new docks. So that community is being obliterated. They're in the final stages of being wiped off the face of the earth. I sound angry, don't I?

Yes, you do. Will there be room enough for them on the other docks?

The people who live in the nice houses over here, they're gonna sue the developer. The lawsuits will go on for probably twenty-five years. When they move, there's gonna be lawsuits. Two of them are moving right next door to us. There's gonna be two house boats there from the Gates Co-op. We know the people that are moving here and we like them, so we don't have a problem with it.

Would you say that the Co-op people are the inheritors of the 60s spirit?

Yeah, they are the successors of it all. The last remaining vestiges in this area. A lot of people over there have been living here just as long as I have. And their children. There's also new people, there's a lot of young people that have moved here, to this dock. We're just not gonna let go. This place is still like it was.

The Tolerance
of
Funkiness

In a strangely absurd 1970s front page photograph from The San Francisco Chronicle – it looks like a tableau, something cut out of a theater play – police officers are pointing their guns at a young guy seemingly prepared to defend himself or his boat with a knife. Everything is within close range and the opposing parties can almost touch each other. The imagery is surreal, but we know it happened because the young man with the knife is still here to tell the story and show us his thousands of photos from that intense period of confrontation.

His name is Russell Grisham.

They decided to evict us and they started with my boat. I put up some resistance and kind of set the tone. The resistance went on for seven or eight years.

How did you resist?

With a knife. We actually defeated them when they got after my boat. We surrounded them and the guy that was running the tow-boat quit and left the cops stranded out there on the houseboat.

I had two boats, the one that I was living in, and this one was next to it. Once they got us out of the way a little, everybody started building and it's become much bigger, several hundred since then.

How did people here make a living?

They got food out of the garbage bin at the Big G supermarket. Someone would roll in here with a pocketful of money. It was just whatever came by.

We were always having parties and charged admission. We kept the money in the neighborhood. It was wonderful. On Charles Van Damme we had all these parties for years. People came over to help out and sweep the floor and whatever. Ten bucks here,

ten bucks there. There was always some money. When they got rid of that ship, we were screwed after that.

Who would move here?

Drug dealers, drug takers, rock'n'roll musicians, barters, sculptors, a few regular folks. Nine-to-fivers who wanted to live in a fun style. Artists, writers, creative, talented people. They were attracted to the free lifestyle here, the tolerance of the funkiness. The architecture was not like the right angles and boxes everywhere else.

What was going on in the Haight-Ashbury district... People had come, flower in their hair, to San Francisco for rock'n'roll. Some people didn't like taking LSD in the middle of the city, and they began to migrate up to Marin County, closer to nature. Sausalito's the first stopping off point. It was also a waterfront with a lot of old landing crafts, chasers, balloon barges, pile drivers, dredges, lifeboats, various things that were left over from World War II. Don Arques, who owned the property and all the stuff that had been dragged in here, ferry boats and whatever, was the seventeenth wealthiest man in California. He didn't need the money. He liked to live in a big junkyard, in the middle of it.

Everybody who lived here was a personality. It was a character community. It was maybe 6-700 people here at the time.

And basically people built their own boats and homes?

People would scrounge materials, buy some parts, reuse materials. The first initial, green, recycling community, with alternative energy, solar, geodesic domes, wind. People were doing stuff.

I went to India when they made that movie, "The Last Free Ride", because I had read a book from the Whole Earth Catalog that Stewart Brand puts out. I said, what we need here is a solution to the sewage problem, because that's what's inviting the county and all this effort to redevelop. So I went over there and came back and went to the University of California at Berkeley, the sanitary engineering department, and to the National Science Foundation and the EPA and to Mr. Arques, trying to put together everybody that could help in various ways to make a sewage system for the community out of some of the old boilers that had been on these barges.

Mr. Arques said I could use anything I wanted. So we were gonna make algae ponds, grow algae on top of the sewage, and go around with a small boat and a suction and a holding tank, and clean it up and pump into another tank and heat it up from solar, water circling around. I had a toilet from Sweden in The Owl. I came back from India

with this idea how to make a methane generator. I made one inside my boat. My plan was to make my own gas for my stove. The inspector from the county came down and decided that what I was making was a bomb!

I was a middle-class guy from a straight neighborhood in LA, someone they could talk to. A lot of people were a little more extreme and not as approachable. I was approachable, but I didn't cooperate. They wanted me to fill out an occupancy permit. I said, why should I fill out when you're not going to approve, when you're gonna say that my place is not up to par? It just gives you a reason so you can come in and deny my occupancy. I won't sign nothing. Get out of here. Leave me alone.

So we just resisted. They decided they weren't getting anywhere and got fed up and issued permits to the developer. It was time to kind of push us out. So they kept coming in. They came in with 110 sheriffs, flak jackets, armed.

There's more boats here now. It's really making money. Every square inch of here is dollars. Spitting out money. We were all living here more or less for free.

It was a very creative community. Music, art, sculpture, all kinds. We had to escape from the violence and injustice. The rest of society wasn't doing this. It was kind of very regulated, right angles. I kept arguing that they should preserve this, as an experimental lifestyle.

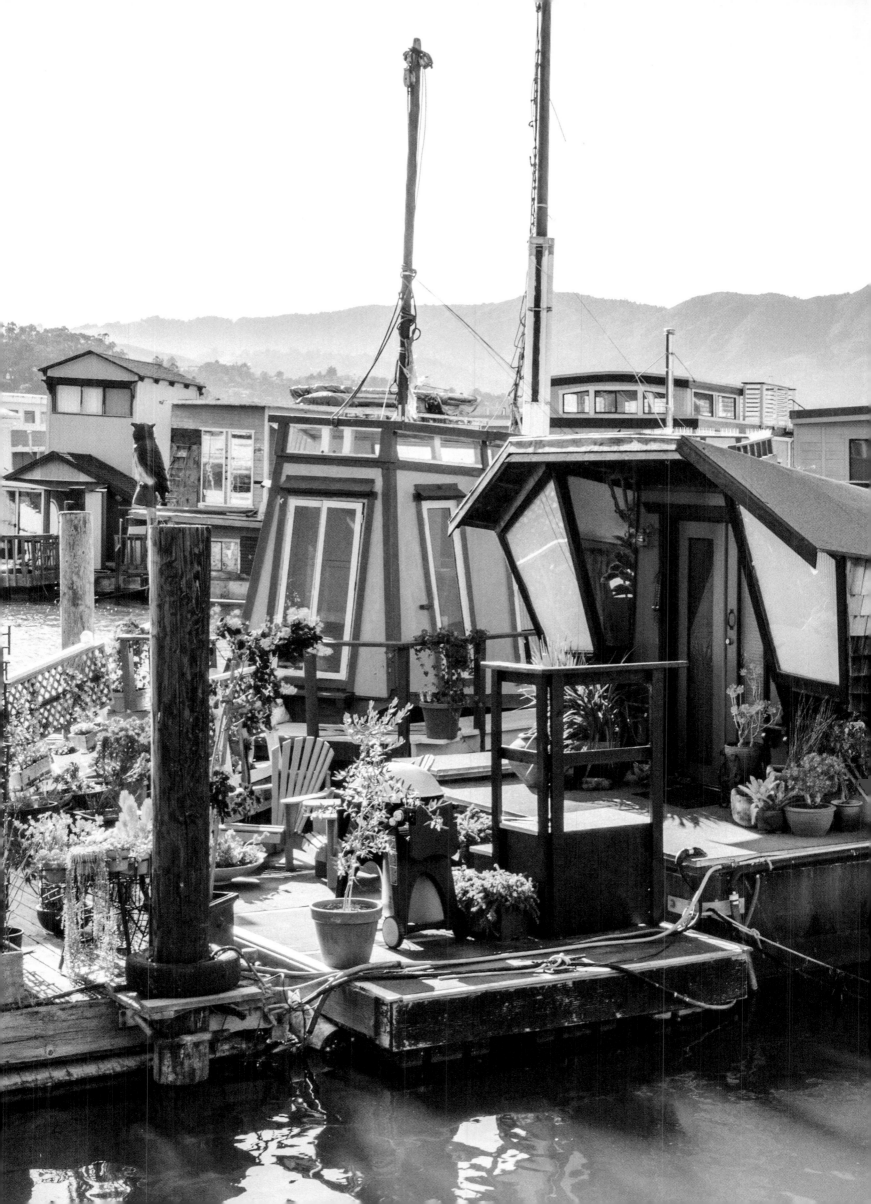

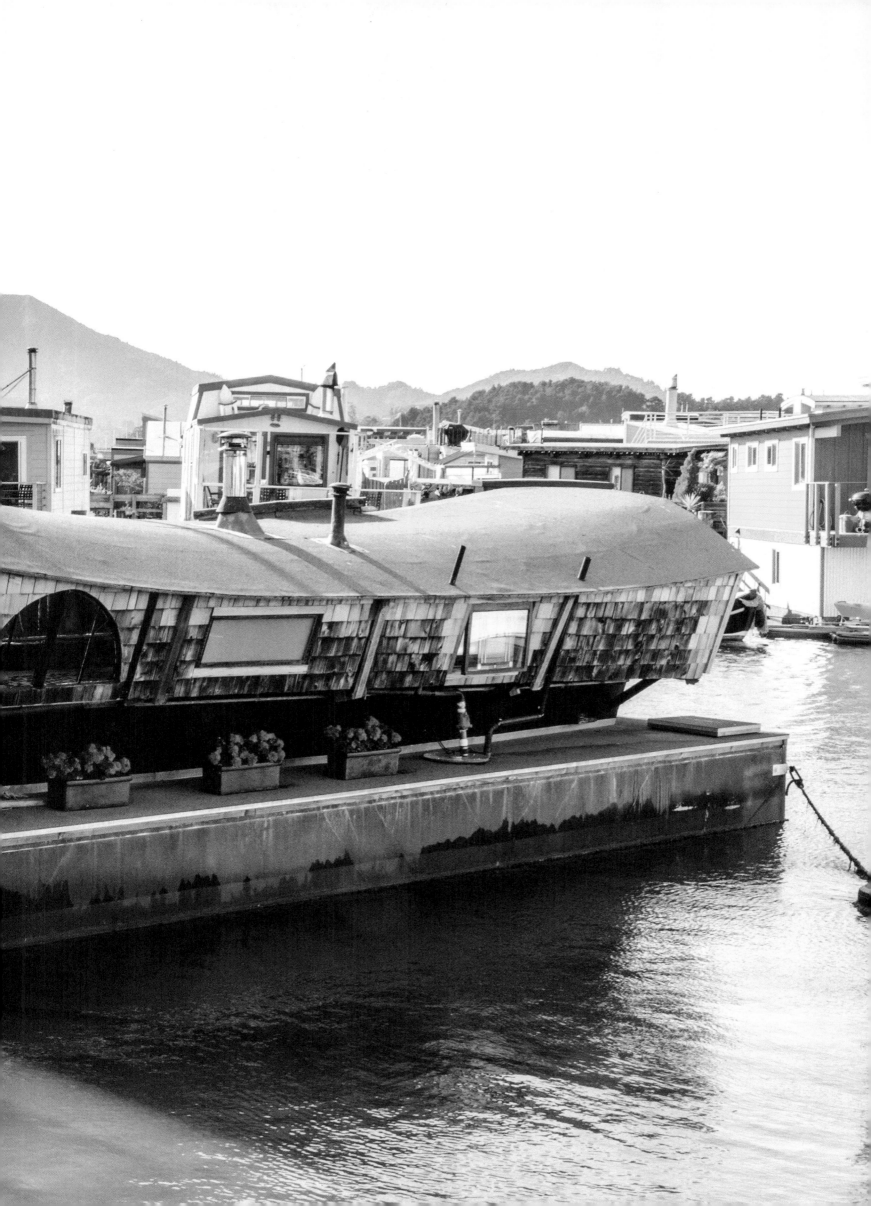

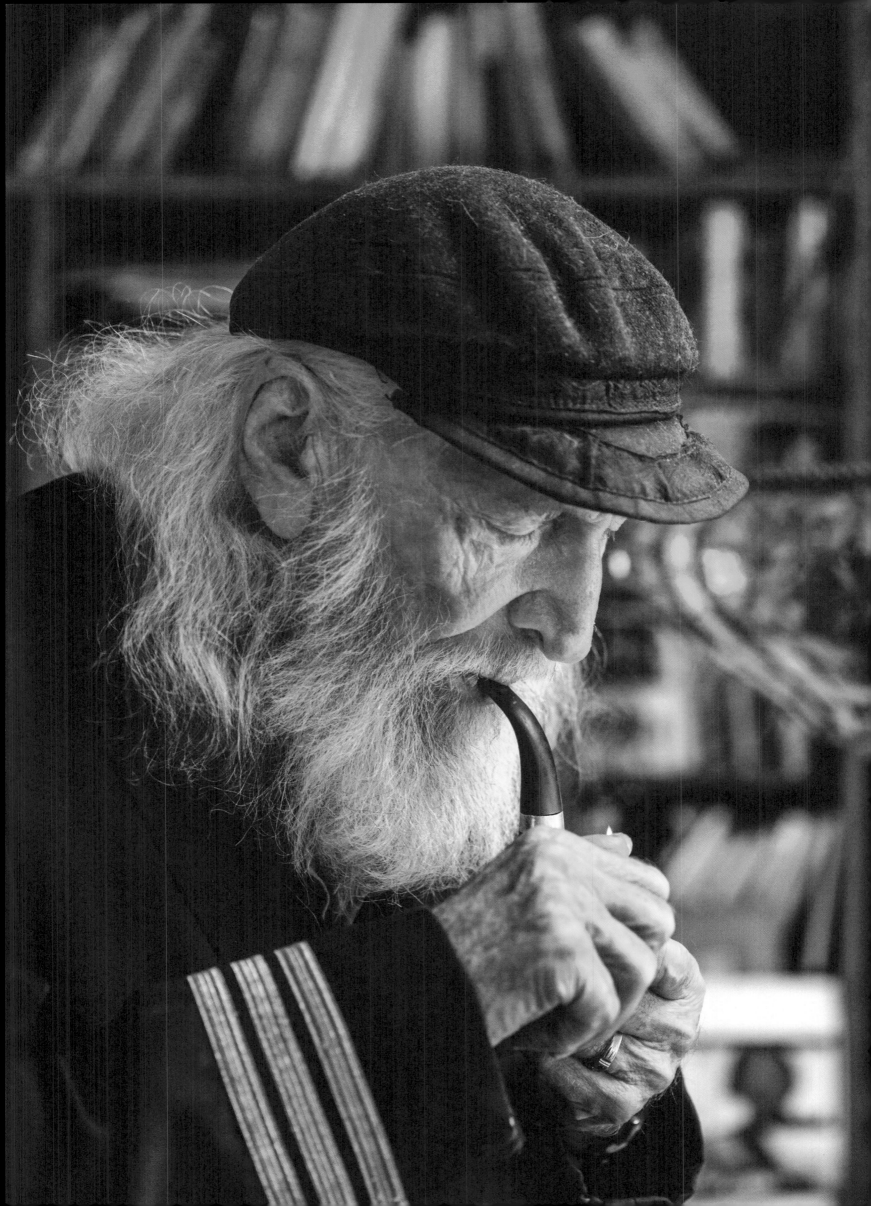

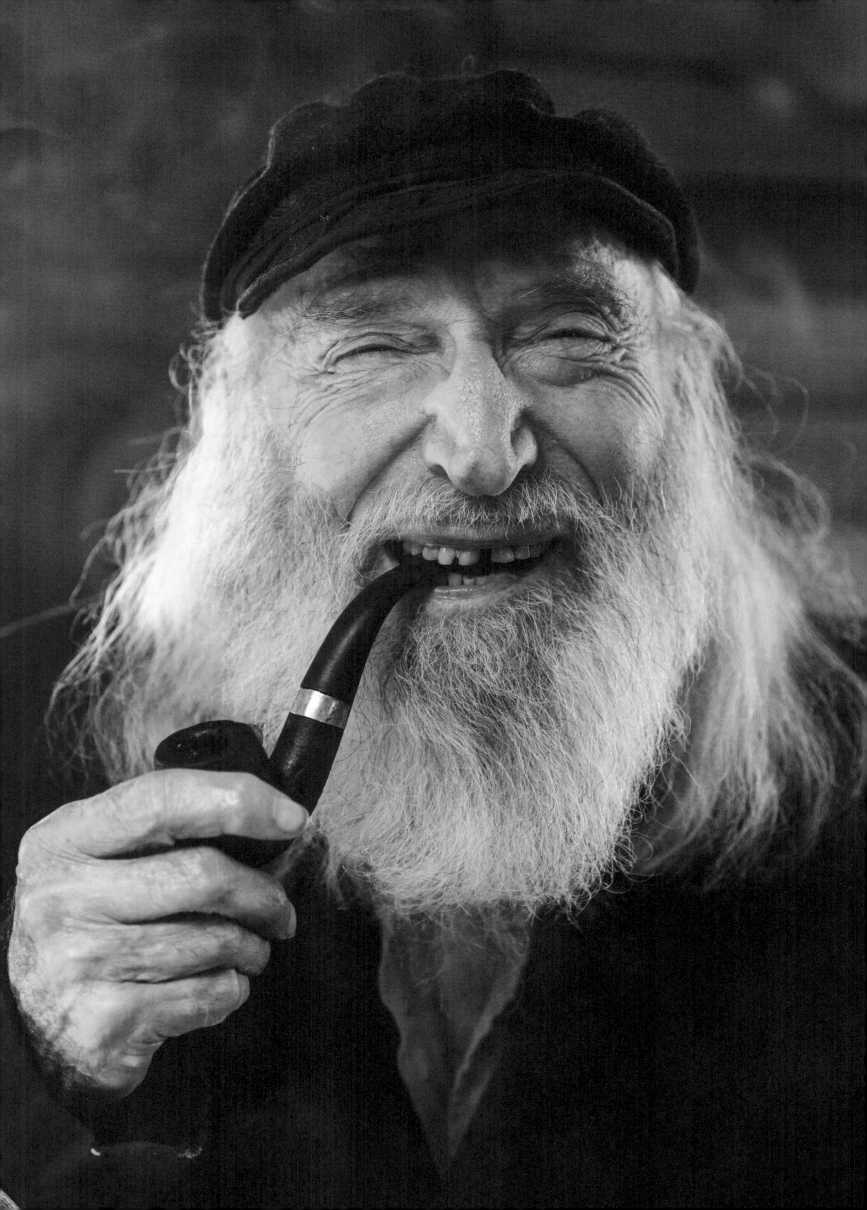

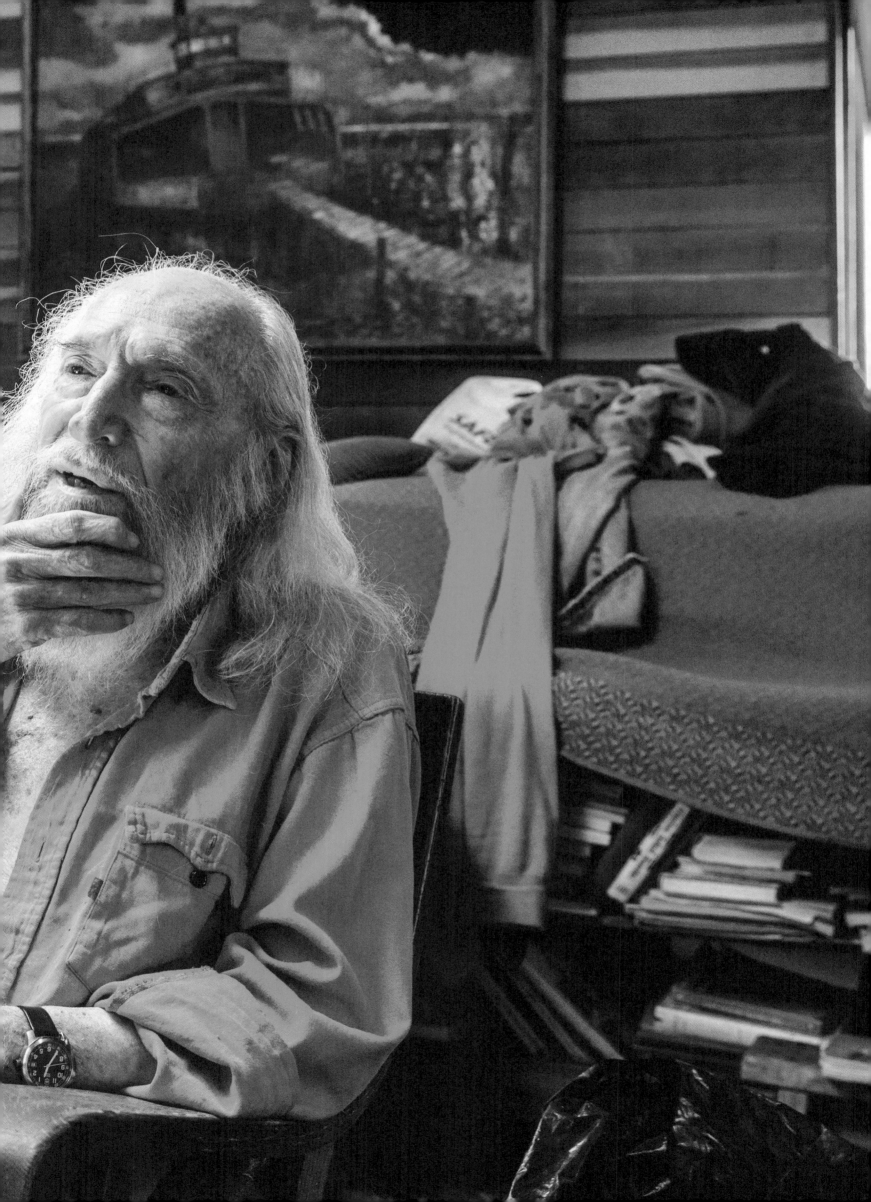

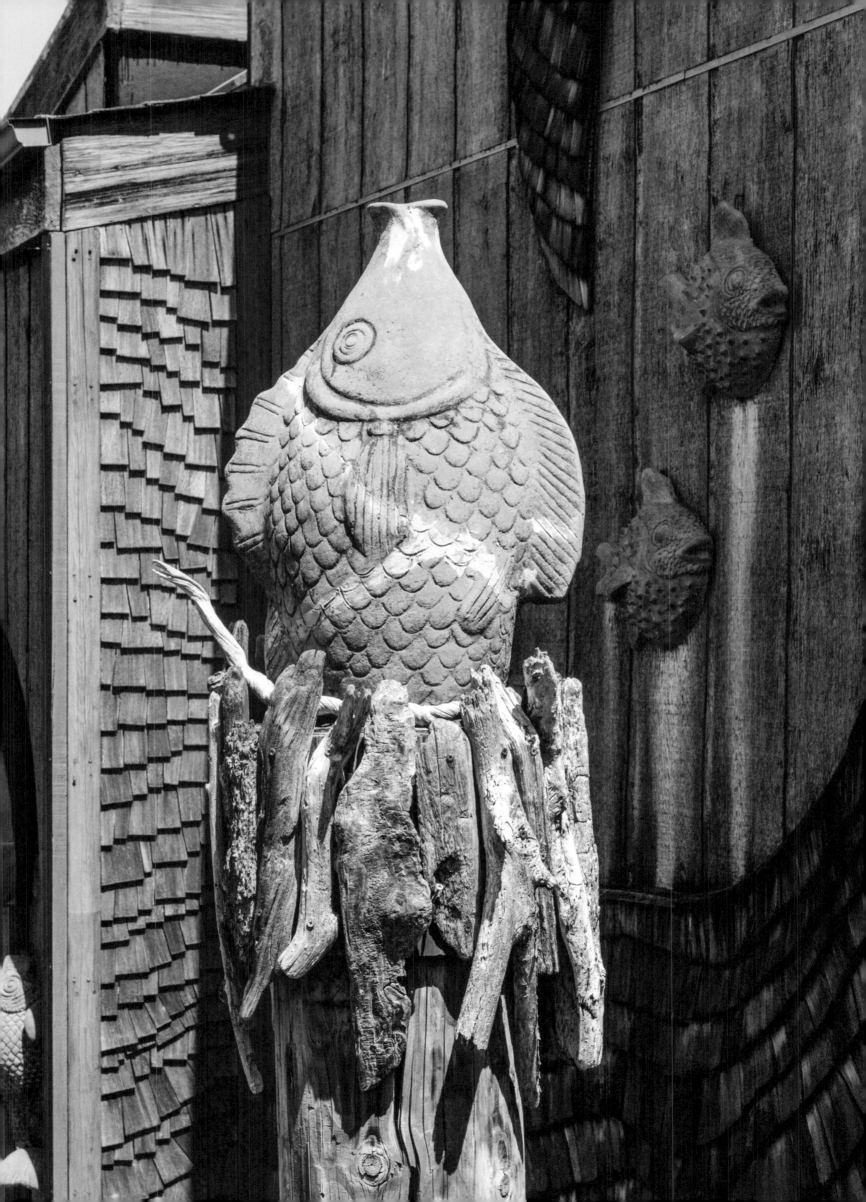

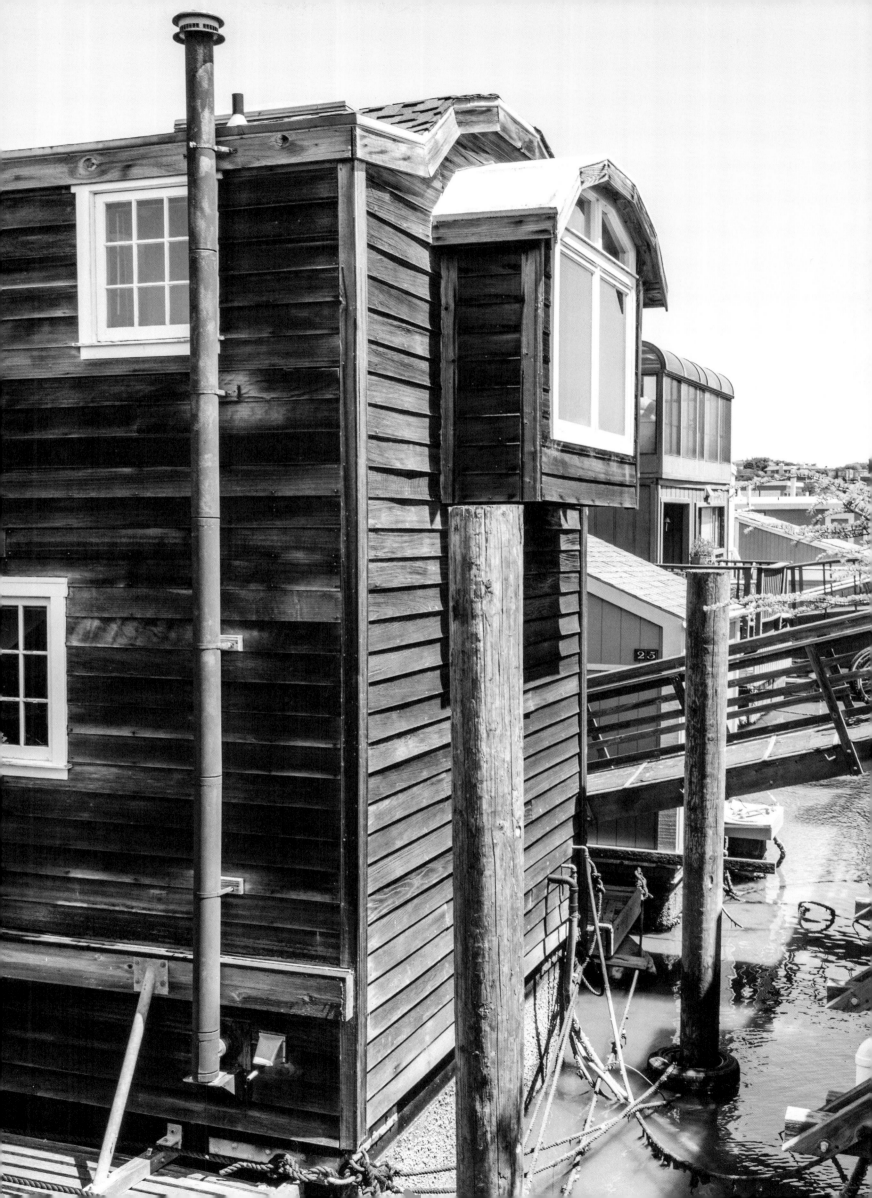

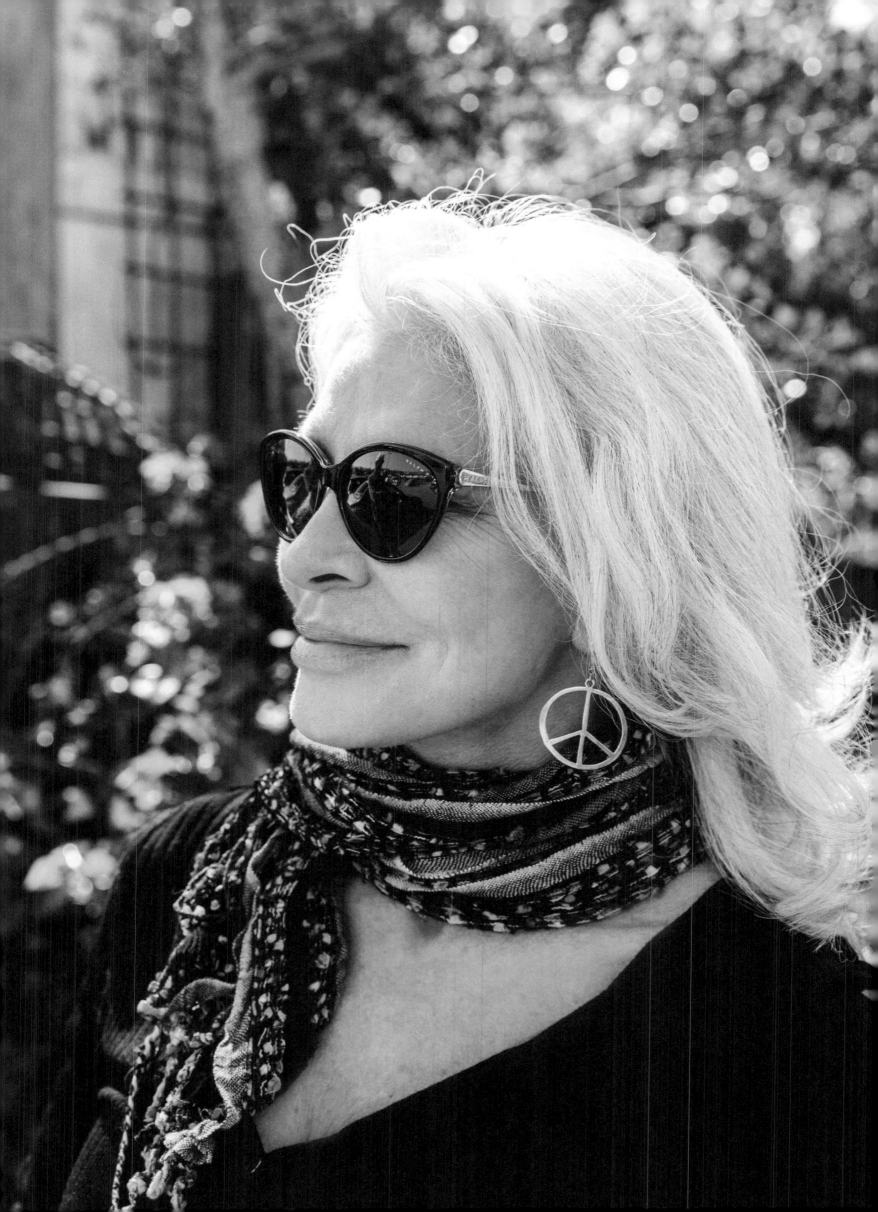

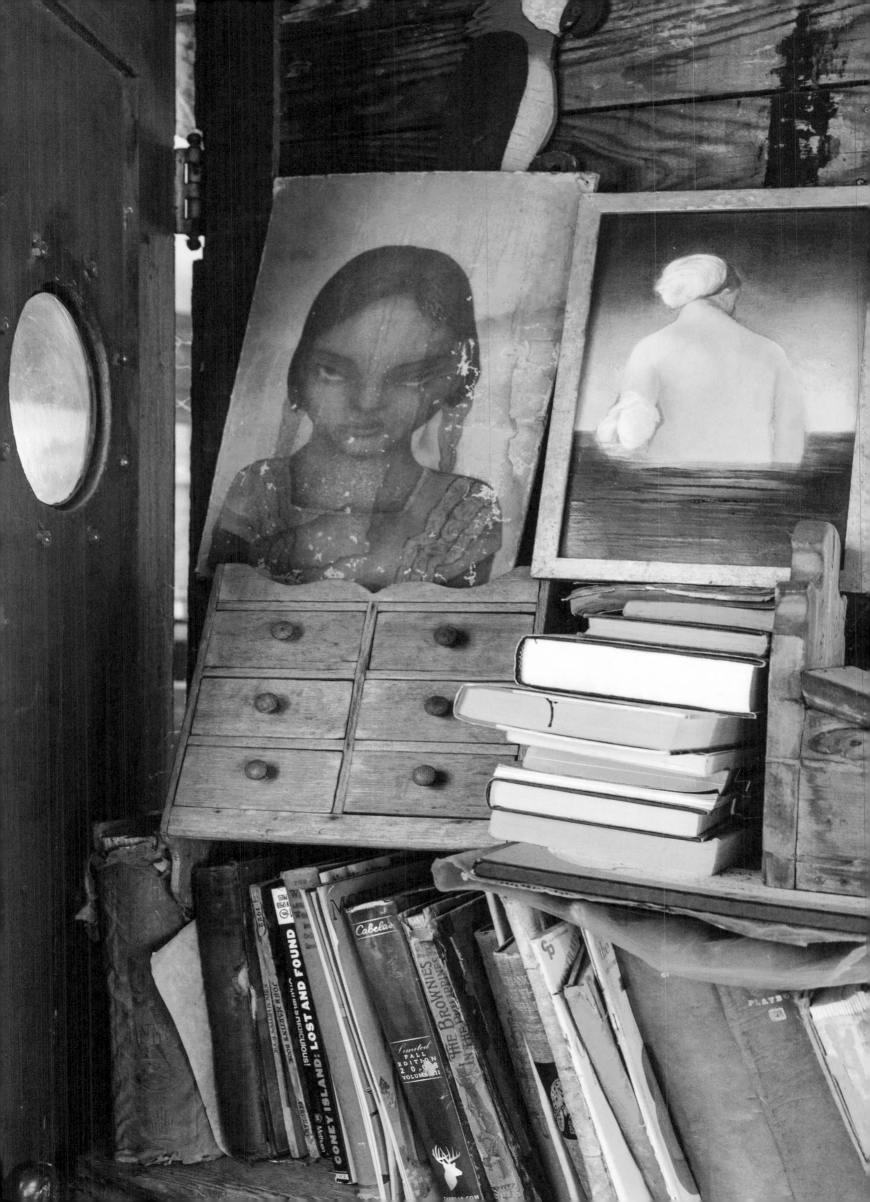

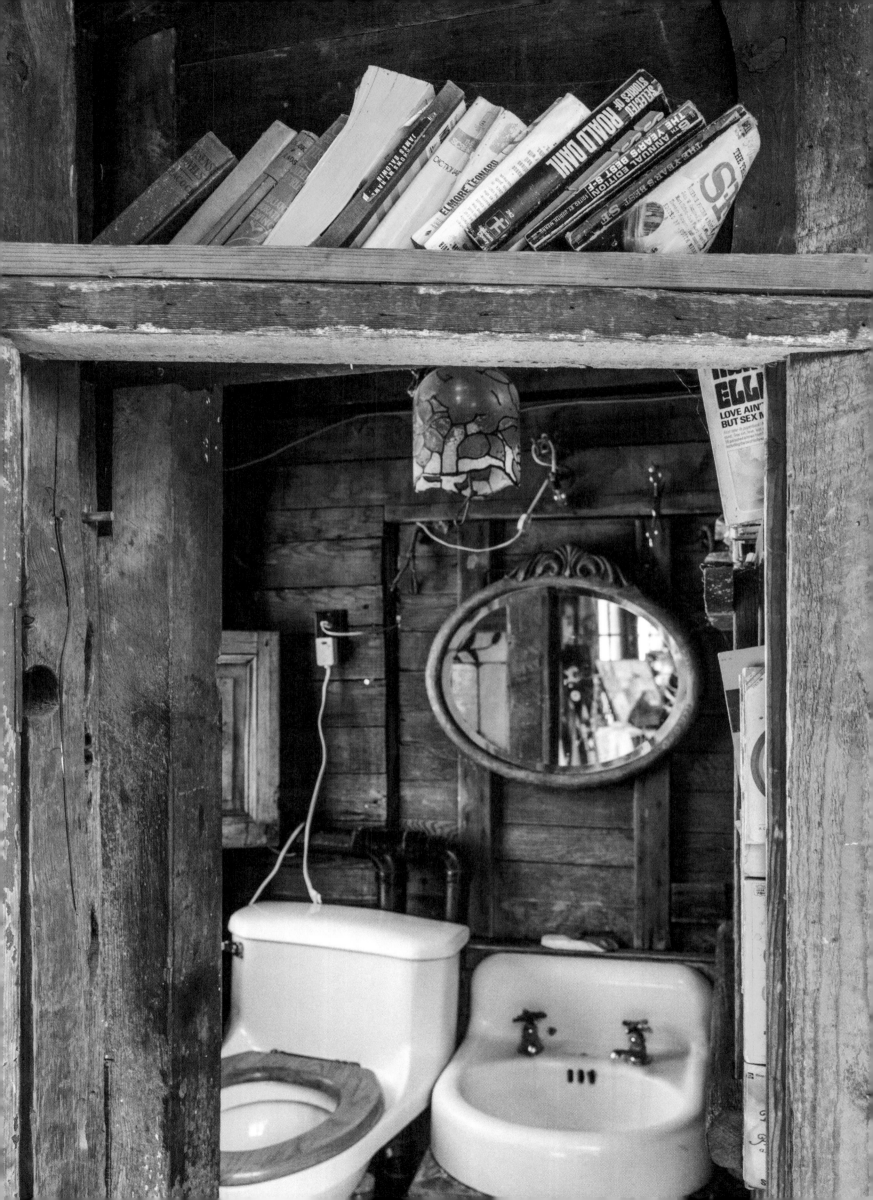

The Grandfather
of Them All

His record collection needs to be seen. He will tell you a lot of it is country and western, but it looks like an anthill or a brittle art institute installation not to be tampered with. It's impossible to tell one album cover from the others. They have all fallen into one another, becoming one single colorless body. It is more of an image than a collection of sounds. It is a reminder of how we once used to distribute music. It's like an inverted chrysalis, butterfly songs returning to their anonymous past.

Larry Moyer's friend and brother in arms Shel Silverstein dabbled in country music territory, writing the tongue-in-cheek macho song "A Boy Named Sue" for Johnny Cash. The Evil Eye, home to Moyer and his wife Diane, was once bought by Silverstein and is still, after the death of the free-spirited author, illustrator, songwriter and playwright in 1999, owned by the Silverstein estate. It is a World War II balloon barge that was converted into a home in the early 1960s.

Moyer acts as the eternal caretaker, a torch carrier with the same kind of playful humor as his former colleague, his philosophy being that boundaries are for the fenced in.

The Evil Eye is covered in a layer of historical dust. It is ingrained in the books and plants and film cassettes and figurines. There are old clothes on hangers and an opening between the two floors, surrounded by what feels like an indoor desert garden.

And the resident himself seems to remember most of the characters who have migrated through the community. Here they all came together, the boatbuilders and the dreamers and the castaways.

Moyer starts dropping names. Masturbating Mark did just that, incessantly. Naked Bob was a handyman in the 1970s, his only garment a tool belt. The Bee Junkie sat covered with buzzing bees without moving a finger. Then there was Normal Norman, Abnormal Norman, Sick Dick, and Slick Dick.

Airplane Dick had three wives, by the way.

Larry Moyer used to be one of the anchor-outs, solitary sailors without a walkway, at times almost a hermit out in the bay in his tiny floating studio, square and brownish,

not very psychedelic-looking; an eyesore to some, but a beacon of light to the locals. That is where he would paint and slowly acquire the role as Houseboat Grandpa with a white Father Christmas beard.

Nowadays, he mostly stays at home on board The Evil Eye on Liberty Dock. If there is something vaguely familiar about this place, it's because there are film sequences to be found on the web with Dr. Hook and The Medicine Show singing and giggling their way through "Sylvia's Mother" and other songs in this old living room of Shel Silverstein's. Through the windows you can spot the impressive Owl structure rising almost ominously against the glittering bluish background.

I've got all of Shel's books and stuff here. He was an old friend of mine, we did a lot of work for Playboy magazine over the years. That was a great life. We were both living in Greenwich Village in New York and we started working together and traveled all over the world. And we got paid for it. That's what always impressed me, that you could get around and lead such a terrific life and get paid for it.

Most of the time money will only fuck you up. I attribute poverty, I've had a great life, but it's poverty that's been the driving force.

I was a big-time Communist in the old days, the 40s and 50s. Right after the attack on Pearl Harbor I was living in Brooklyn. When the Japanese attacked, noone had ever heard of Pearl Harbor, but now they needed people to work at the naval base. The Japanese had sunk everything. So I signed up, it was a good way to get out of Brooklyn and I wasn't ready to do a lot of heavy fighting so I wanted to take a couple of years off. I figured the best place to spend World War II would be Hawaii. I saw these little Hollywood movies, you know, with beautiful girls running around handing out flowers and swimming out to the boat. Those were fantasies. Coconut trees. So I spent a couple of years in Hawaii and that's where I got into this whole Communist thing.

This was in the middle of the Cold War, too, with McCarthyism and everything, so I decided I wanted to see the way Communists really lived. I got to travel to all the

Eastern European countries and went to Moscow in 1957.

From Russia I took the Siberian railway to China. I was broke and being broke in Moscow is not the same as being broke here. In those days, nobody had any money. I ran into these Chinese guys, big guys in the Communist Party, in the only Chinese restaurant in Moscow. They said, do you want to go to China? I said, sure. Come on, they said, as our guest.

So I went to the United Press office in Moscow and said I'm on my way to China. They wouldn't let any American reporters in at the time. It was Red China, the yellow peril thing. I said, I'm going, would you give me press credentials? They said okay. So that was it. I was a correspondent for the United Press in China.

It was terrific. Because I was working for the UP I could get into these diplomatic circles. At one time, Mao happened to be there and I told him I liked his poetry.

There is a line of people, he's standing there and you shake hands. A lot of people don't know that Mao was a good poet and a great calligrapher. So I told him I liked his poetry and he said, what poem did you read? I said, the one where Mao felt like an old monk walking in the rain with a leaky umbrella.

And that was exactly the situation. Communism was a leaky umbrella. He was walking in the rain, for real.

When I came back from China I spent some time in Moscow. Eventually, they threw me out, very politely. The US State Department had told me not to go to China, my passport said I couldn't go and stuff like that. But I said, hey, I'm gone. I'm an American, that's what it's all about. I should be able to travel freely. They threatened me: when you come back, you'll be in a lot of trouble.

I then went to East Germany, and that finished it, you know, as far as Communism was concerned. That was it. I realized that I was living pretty good here. Whatever people say about America, and noone is more critical than me, it is terrific. I mean, where else can I live like this?

That's basically what America is about. The craziest motherfuckers in the world

came here. It's the best and the worst, this country, as far as I'm concerned. I think it's very simple. If you want the best, you go where the best is.

Like when I came here… I went with Shel to do a story on the hippies, the Summer of Love, 1967. I was in New York, living in the Village, and it was my birthday and someone told me things were happening in San Francisco, you gotta go down and take a look at it. She gave me the telephone number of some guy. She said, when you get to Sausalito, call this friend of mine.

So we went to the Haight and did the whole hippie thing with the dope and the sex and the rock'n'roll. After about three months I remembered I had this number in Sausalito; let's call the guy.

I came down here and the first boat I was on was The Becky Thatcher. Dino Valenti, the rock musician, was here and he was playing music with his band. I walked out on the deck and people were walking around naked on these fantastic boats. Mostly home-made, people would build their own little ships.

This is a balloon barge, but they had landing crafts. You've seen movies of the Americans coming onto the beach in Guadalcanal and Iwo Jima. They had a lot of these landing boats available, and for $50 you could get one and people would build cabins or whole houses on top of them. And so the whole community was living on World War II recycled stuff or anything recycled. The people became recycled themselves!

The whole mentality was completely anti-military, completely non-conformist, unregimented. People were smoking joints and running around naked. There'd be all kinds of music. And I said, wow, this is where I wanna be. I want to spend the rest of my life here.

By that time I had decided I didn't wanna do anything for the rest of my life. I just wanted to hang out. It sounds weird, but I thought this is the place, with all these other crazies!

Was that better than traveling around the world?

Not better. Just different. Just another thing. I used to make movies. I won the best director award at the San Francisco Film Festival in 1963. The movie was about the beatniks in Greenwich Village. It was the early 60s, the beatnik thing was happening

and I was working with Time-Life at the time, as a film editor. And I was making this vampire movie called "Lost to the Vampire". There was this old broad, like she's 500 years old, and when she drinks the blood of a young girl she becomes young and beautiful. In those days, it was very rare to see naked girls on the screen. I needed a girl being strangled in a bathtub. All she had to do was be beautiful. And scream. So all day long I'm interviewing and auditioning these girls. Eventually they would take their clothes off. Towards the end of the day this lady walks in, great, beautiful lady. And I fell totally, completely in love with her. So I said, anything in this world you want, I don't care what it is, I will get it for you. She said, I want to star in a feature film, and I said okay. She was the girl that got strangled in the bathtub. She looked so good being strangled in a bathtub that I married her!

Then you won an award.

I bribed them. There were four guys on the jury and I bribed three of them. Have you ever tried to bribe anybody? It's not an easy thing to do. You wonder how much you're gonna give them. One of the guys was a Mexican director. I said, what do you want more than anything else? He said, I want a 357. Magnum. Difficult Mexican, he wanted the biggest gun! So I took him to some place downtown and got him one.

Another guy was a Russian movie producer. That was his front, he was really a KGB guy that I knew in Moscow. Actually, when I met him he was following me around. He later became a general. I said, you don't have to follow me around, let's hang out together. So he became my guide in Moscow. With a top KGB guy you get the best tables in the restaurants. Everybody's very nice. So he's one of the judges! That guaranteed his vote.

The third guy was a professor at Berkeley. He was a cigar freak. Like any other junkie he'd do anything to get a good cigar. Kennedy had just done the Bay of Pigs invasion in Cuba and there was an embargo on Cuban cigars. What Kennedy did was he brought all the Cuban cigars to Washington. He had all the good stuff. I met a guy at the Italian consulate and saw this box of Cubans, the best, so I grabbed a bunch of them. I was overcome with greed.

Have you ever been overcome with sheer greed? It is a sensation, you can't control yourself. I gave the cigars to the professor and he was the third judge that I bribed. The movie had some merit and I ended up marrying the girl in the tub. These things just happen.

When I came here I thought I don't wanna do any more of that stuff. Once in a while I'd shoot some photography with Shel. Sometimes my friends would make a movie and I would go work on it.

I have a boat out on the bay, anchored out. My studio. I don't go there as much as I used to. I've got some seagulls on the roof and some Canadian geese that just laid some eggs. It's a great place to go. It's like my private lunatic asylum.

What do you do when you're out there?

I paint, I do some writing, shoot some video, play with my cats. People stop by once in a while.

Here, I was just hanging out. The nice thing about it was that nobody had any money in the old days 'cause nobody was working. A lot of people came here because they just didn't want to work anymore. People came from Haight Ashbury. They were unemployable. Nobody would hire any of us. A lot of it was bartering. You would trade some work on a boat, you'd help somebody paint and they would help you with the electricity. It was that kind of trading back and forth. If you had some dope you could trade it to somebody for food.

I guess you could say there was a criminal element to that. There was no law down here, no rules. The cops never came down so we had to police ourselves. Not an easy thing to do. Now, if some lunatic shows up, you can always call the cops. In those days you had to take care of all of that stuff yourself.

There were no rules, no laws, no regulations, no building codes. You could build any kind of boat that you wanted. You could do pretty much what you liked.

Was it a good life?

It always gets romanticized. I won't tell you about the terrible shit. There was a lot of dope, a lot of drugs around. Everybody was pretty high all of the time so they couldn't really work too much. But people built their own homes, you learned a lot of stuff. There was a certain amount of freedom. You know, freedom's a weird word. If you ask people about freedom you'll get totally different answers. But whatever it was, everybody was kind of finding it here. When you're experiencing it you're not really realizing that you're enjoying it, but when you lose it is when you'll understand what it is. It's like when you're in love. Same with freedom.

What kind of freedom did you experience here?

Freedom's not an easy thing to handle which is why a lot of people don't really get to it. If you've got a job, you wake up at a certain time and you go to work. Here, you're not doing anything special. You have the whole day. And you have to figure out how to get through the day. Do whatever you want. That itself is a big challenge, that kind of freedom. You can't blame anybody out there and say that my father is fucking me up. It's all on you. See, that's another thing that comes with freedom.

Then there was a lot of sexual freedom. It pretty much meant that you could have as much sex as you wanted with whoever you wanted. The whole community was into it. It wasn't a big deal. There was a lot of nakedness. You could walk around without clothes if you wanted. Almost anything you did was okay with your neighbor. That's also freedom. You're free from everybody else telling you do this and don't do that. You really had to fuck up to fuck up here, do something terrible.

Did this freedom become a problem at any time?

Of course! After a while, when you get into the drug thing, it's completely free and stuff, and some people really got shot down. A lot of people died. Originally down

here, there was a lot of marijuana, a lot of LSD, mescaline, mushrooms, but after a while speed started coming in. Amphetamine and heroin and cocaine.

I never got into that stuff. A lot of the people you were with were hardcore junkies and hardcore hookers, but it was okay. Nobody judged anybody. So there was a lot of drugs and a lot of music. Everybody played the guitar or other instruments, and that was really nice. People sat around playing a lot.

You were living with some really dangerous guys, too. I never had any problems with them. They just happened to be killers or something. Stuff like that.

And there were a lot of nuts down here. They would have been in a nuthouse if they weren't living here. You don't get a chance to live with crazy people every day. Here, a lot of your friends and neighbors are out there. It's quite an experience. They're telling you some pretty bizarre things. I never questioned them. I didn't say, are you kidding?

We didn't pay any rent. Once they brought the development in, we couldn't afford to live here any more. We were fighting for our whole lifestyle. We were up against some big bucks and the cops. They looked around and said, if we can get rid of these people, which was us being here, we can really make some bucks here.

But a lot of people here on the dock now are terrific people, great architects and lawyers and doctors. The guy at the end of the dock is the official doctor for NASA's space program. They're all my friends.

Could you, at the time,
imagine the changes that would take place in this community?

I never could imagine any of the great things that happened in my life. But I don't have much of an imagination. It's true. I can't do abstract paintings. I can't really act. To become another person, to get into a whole other personality, takes tremendous imagination and I don't have that.

What else was happening here? One of the great lunatics, his name was Ricky, told everybody he was God. Little Cuban guy, one of the world's great harp players. But he was out there. He had a boat and he invited us all out to it one day. He's sitting there

and he's playing the harp and he stops and suddenly says, I'm gonna rid myself of all my material possessions. He was gonna go on a spiritual trip.

The guy who thought he was God takes his clothes off and then throws his beautiful harp into the water. Then he takes out his teeth. He gets his wallet and throws it out. I was with this lady, and she jumped in after it! Most of the time you tried to stay out of the bay. In the old days there were no toilet facilities whatsoever.

Anyway, he throws everything out and then grabs a machete and starts cutting the lines of all the boats. He wants to liberate the boats! The boats don't want to be tied to the docks! He's gotta cut them loose so the boats can do what boats do.

So they call the cops and the cops take him away. But they didn't want to put him in jail or in a nuthouse. He was one of those brilliant lunatics. Great poet, great singer. He'd go to a Howard Johnson and tell the waitress that he demands to see Howard Johnson. The manager comes and says that he is somewhere in Nebraska or whatever. Why do you want to speak to him? I want to buy the place and fire you because the food is so bad, he complains.

He was just one of them in that picture on the shelf. The girl who is almost naked was the daughter of a big-time doctor in Los Angeles. She ran away from home when she was eighteen and took all his drugs with her. She came down here and was of course immediately popular among the locals. And she's still here. I think she is in a half-way house. There's a lot of people rotting away from some kind of scene somewhere.

After they took down the shipyard this was just empty mudflats owned by a guy named Arques. He was like George Washington, he owned the property and he let us all stay here for free and protected us from the authorities that always wanted to throw us out.

The county's health inspectors would come down and become horrified by our shitting in the bay. They'd look at the wiring, it was in the water and they were horrified. They'd walk in and none of the boats were up to code. Everything was illegal down here.

On the one side they wanted to get rid of us, but they were a little touchy and didn't know how to do it. One of the reasons they didn't come was that a lot of people here

were armed. Many were World War II veterans, like me.

I was stationed for a while in San Diego and while I was there I was lucky to get a job as a dance teacher. At night I'd put my suit on, so during World War II, which was the most horrible, undescribable war of all times, I had a good time. We were gonna invade Japan, but then they dropped the atom bomb and we were so happy. When the Japanese surrendered I have to admit that not a lot of people got into any moral, ethical considerations about the dangers of atomic energy. It was the end of the war. The bomb had saved our ass.

What else down here? Anybody could come down here from anywhere, and come into the community. Get a little boat, fix it up. Whatever you needed seemed to come around. If you needed wood for your boat it would float up. You could find it in the old shipyard. If you needed food there was always some around that you could share. If you needed some love, somebody would always show up and deliver it.

If you got sick you could always go to the hospital, but we pretty much took care of ourselves. We occupied this neighborhood. A bunch of people came here and they occupied it. Then people started coming, living on boats. They stayed rather than moving around. It wasn't just a vocal protest about Wall Street, like the Occupy movement; we actually moved here and lived here.

Every once in a while the media would come because they had heard about a lot of freaks down here. Naked people. Crazy people. Dopies. They had a romantic idea about what it was about.

And this guy Russell Grisham, he lived out on a boat called The Owl. You can see it from the window here. At that time Russell looked like a movie star. He was beautiful.

Whenever we got a reporter down here, for the Houseboat Wars or the lifestyle, whatever that means, we'd get young Russell to take this girl reporter around. We figured he would show her the best part of our lives. He was a charmer.

There wasn't much electricity in the early days so there was a lot of candle light and kerosene light. If you're living in a neighborhood with just candles and kerosene light, it does something to the whole mood.

Then, at some point, it became fashionable to move here.

Yeah, the new people. At first we tried to keep them out. That was what the House-boats Wars were all about. We put up a pretty good fight. I gotta admit I enjoyed it. Here was an old Commie and most of the time you'd be theorizing about the collective struggle, but here I actually got a chance to enter into an almost daily confrontation with the authorities. It gave you a nice revolutionary kind of feeling. The heavier the authorities are, the more pleasure there is in fighting them. It's a weird kind of fanaticism. I've been a fanatic a few times in my life and I always loved it. As a fanatic you're always right. You don't have any moral or ethical considerations for anything. It's a terrific feeling.

Of course, I've been smoking dope for 65 years, something like that. It probably affected my mind, all the drugs and stuff, but I don't remember that much. There's an old saying, if you remember the Summer of Love, you weren't really there.

Now, the people on the docks, I love these people. They're my friends. I've overcome my initial hostility towards the rich. Being a Communist I was ready to eat the rich. We were not just gonna kill them, we were gonna eat them, too. But once I got to know some rich people, they were terrific. Some of the best people I've known are rich people. I've been to parties where millionaires discuss revolution and the overthrow of capitalism. They may still talk about Marx. Not Stalin so much, they're all pissed off with him.

What's the difference between illusion and delusion? Illusions are all I have. At certain times in your life you feel like you have stepped across the line. You can walk down the street and everyone looks like an actor and you feel like you're in a movie. To fantasize and be who you want to be is easy down here. People will accept you.

But then we've had some really bad characters, too. In the early days it was pretty patriarchal, it was mostly guys. Once the women started showing up they began having kids and needed protection. It became a little different when the broads showed up. It started changing, it wasn't quite as militant as before. One of the reasons the cops never came down here in the early days was because they were scared. They had heard that everyone here was crazy. The cops can handle everything except lunatics. Some

of these people who showed up were really bad. Different people would come out and talk to them, but there was just no stopping them. They started preying on the kids and the women and just doing some bad shit. We had people like that, gangsters.

We didn't do it consciously and say we wanted to do an alternative thing, but that was what was happening.

And then the development came. We fought them for a few years and we lost the fight. Russell was one of the heroes. They brought in some Samoans from Oakland. They're all eight feet tall and their necks are bigger than their heads. They're sweet guys, but they just love to fight. The developers, that now run the Waldo Point Harbor, wanted them to protect the property.

There were a lot of creative techniques that we used to fight these guys, nonviolently. I'm not really good at any violence, but I did carry a gun for a while because if these Samoans grab you, they could either kill you or cripple you.

Some people would steal and a lot of people would eat leftovers from the restaurants. The expensive supermarket would put out food in the back that was dated and we would go there and eat. When you're hungry you steal food. We had some pretty good thieves. There was one guy called Jack the Fluke. He was into everything, drugs, sex, an outrageous guy. He was a chicken thief. Everybody had a specialty. His was the barbecued chicken thing. He was so good, but one day they caught him and they were chasing him down the road back here and while they chased him he was eating the chicken! By the time they got him the chicken was gone. They couldn't do anything to him.

I remember one time when we were sitting around starving. Getting heat wasn't easy. Think about it, it was pretty tough times out here. We weren't eating much, freezing our asses off. We didn't have any food, we didn't have any dope, we didn't have anything to drink. We were too tired to go out and get firewood and this girl walked in, she had just come from Yonkers, New York, a seventeen year-old runaway, and she turns a couple of tricks on the highway, goes to the supermarket and comes back with a

couple of bags with food and a bag full of grass. I was very impressed. Things like that would happen.

The closer to the edge you came, the more blessings, the more lucky things would happen. That's the way it's been with me.

You had some kind of career when you lived in New York.

Oh yeah, I did movies. The un-American Activities Committee was after me in San Diego and they wanted to subpoena me. I just jumped into the car and drove back to New York. I worked in theater for a couple of years and got into the movie business, where I was for fifteen-twenty years. I was an editor, a camera man, directing, a little bit of everything. I worked as a photographer once in a while, for Playboy, doing some shooting. That was easy. I just played around, I was never that serious about it.

I didn't want to continue. I really enjoyed making the movie or shooting the picture, but having to deal with lawyers, contracts, actors, raising the money, I didn't want to have anything to do with that. Getting a distributor. Most of the time was spent doing that.

I did TV commercials, travel stuff, documentaries. But eventually I had had enough of New York. I just didn't want to do it anymore. I jumped into my car and drove out here, and fell in love with the place.

Did you rebel against your parents?

No. My father was a tailor, a really good one from Russia. He had six brothers. They lived in one room about this size, a log cabin. His father was a shoemaker and he cured his own leather. His mother and father slept in one bed with a curtain across this room. He and the six brothers slept on the floor, lined up against the wall. That was his life. But one day the Cossacks showed up, and it was a pogrom kind of thing except they were basically after one of his brothers, a revolutionary I guess you might call him. He was hiding under the bed and they dragged him out and dragged him around town behind a horse with a rope around his hair, and then took him to Siberia.

He later escaped. My father saw this and came to America, he came to Brooklyn, and here I am one generation later.

My mother was a seamstress. Her whole thing was just being a mother. They were orthodox Jews, they lived pretty much in the old Jewish tradition. Not the lunatic fringe with the hats. She was just a mother, never learned to read or write. Completely illiterate. She came from the same neighborhood, but they met in New York.

The great thing about it is they never had any great influence on me. There's a weird thing about being a Jew. It's not really religious, it's like a tribal kind of thing and there are certain values that they have, that they aspire to. So it's a whole culture where you become Jewish without knowing. Most Jews are atheists. The culture is actually pretty fascinating, you know.

I got fascinated with these super madmen, Jesus and Mohammed and Solomon and King David. These three incredible religions came out of just a few blocks. What is it about this place? I mean, these are heavy-duty nuts. You can't argue with these people.

It's one of the beauties with being a fanatic, you can't argue. It's like being in a pissing contest with a prick. You cannot win 'cause it's their thing.

As far as I'm concerned, America is the best and the worst, because of the diversity. In every ethnic group there's the best and the worst. I hung out with the best. This boat is like a big debris box, I have all my life scattered around here, all my movies, the old photographs. I've been here for forty years or more and something is always happening.

I'm ninety and I see stuff as a movie, it's all like a movie to me, or a play. I'm now in the third act. I can hear the fat lady singing in the wings, rehearsing. This is where I play out my third act.

Shel would spend some of his time here, but I would take care of it. When he died I stayed here. I caretake the boat for the family. I don't have to pay any rent, gas or electricity, telephone. If you wanna live on this dock you'll have to come up with, I would think, $5,000 a month, just being on the dock without living luxuriously. So I was lucky enough to just keep this floating for the estate. Otherwise I couldn't afford to live here.

I never really wanted to work. I don't know if there's a word for it, but every disease has got a great word for it, a phobia. I've had a phobia about working, but I got my first job when I was sixteen and graduated from high school.

The alarm clock rings in the morning. It is the most terrible sound. I have to get out of bed, get dressed, walk to the subway, go to work, punch in. They ring a bell and you go to work and they ring another bell and you eat and they ring yet another bell and you stop eating, and then you go home. Wait a minute! This is what it's all about?

So I had to figure out a way to get through life without working a regular job. At least I could be a cowboy! What a life, you get to spend the day riding horses and killing bad guys. But cowboys are working their asses off. In my neighborhood in Brooklyn during prohibition, the gangsters were the only ones doing well. They had all these beautiful broads they showed up with. They owned most of the night clubs and movie studios. So I thought, man, I wanna be a gangster and get these girls.

Then I saw my first dead gangster lying in the street. I figured it must be an easier way. I watched the movie "La Bohème" with guys hanging out in Paris or wherever and drinking lots of wine and there were always girls around guys making pictures. Some guys are writing poetry and some guys are making music. Nobody's working. I didn't consider writing, painting or music really working. I thought, who are these guys?

If these guys are artists, that's what I wanna be! If you're an artist you don't have to listen to the fucking alarm clock.

In the early spring of 2016,
Larry Moyer passed away at the age of 92.

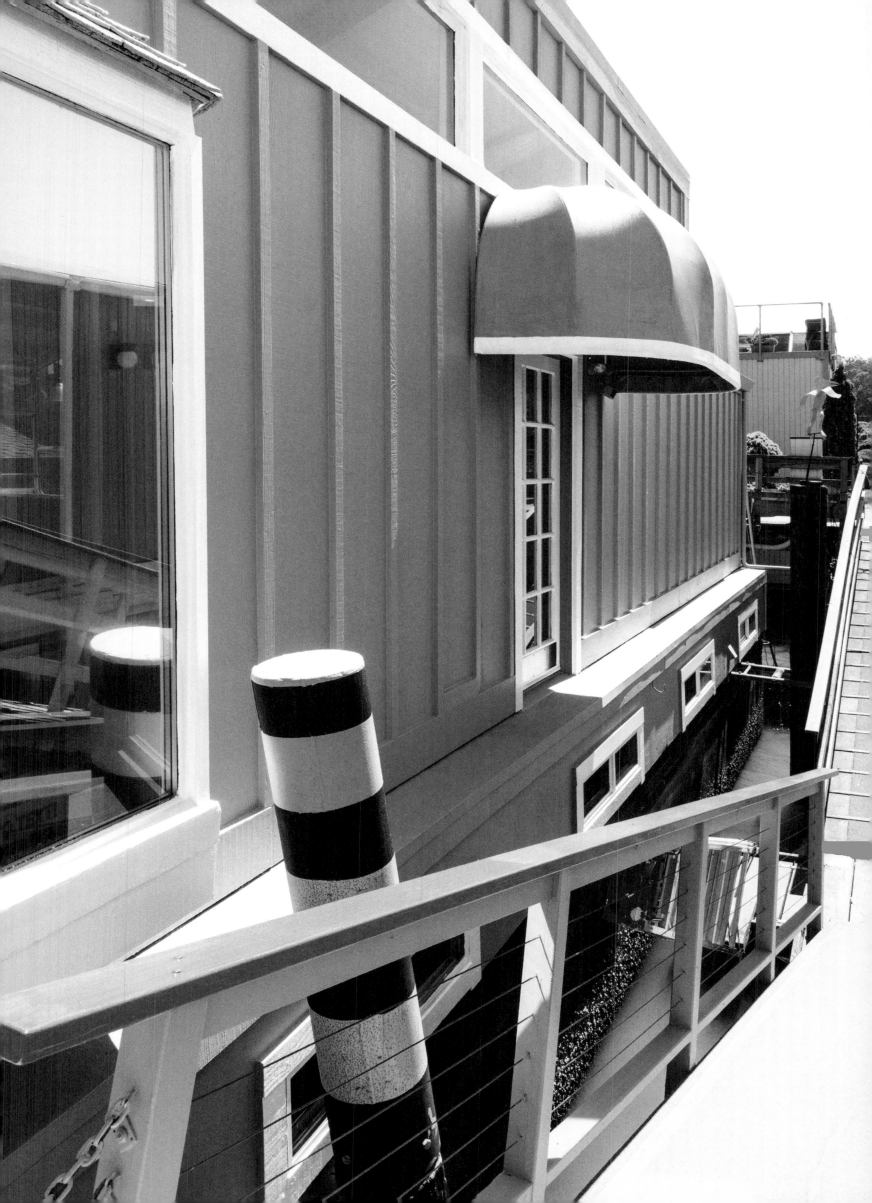

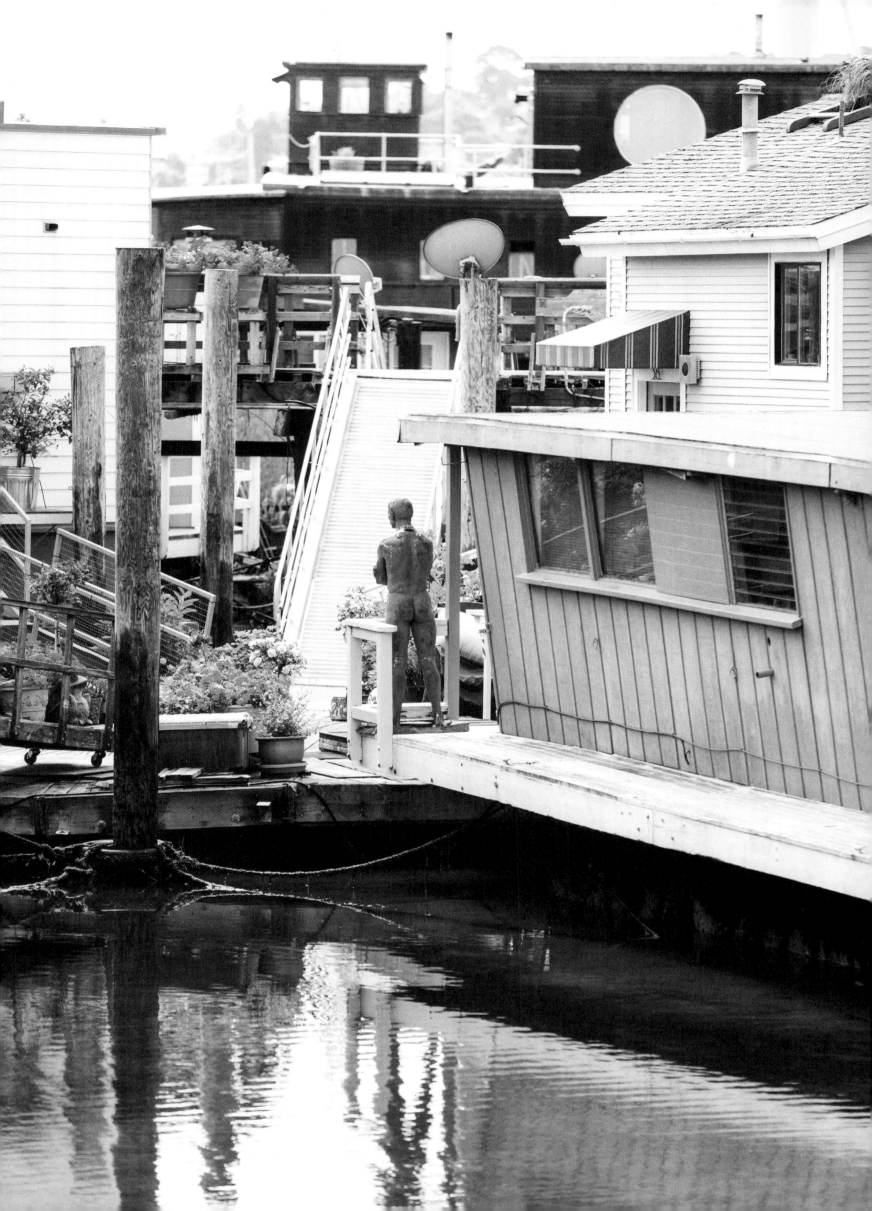

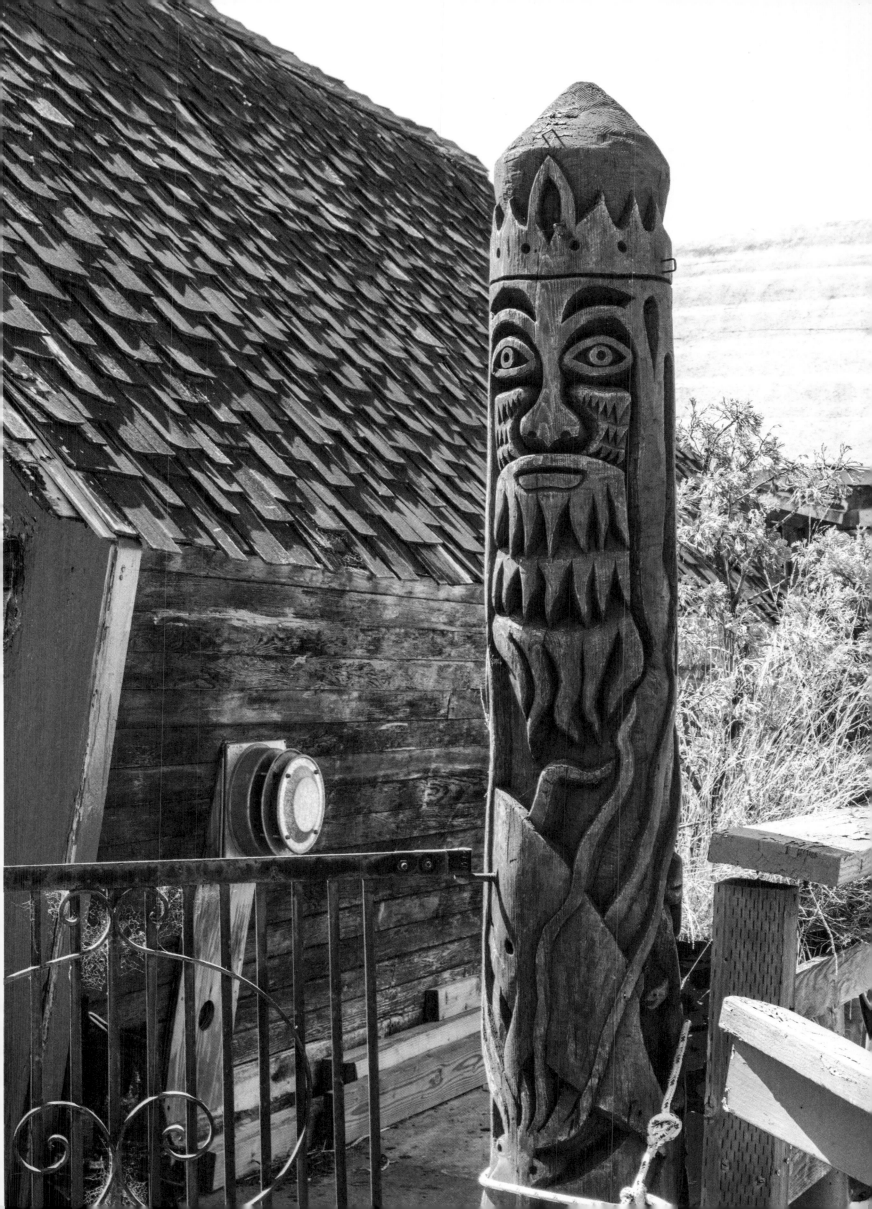

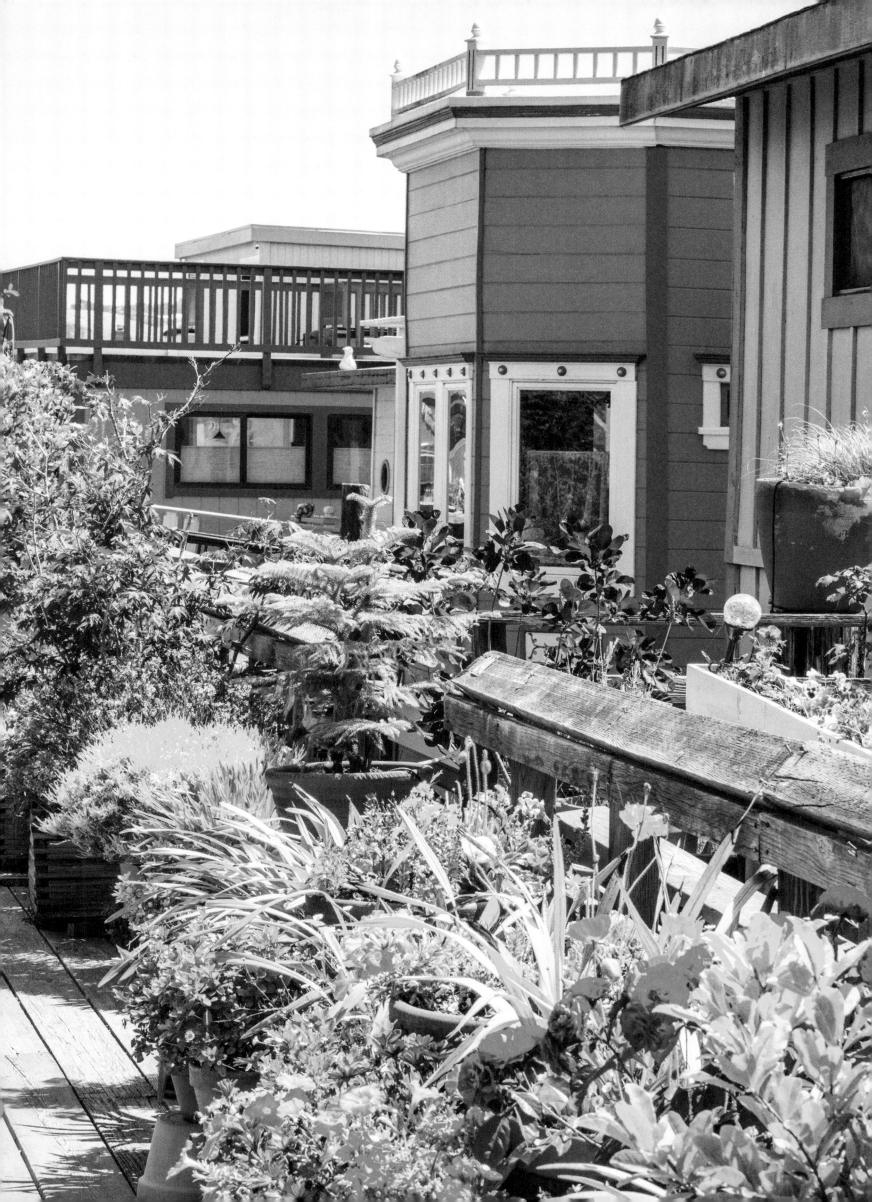

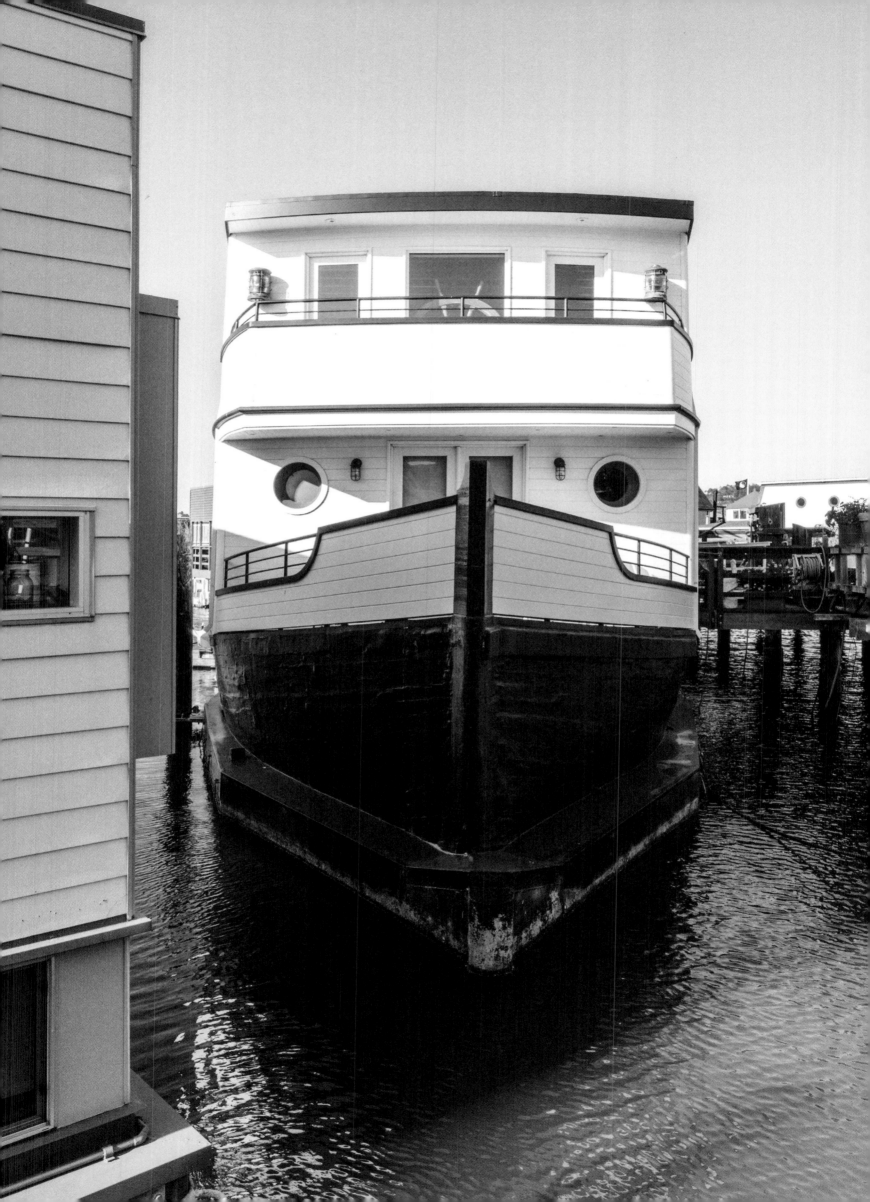

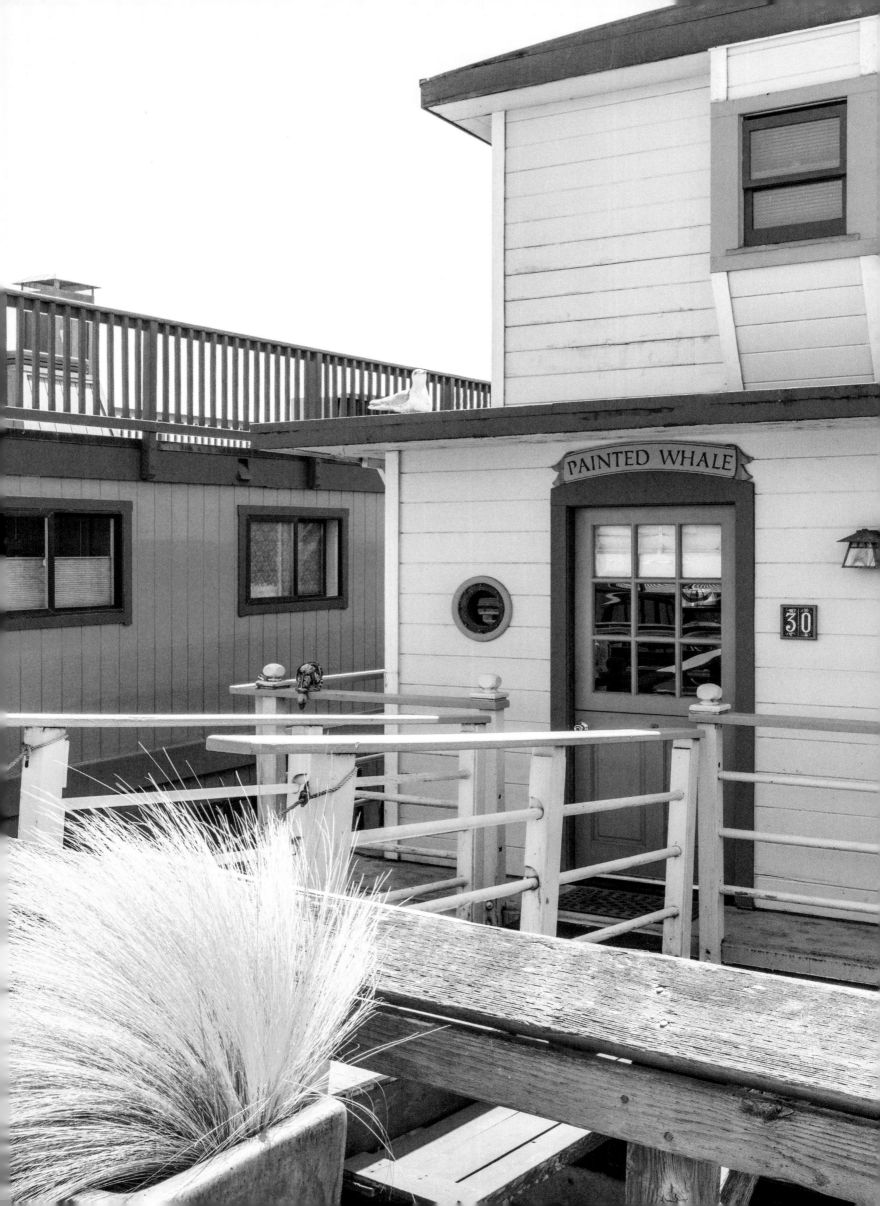

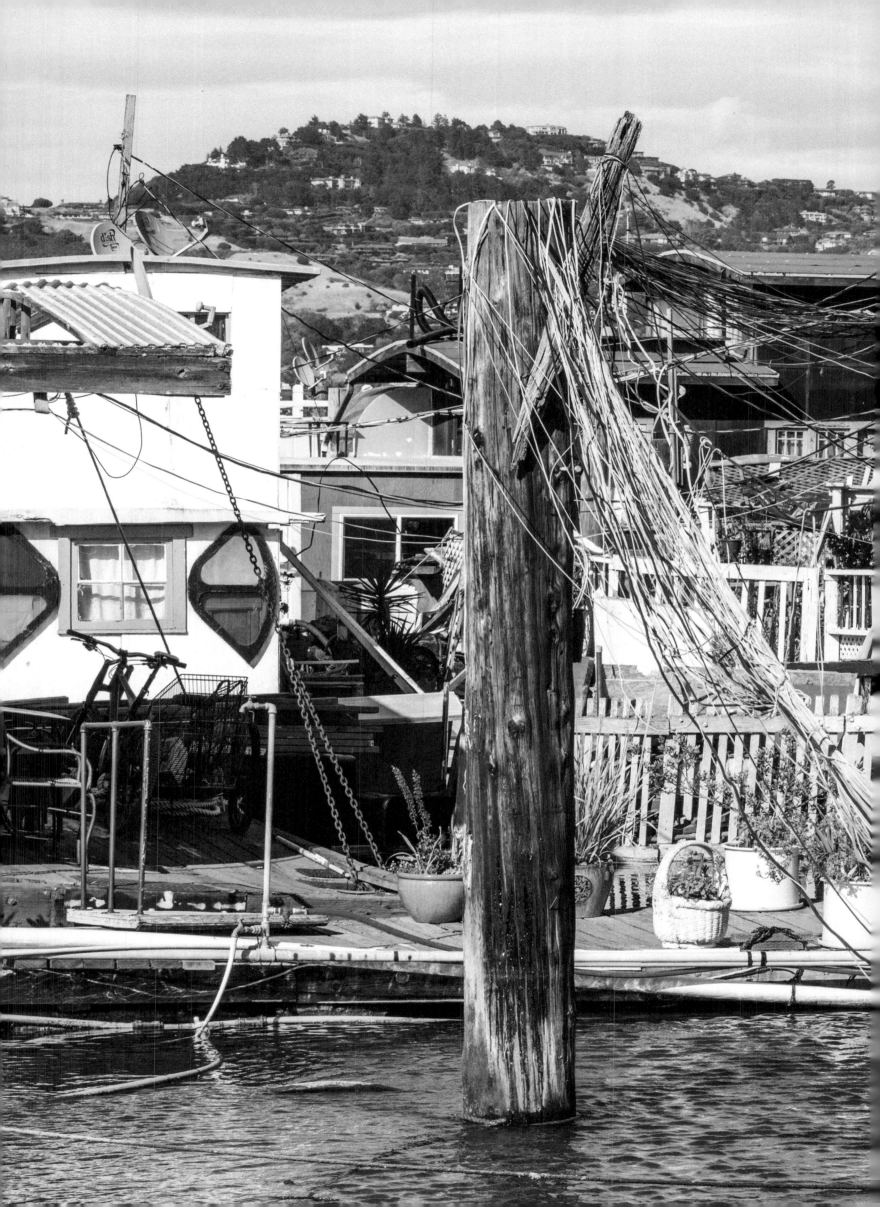

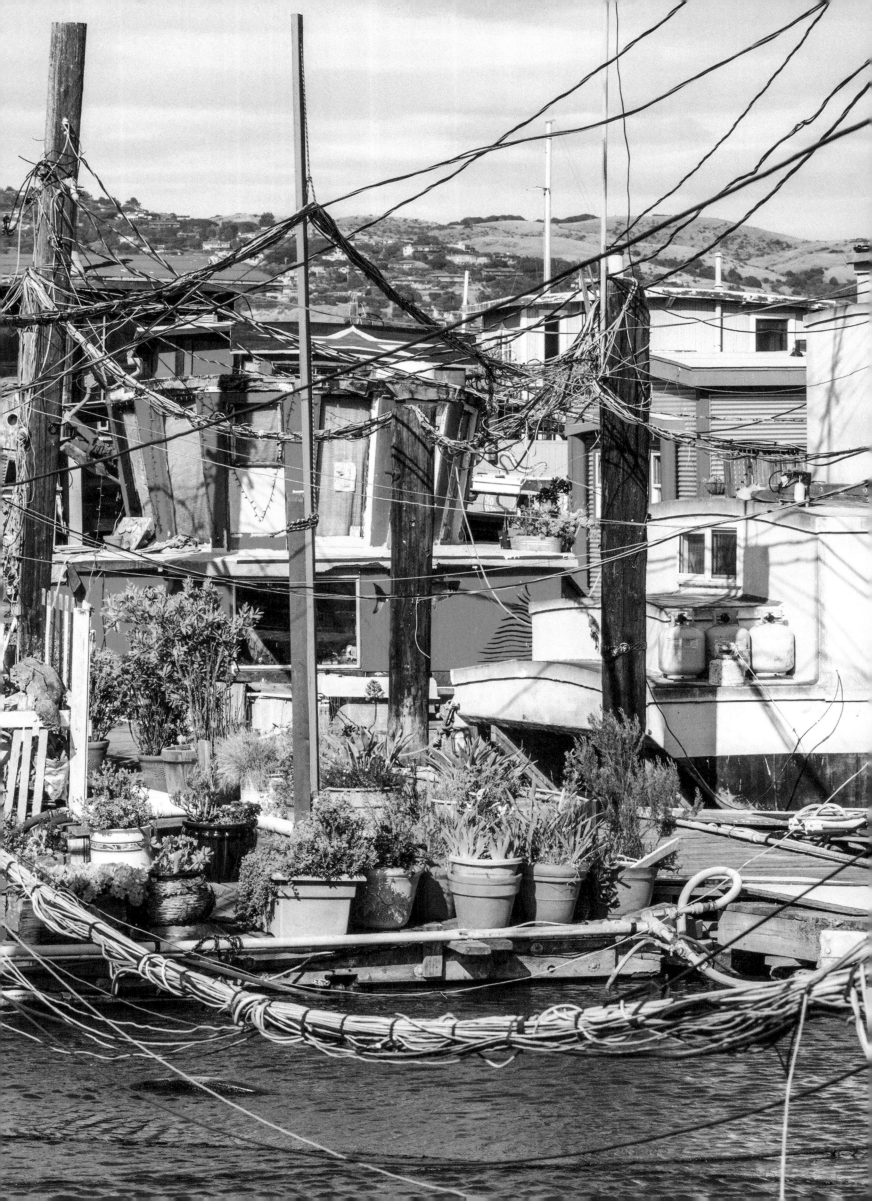

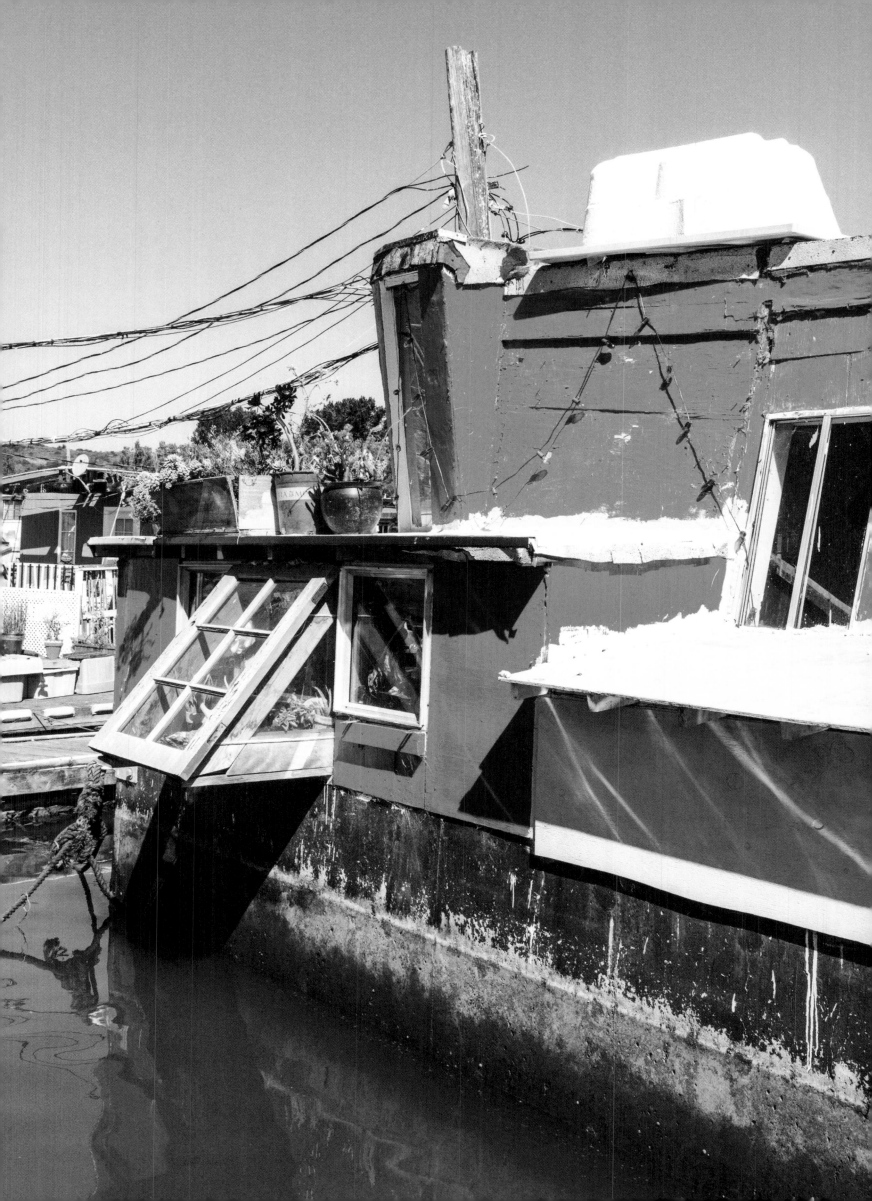

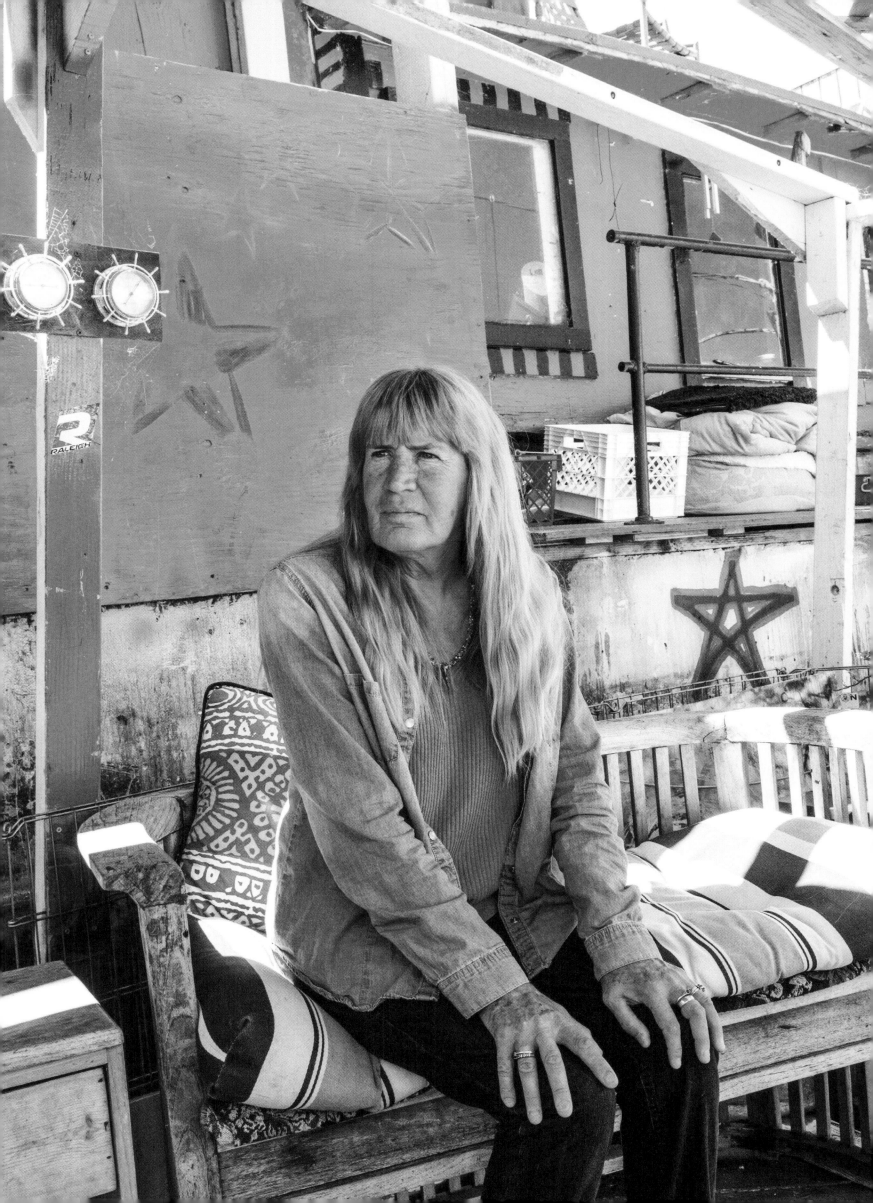

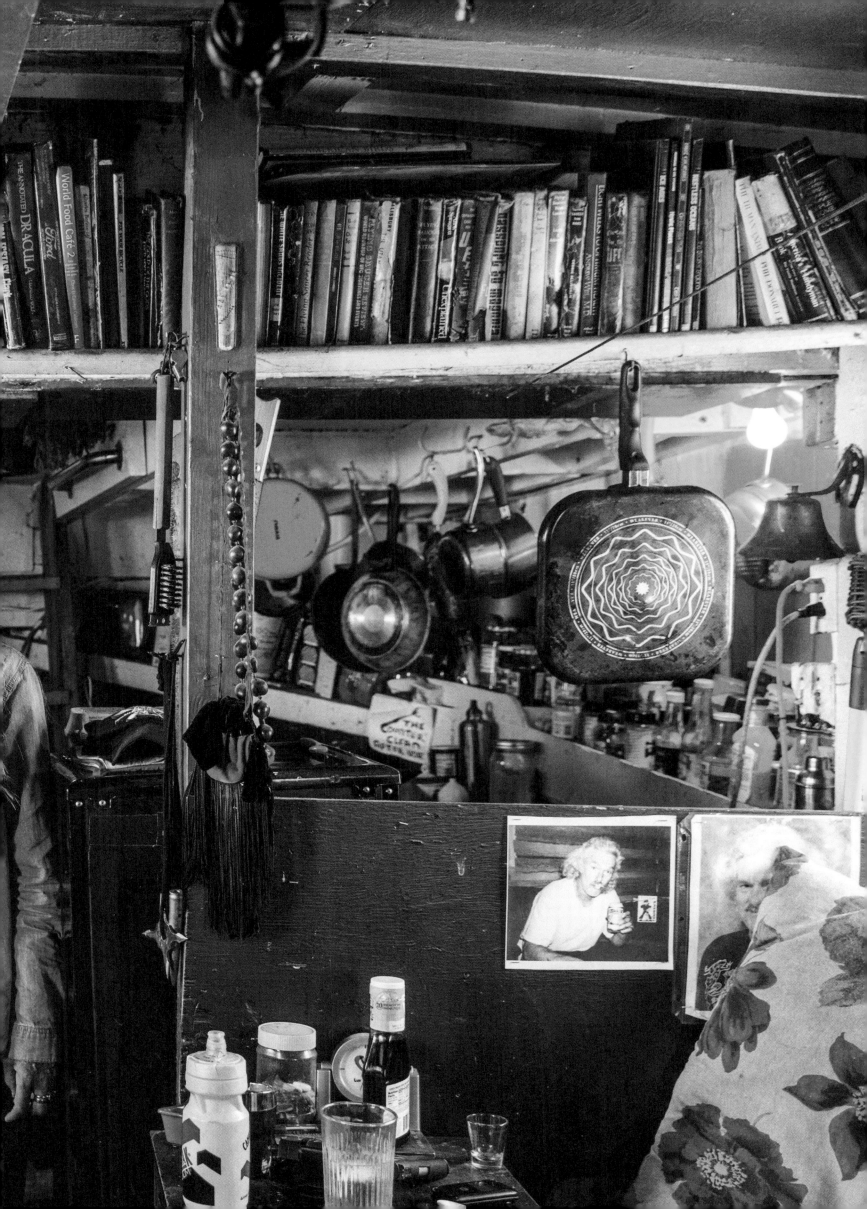

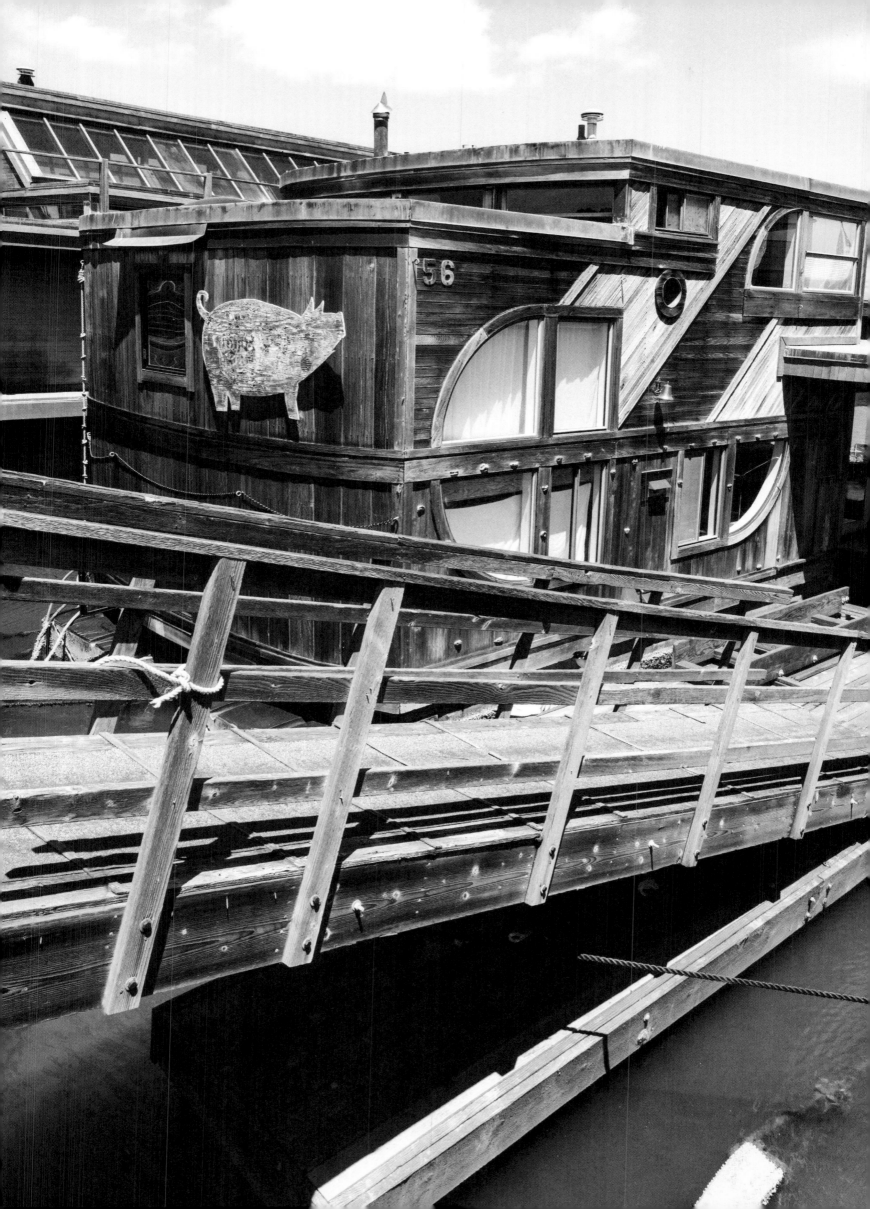

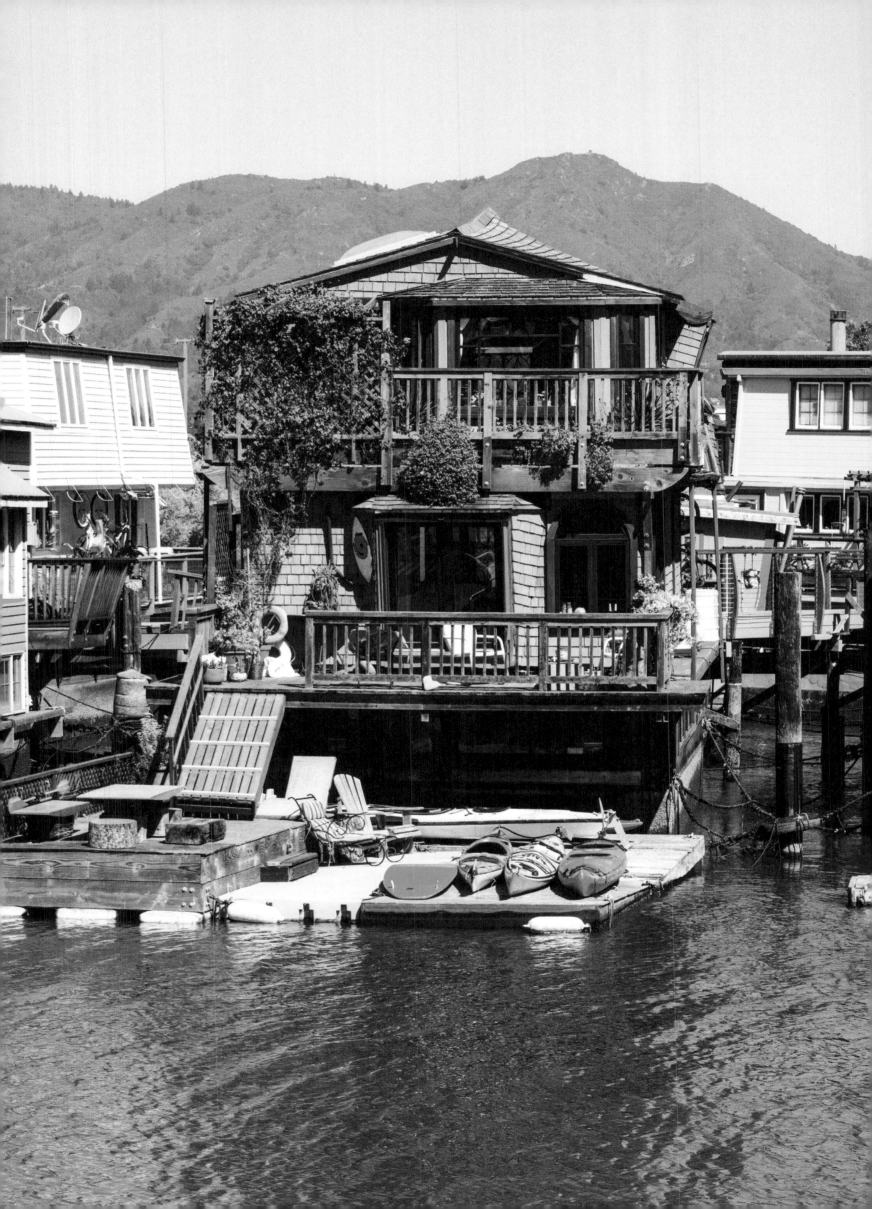

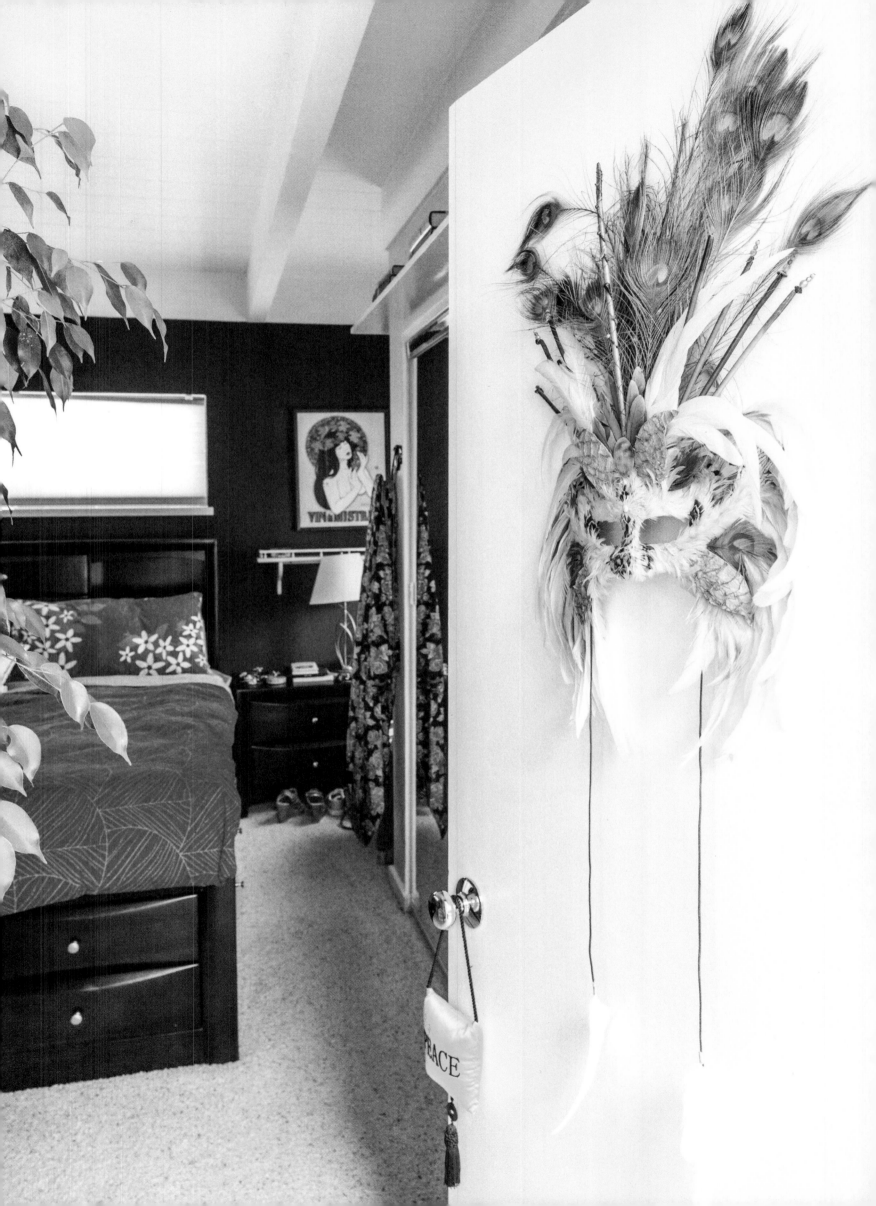

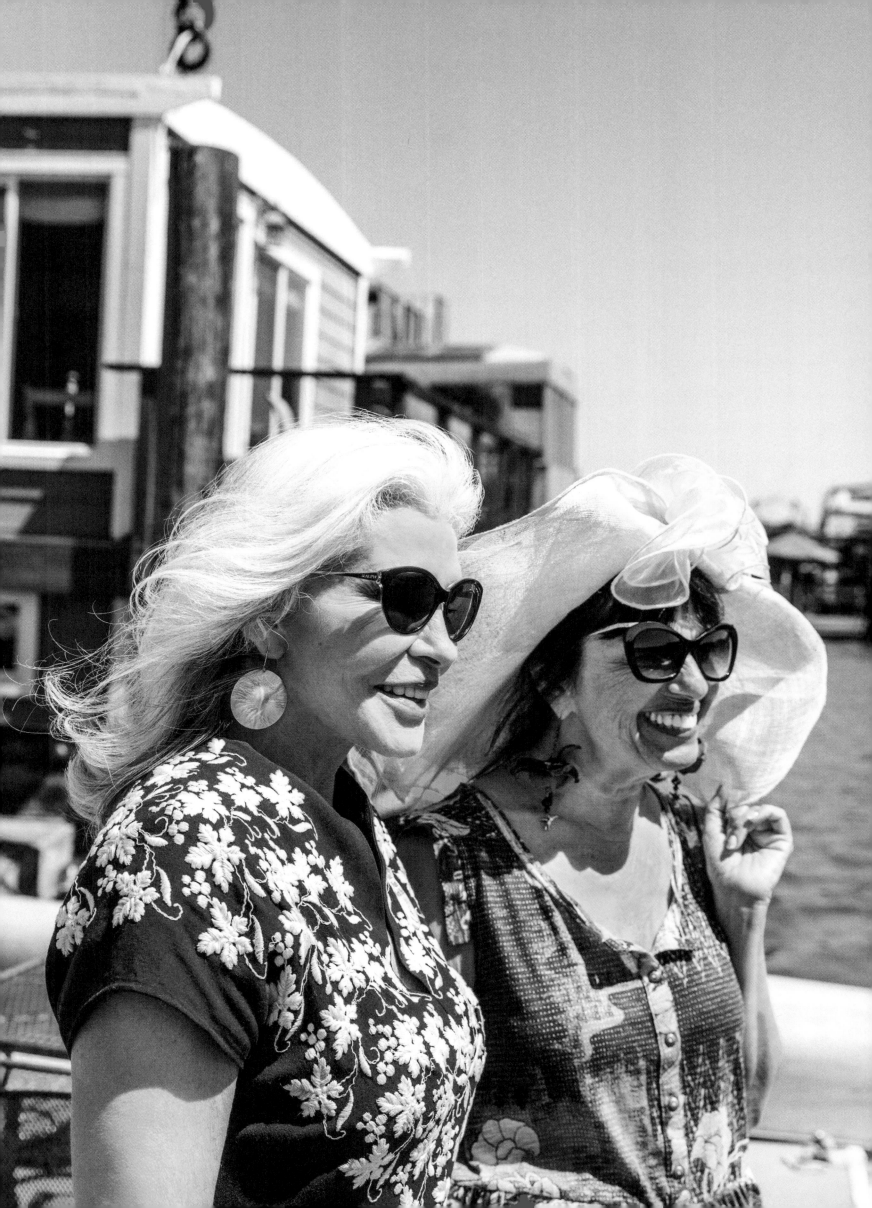

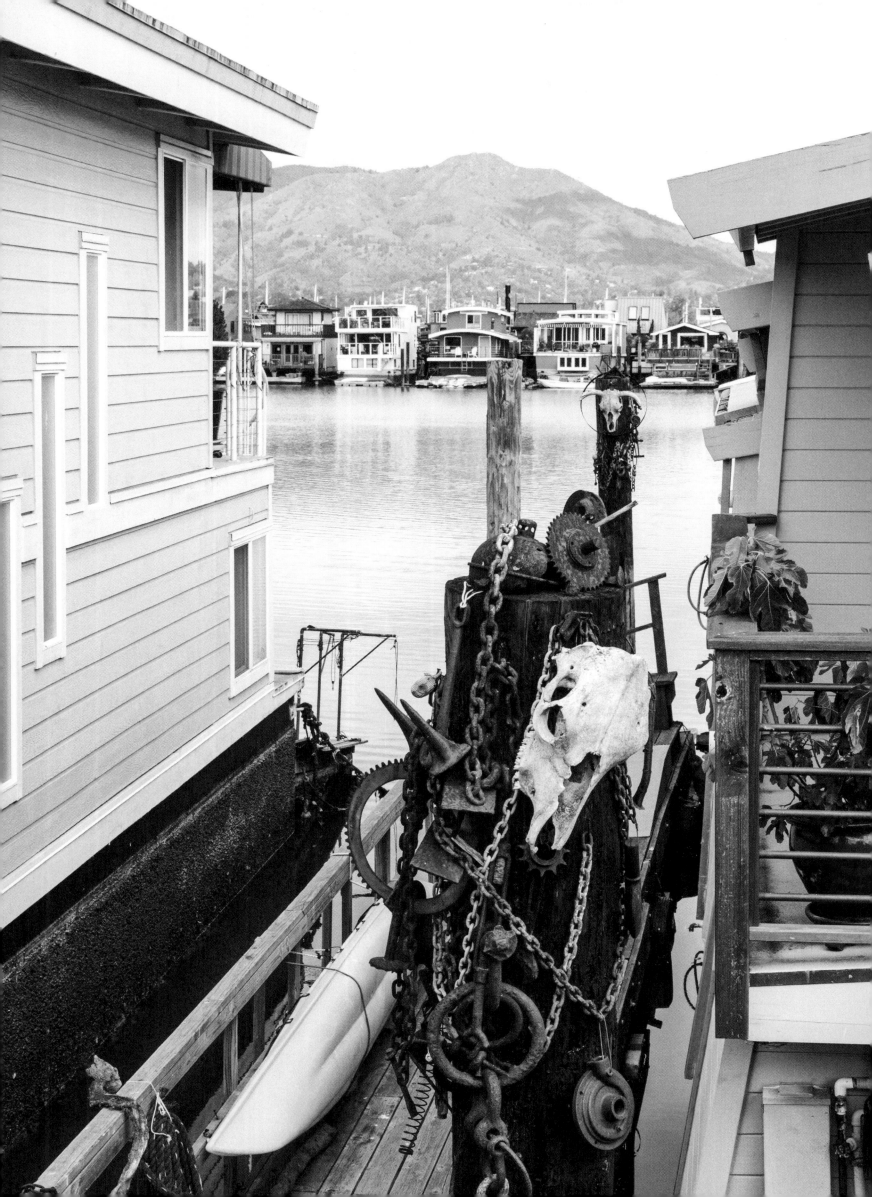

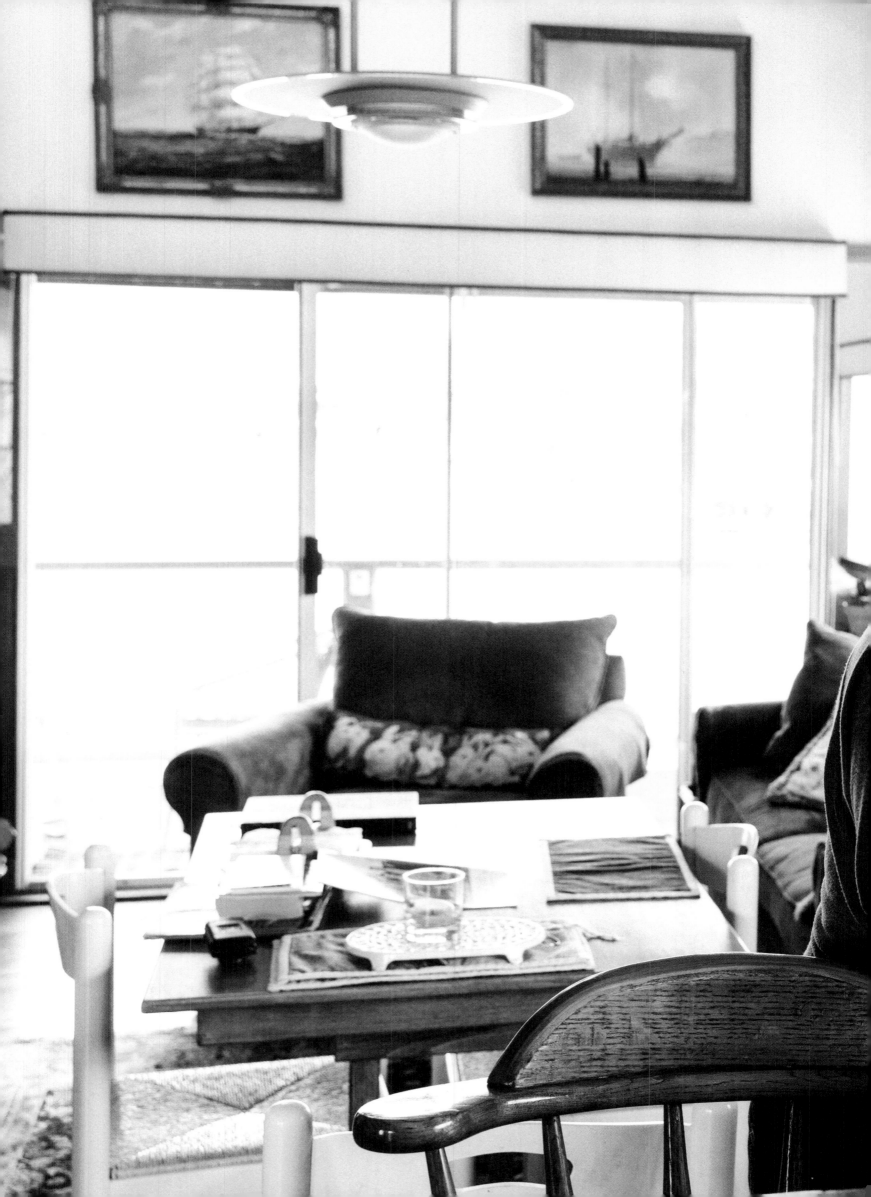

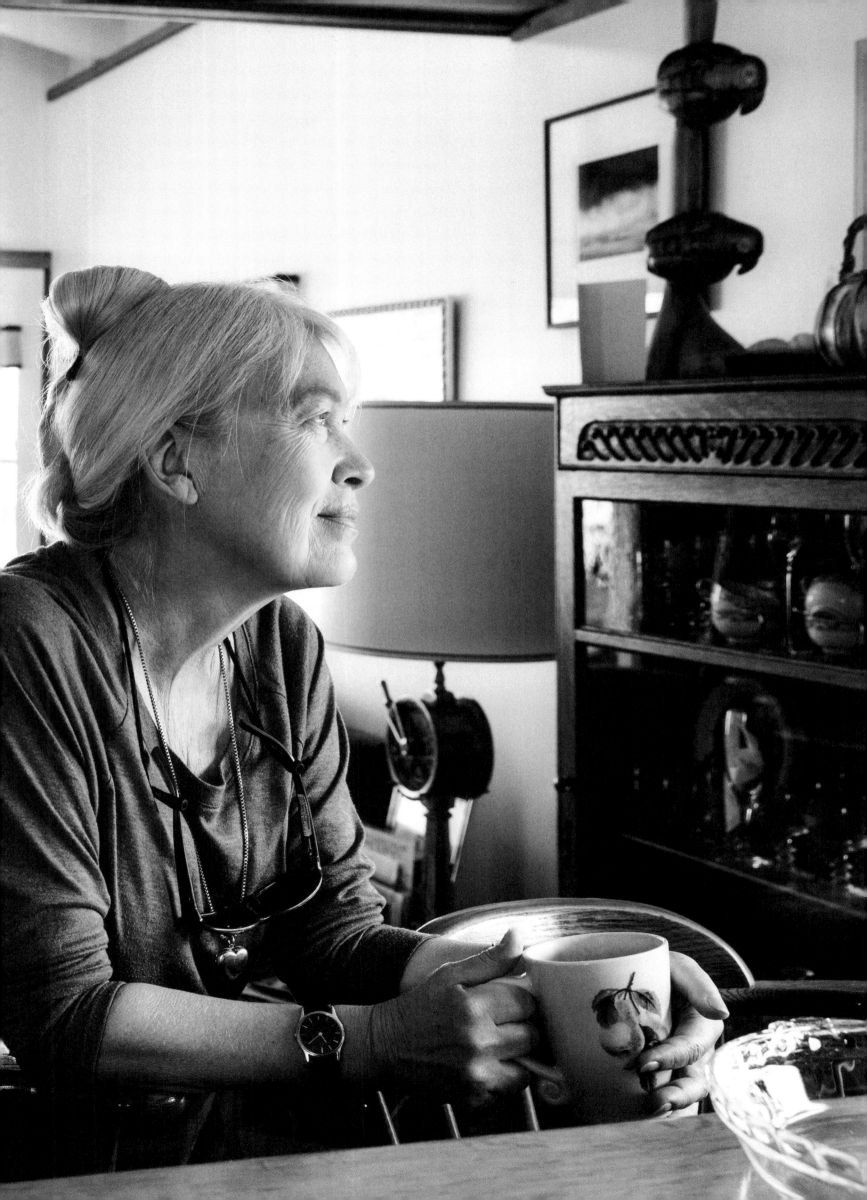

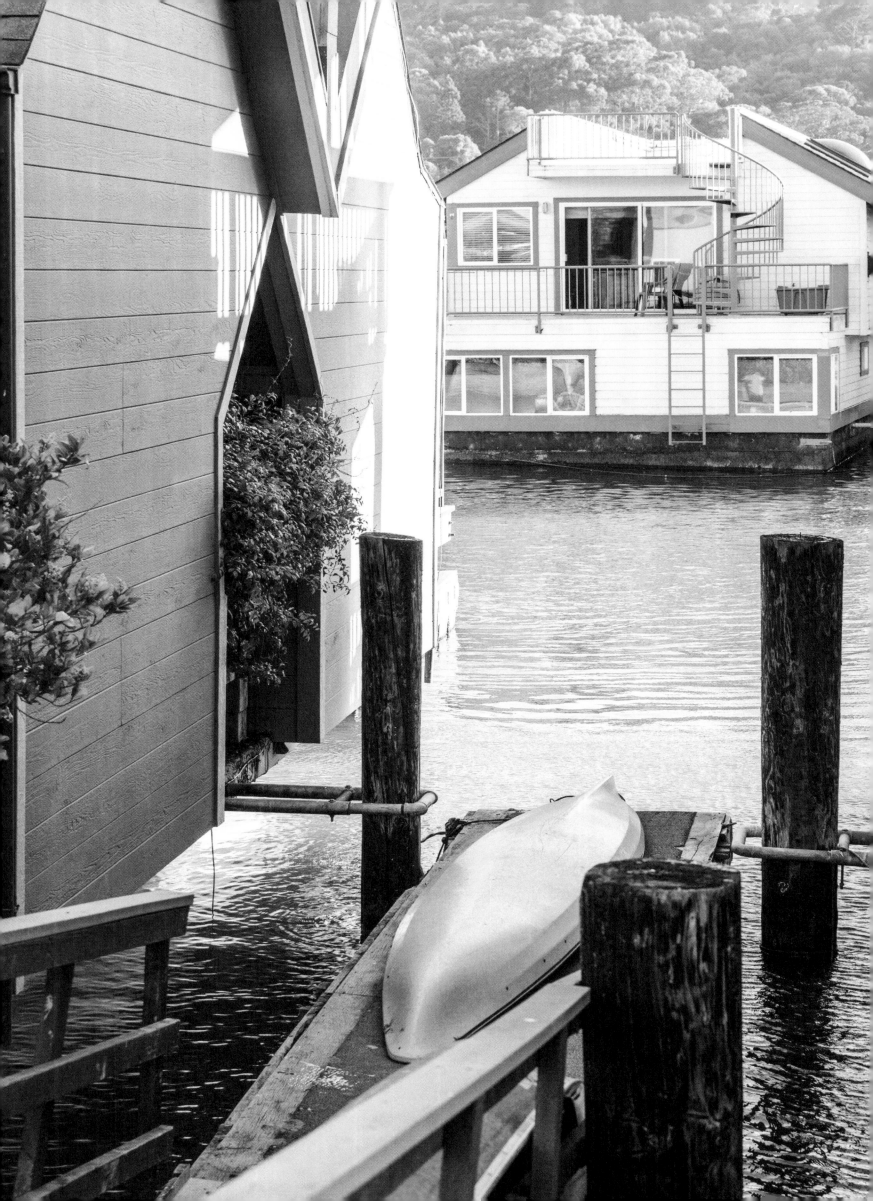

The Days
of Miracle and
Wonder

The shantytown look of Gate Six suggests a world without borders. This could be anywhere on the globe. If you dismiss the hillside houses in the background, the Gates Co-op is just a fleeting, limbo-like existence. It's a congregation of shacks on water, a labyrinth of driftwood and loose ends. You jump from one brittle walkway to the next as if they were pieces of floating ice.

It still has a lot of soul of the laid-back, ramshackle kind.

Yellowish colors cover greying foundations. Windbells make the totem faces grin. The painted flowers on walls tell you these are family homes. Quite a few youngsters hang out for shorter or longer periods. Like Mike from Germany and Ashley from California, who spend time in a friend's candy-colored house waiting for the big surf down in Santa Cruz. Dogs and cats know all the short cuts. Not even the weirdest mind can figure out how all these wires criss-crossing the water's edge might interact.

You would expect accidents, electrocution. You'll get survival on lean budgets.

You get to sit beneath a peace sign and listen to stories about days of miracle and wonder, of wheelin' and dealin'. Yes, there was a lot of that; the days of sassafras and moonshine and green tambourines.

Those who stayed and moored themselves to the communal spirit needed to be or to become self-reliant in most ways. Even now you will run into the janitor types, such as the thin, wrinkly garbage collector who pushes his barrow back and forth across the asphalted parking lot, and the handymen, good at juggling with tools and improvising temporary solutions, like Claus Koestel. He came here in 1972 and helped Joe Tate, the Redlegs and Gaters guitarist, build a sailboat which took them to Costa Rica and Hawaii.

Koestel's home is a platform with several original buildings that shape a sort of camp at the far end of the Co-op, way out in Richardson Bay. If global warming achieves what has been predicted, this would float while the entire waterfront dips underneath. Major

work is under way to raise the vulnerable shoreline area.

Out here, Claus Koestel relaxes on a bench in front of his peacenik shed, squinting at the sun, relating some of his boatbuilding memories. His home is an old military landing vessel. He has inserted a bathroom in its stern, leaving the propeller outside the window. This may look like backwaters, but like Mr Walker, aka The Phantom, he occasionally travels into town like a regular fellow disappearing in its anonymity.

"Sometimes," he confides, "it gets a bit too quiet here."

You would think that a determined city council and an armed constabulary should have an easy ride getting rid of the lawless, codeless, irregular fringe dwellers of the old houseboat community. A lot of them smoked peace pipes and did not want to go to war in distant countries. Instead, they played instruments and painted and engaged in puppet theater shows. There were mean people around as well, admittedly, guys with anti-social minds and habits, but it is both odd and inspiring that a lot of residents persisted through the Houseboat Wars.

The bitter conflict ended with a compromise of sorts. Many home-made houseboats would remain while an increasing number of fancy homes appeared on new docks and piers. The affluence of the town has spread to its backwaters. There is now an abundance of flaunting, well-groomed tubs and pots. Change and interaction: with so many windows facing each other, it is not easy to keep things secret from your neighbors.

The Flapping of
Peacock Wings

It has been just one long, bad contact lens day for Connie Pearlman. Those darn things simply will not fit or stick. Now she's telling her fumbling fingers to stop trying. Outside, on the stretch of hazardous walkways made from assorted planks and masonite sheets, seabirds feed on the gifts from their benefactor. Most people shoo them off, but Connie takes pity on the gulls and keeps them nurtured. They flap their wings and scream for food, expecting more.

"I've always taken care of all sorts of animals, so people began to come and leave them with me. My father was the same, always kind to the little things."

She is one of the veterans here, has lived here since 1979; a Gate Six fixture who for 23 years was anchored out on the bay with her family on a sizable raft.

"We had a farm there with peacocks and rabbits and chickens. We built an ark for the animals. Initially we didn't have a clue. These birds didn't even know how to swim. Some sank so we had to dive in after them. We moved to a dock later on, but to keep all those animals there became impossible."

She was born in Holland and describes her immediate neighborhood, the Co-op, as the armpit of the area. Most residents now are newcomers, a lot younger. Some seem to be just passing through. When something is unfamiliar you need to become watchful; birds may appear grateful, but humans, she emphasizes, can be pure evil.

The powers-that-be will someday transport her boat, according to their master plan, to a pier with more stable walkways.

"What is life gonna bring? In this place you can see the sky everywhere. When we move,

we will be surrounded by other boats. I will be towed to another dock where everybody will be lined up next to each other like a row of teeth. But where else could I live? Perhaps farther up north, with a garden. But what kind of neighbors would I get there?"

It is different down here, especially when looking into the mirror of memories.

"All the guys here were so beautiful when I moved here. They were all good-looking, but I was already married. I've always taken care of people. I've always worked in stores, all kinds of things. But I'm also the expert on useless information. Been that all my life. My mother used to say that you can't eat off a pretty plate. I married two beautiful men, and now I know what she meant."

Connie Pearlman speaks fondly of the old days when people learned a trade and had building skills and knew how to handle electricity.

"When we were anchored out we had solar cells and a phone. We had a family life out there, with two kids. The row boat ran alongside a rope so that the children would be safe. Sometimes fish and crabs would come into our house. But one day the boat broke."

The Man
on The Moon

There is a Beatles poster on the refrigerator and hundreds of wine corks on
the kitchen shelf.

Downstairs: another poster covering his safety box, same guys from Liverpool.

"This is where I keep my drugs and my explosives," says David Spector.

He opens the safe and reveals its content. Two packs of Lucky Strike.

"You never know when they'll take them away from us."

Spector is a houseboat veteran of 22 years, many of them spent collecting stuff without getting rid of it. His boat actually has a very nice layout. The living room is spacious and bright, as is his bedroom. There is a music studio downstairs, beyond the hidden cigarettes, and an upper deck suitable for sunglassed conversations about the meaning of life.

All of this is hard to tell since there is layer upon layer of things a man brings home or receives through the mail without ever sorting anything out. Books and magazines all over the bed, instruments filling up the studio space, everywhere else heaps of everything.

"You'll have to excuse the mess. No woman has been here for a while."

We inspect his stuff. Warren Zevon, who died in 2003, was his latest LP purchase. Not cd but vinyl. On the couch, there are copies of the Electronic Warfare Defense Electronics magazine from 1977 containing information about how one should look after the atom bomb.

There is an explanation. David Spector is an optics engineer and he once worked for the Apollo program. He can show you a certificate with thanks for his assistance when putting a man on the moon, if only he can find it. He lived in Boston then, the place in which he had grown up and dropped out of high school.

"We saw Neil Armstrong on tv everywhere, we were in rapture when it happened."

And that's not all: he has helped a Swedish artist make her inflatable sculpture able to breathe and he recalibrates old synthesizers and rebuilds electric guitars and reconnects amplifiers. You get the feeling he could have sent Jimi Hendrix kissing the sky.

He is in a sort of frenzy now, showing us cameras and film cameras, too, and the entrails of guitar hybrids. He really liked the old Minox, the preferred spy camera in those days. On his roof there is a home-built weather station.

His small company once developed a device for analyzing people's eyesight, which

caught the interest of the US Army.

"They wanted to check if the soldiers in Vietnam were smoking pot, as if they didn't already know that."

Wine glass in his hand, David Spector now sits on his bed. He has an Indiana Jones hat. Old copies of Vanity Far, Life Magazine and The Economist litter the room. The San Francisco Chronicle covers the floor. Raymond Chandler is present. Lots of sci-fi, and technical literature impenetrable to the common man. His eyes are moist, he is changing the subject.

"9/11 was an eye-opener, we didn't realize how much people could hate us. I've traveled in Japan, but there was no hostility toward the US despite the atom bomb."

When he first came to Sausalito, he lived in town, in a house that cracked without a warning. So he came down to the waterfront, to a sprouting community making use of whatever was available. He still looks like the guy with Lucky Strikes in his safety box when he describes the way this has become a new Suburbia with diligent garbage pick-ups and Christmas decorations in the windows and neighbors who complain when dogs are barking.

"But I was lucky. I was just looking for a place to crash. You get home, you have a glass of something, you go out with your kayak."

He has been a well-respected engineer, courted by army consultants and the CIA. Now he has one ambition left:

"Part of my job as a human being is not to kill anyone."

And how would he describe his current state of mind?

"The pain of being a man."

The Coming of
The Gated
Community

B eing a resident real estate agent, Michele Affronte bridges the widening gap between then and now. Sitting in the airy living room of her own Bateau de Rêve houseboat, she also comes with a few predictions.

There's not too many young ones living here any more because they tend to be afraid that their kids are gonna fall into the water. Although we do have some children on each dock, it's mostly people in their 50s and 60s. We're all pretty well traveled. Just about every neighbor has been around the world.

It's become more affluent, but it's still unique. We all mix. The artists that don't earn any money at all will still go to dinner with someone who is a millionaire. It's not like it's segregated here, at all. It's just not.

But I have seen the changes and there used to be a lot more people living for free out in the water, the anchor-outs, but they're gone because either they were old and died or in the storms their boats would crash against the rocks.

It's gonna change because they're doing this parking lot and they're gonna make it more like a gated community. And it's gonna turn into all rich people. I don't know how soon, but it's just the way prices are going up. I think that's where it's gonna end up, unfortunately.

Can you still have a houseboat without being affluent?

Yeah, a lot of people around here are on social security and don't have that much money. They've owned their boats for a long time. But if you're gonna buy a new one now, you will need some decent money.

Myself, I bought here not just because of the beautiful water, but I wanted a lifestyle like this. I came from Venice, California, and before that I grew up in the 1970s as a complete flower child. I went to Grateful Dead shows and had my hair down to my butt. I had the whole thing. I lived on a pot farm up in Garberville at one point in my life! So that's why I came to this community.

How is it different from Venice?

It's similar except the politics. Here, your politics are very, very important. Everyone talks politics and people really base their friendships a lot on that, whereas in LA people don't talk politics nearly as much. You just come up here and it happens to you. Living here, you become very political.

Which issues do people get involved in?

Janine is a little bit radical, she gets herself arrested all the time, like when she tried to handcuff and make a citizen's arrest of Karl Rove, the former Bush aide! When the war in Iraq started we all took to the streets. I went to every single anti-war rally in San Francisco and most of my neighbors did, too. We believe in peace and we don't want war. We don't want conservatives running our country. In LA it's not such a big deal. People there don't dwell on it so much.

But now you may have a gated community here in the future?

It is sad, but you know a lot of us from the 60s and 70s won't be around any more. That's the thing. And to reinvent that group... we were who we were. So I think this is what's gonna happen unless some new group of people come about because of some disaster that happens in the world. We came about because of the Vietnam war. When we're gone there'll be something else, and we'll be the history.

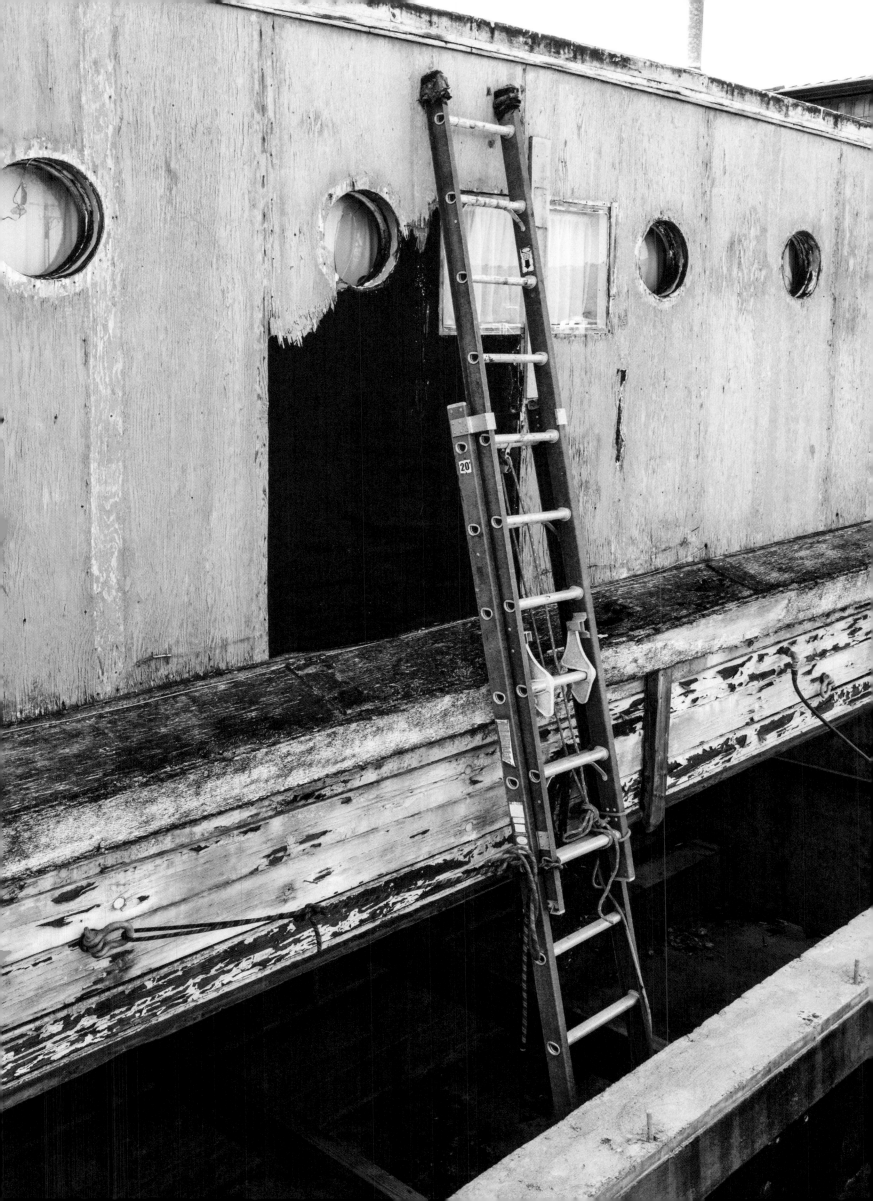

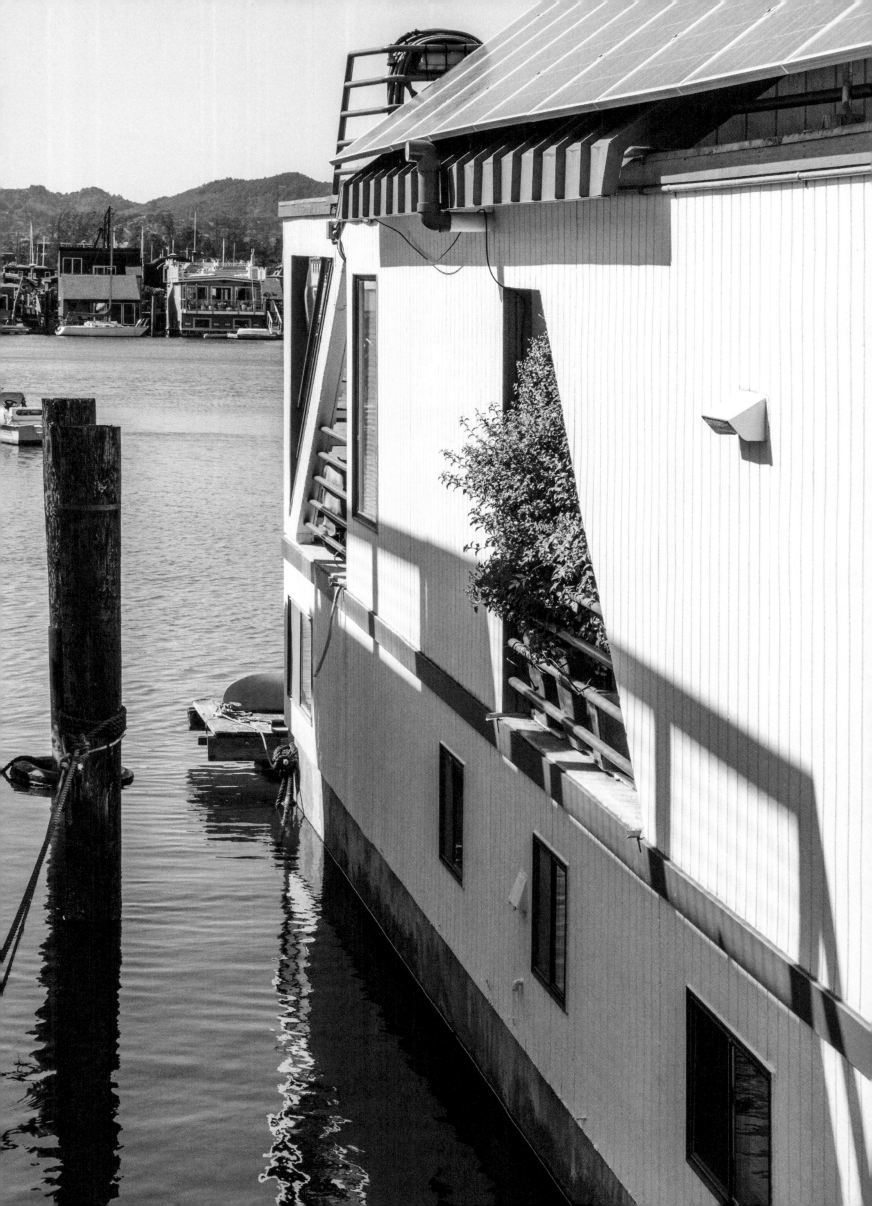

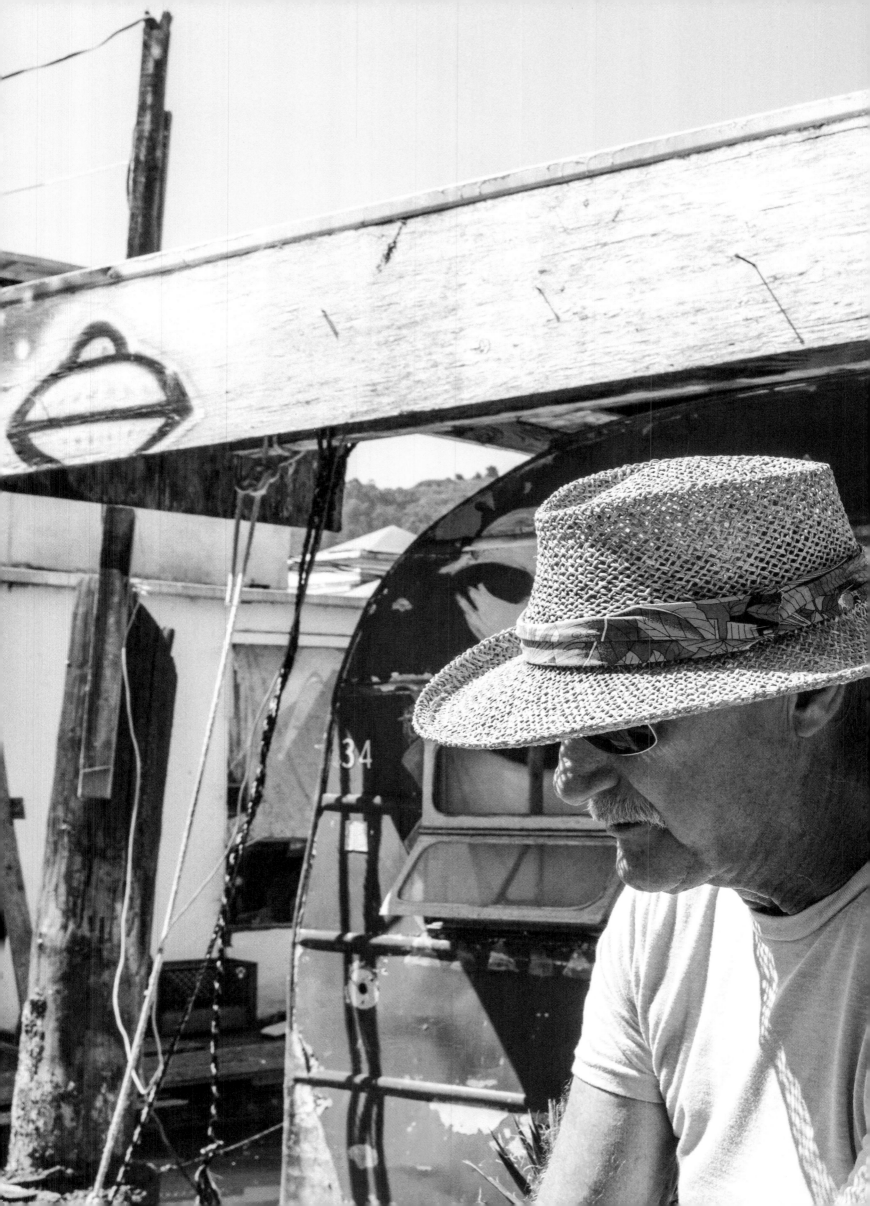

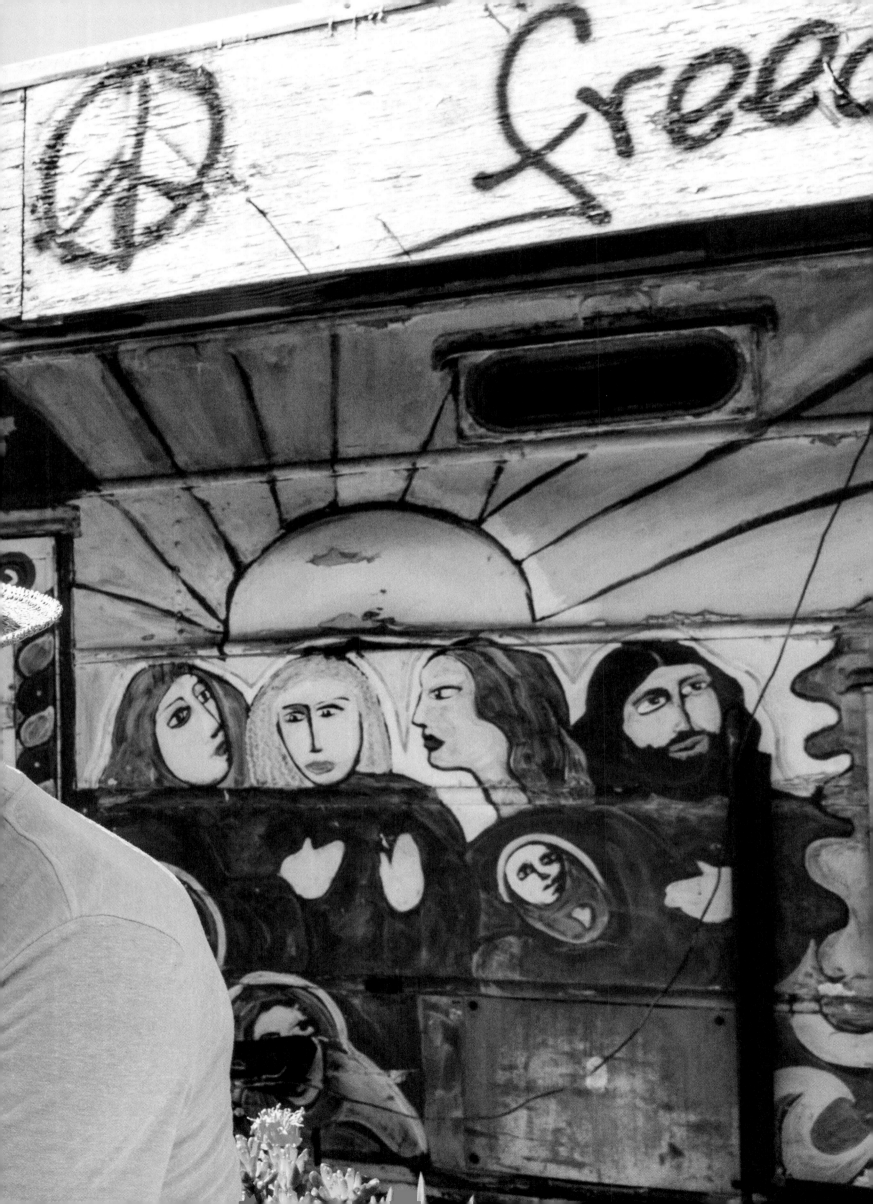

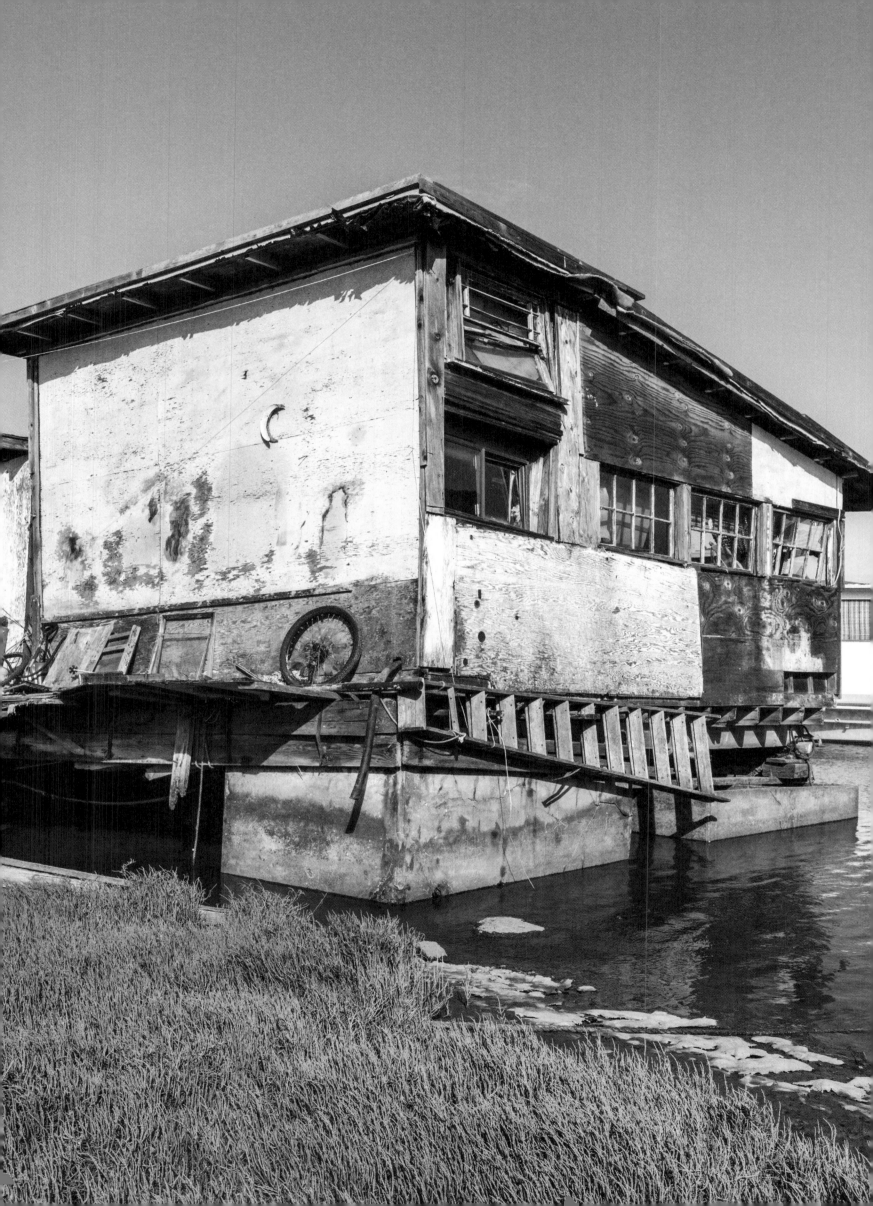

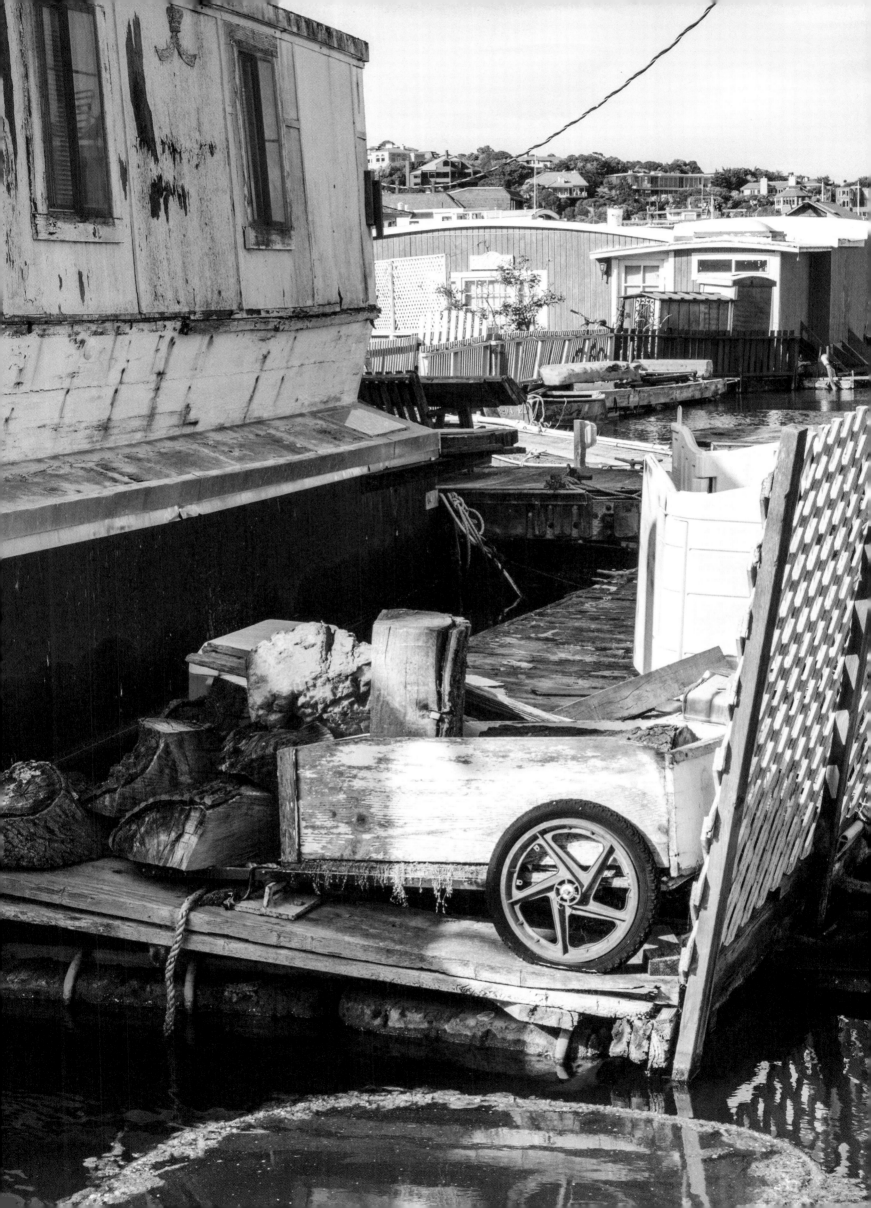

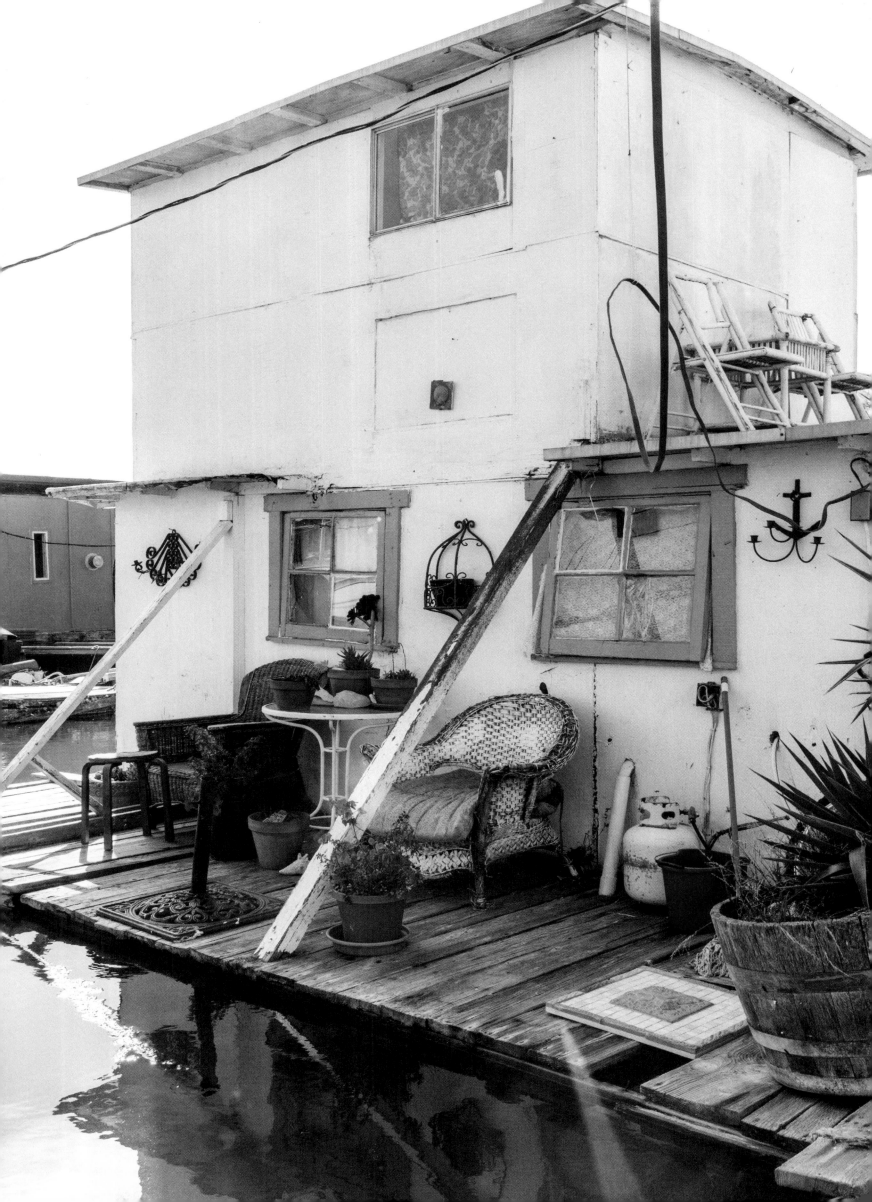

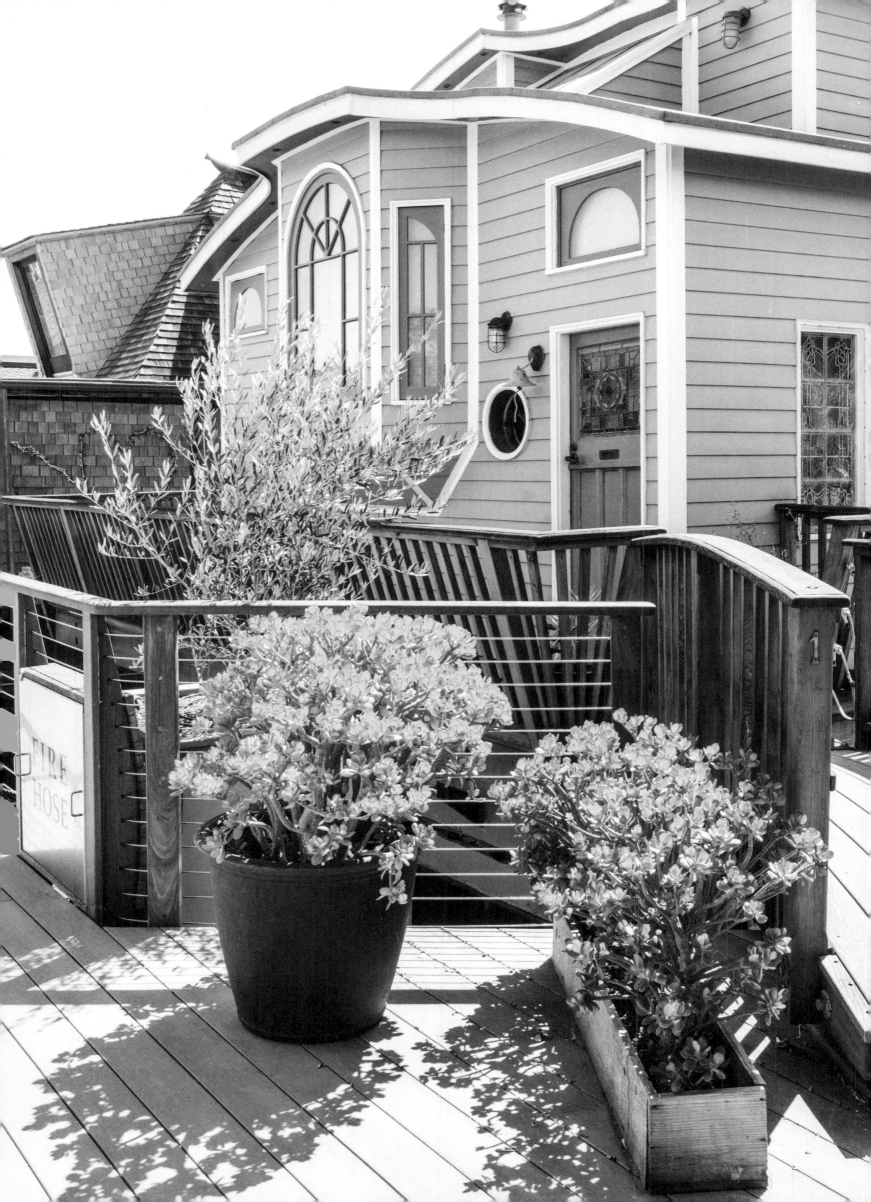

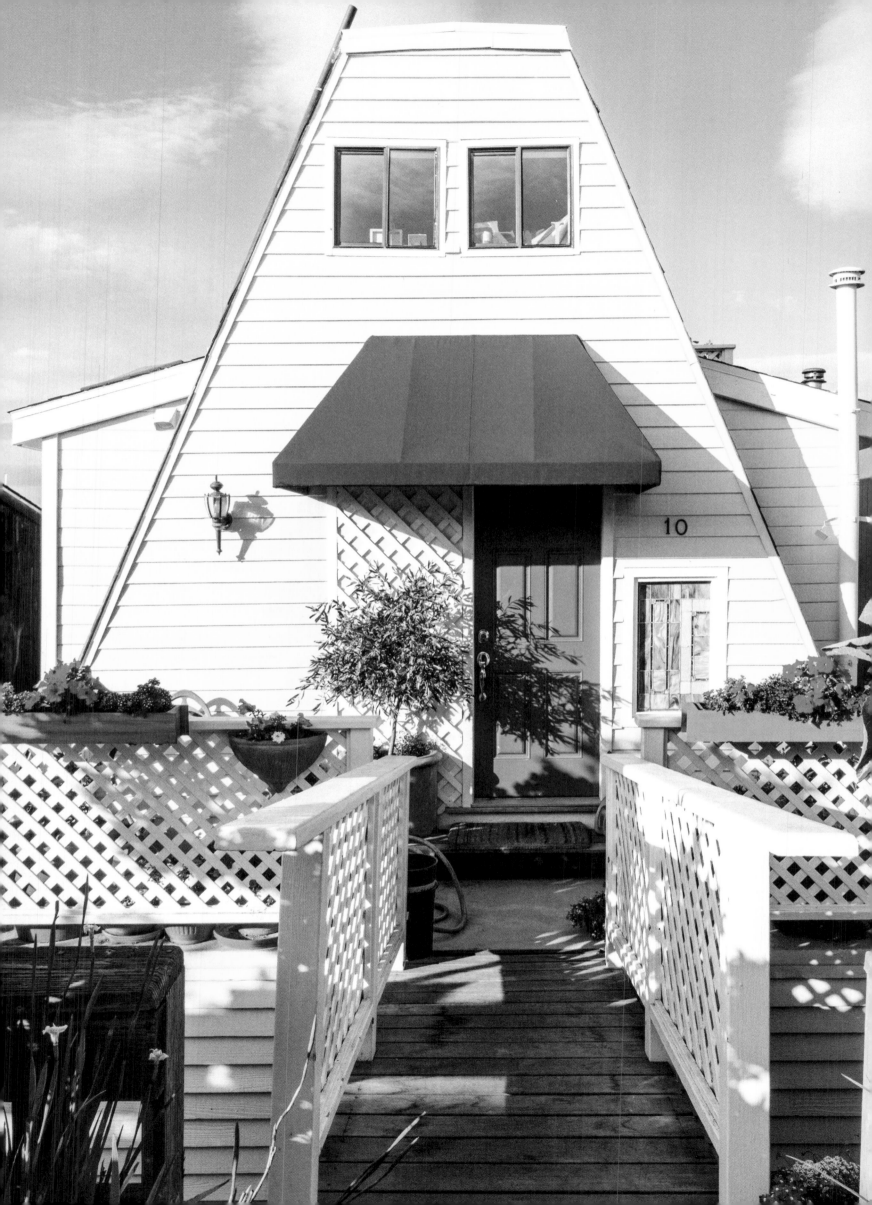

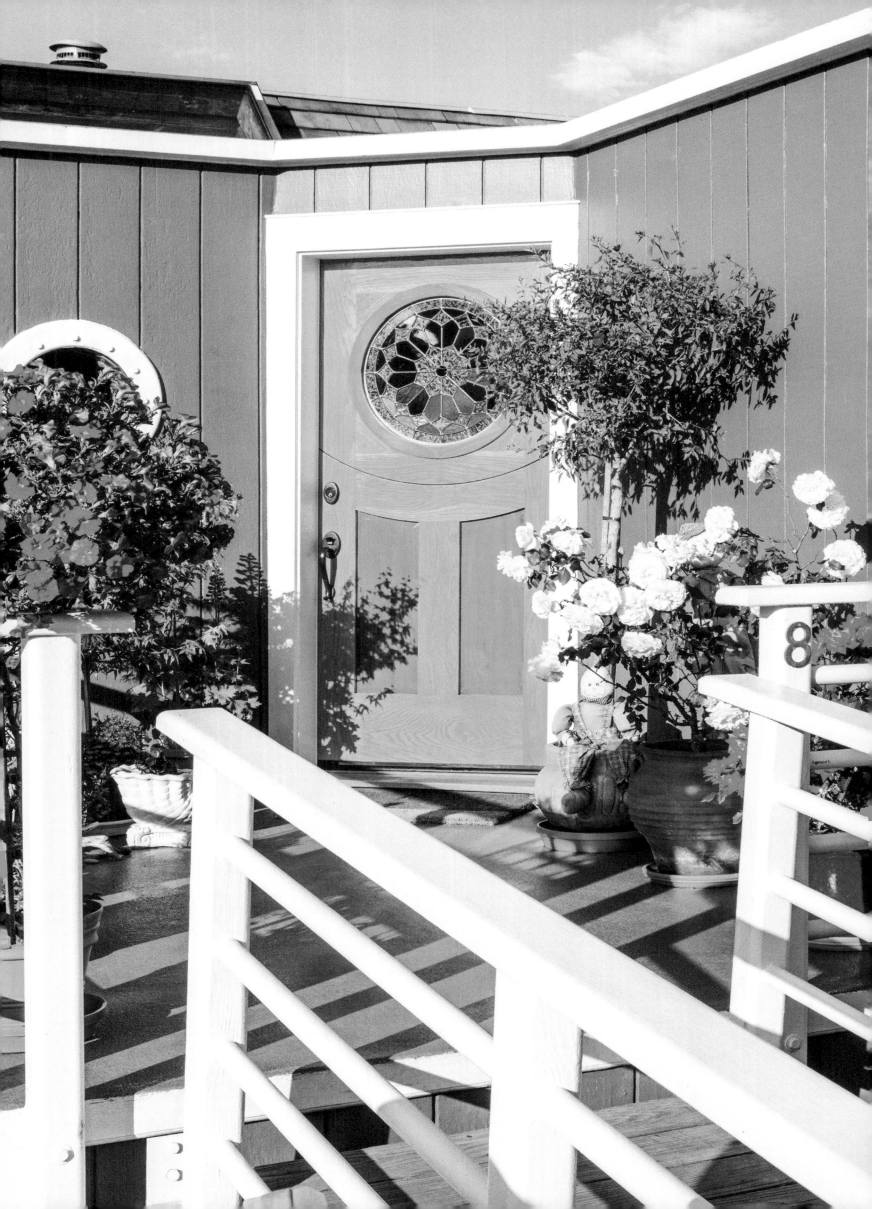

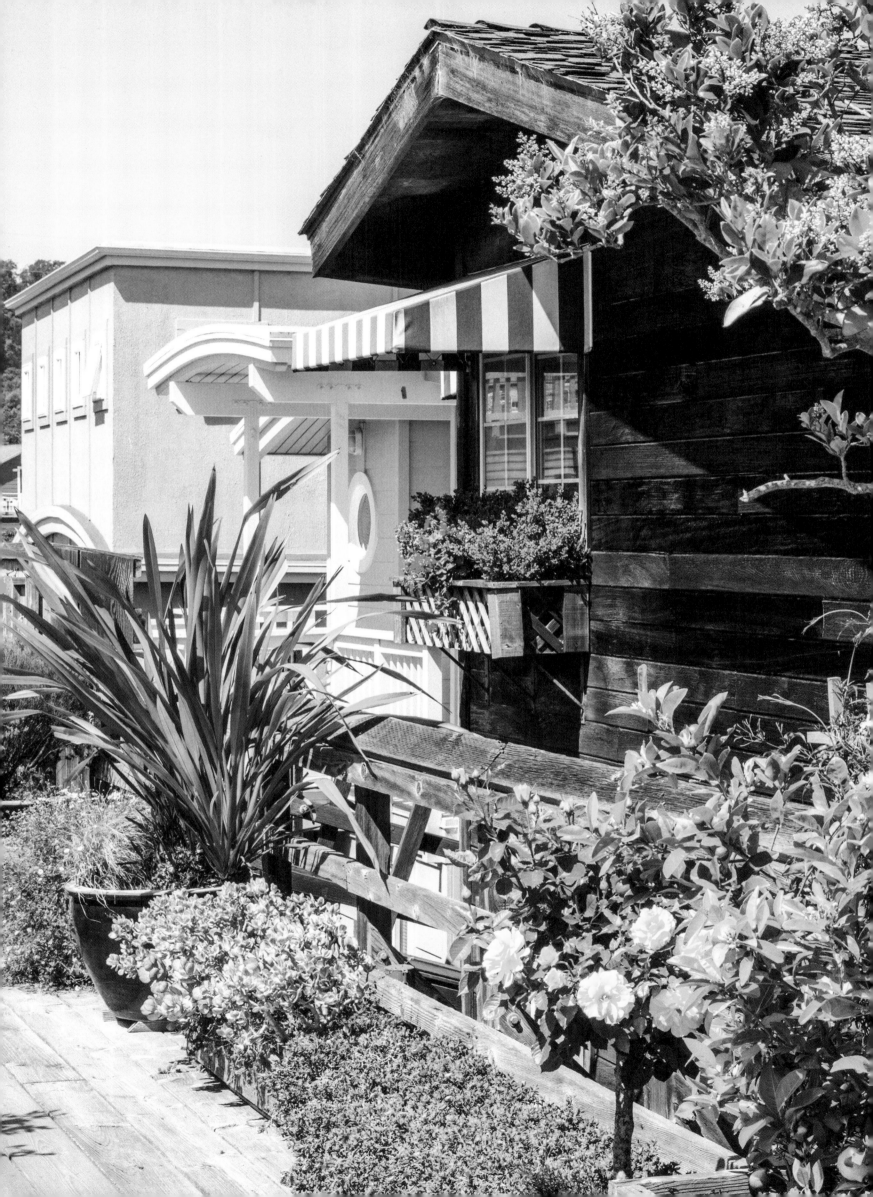

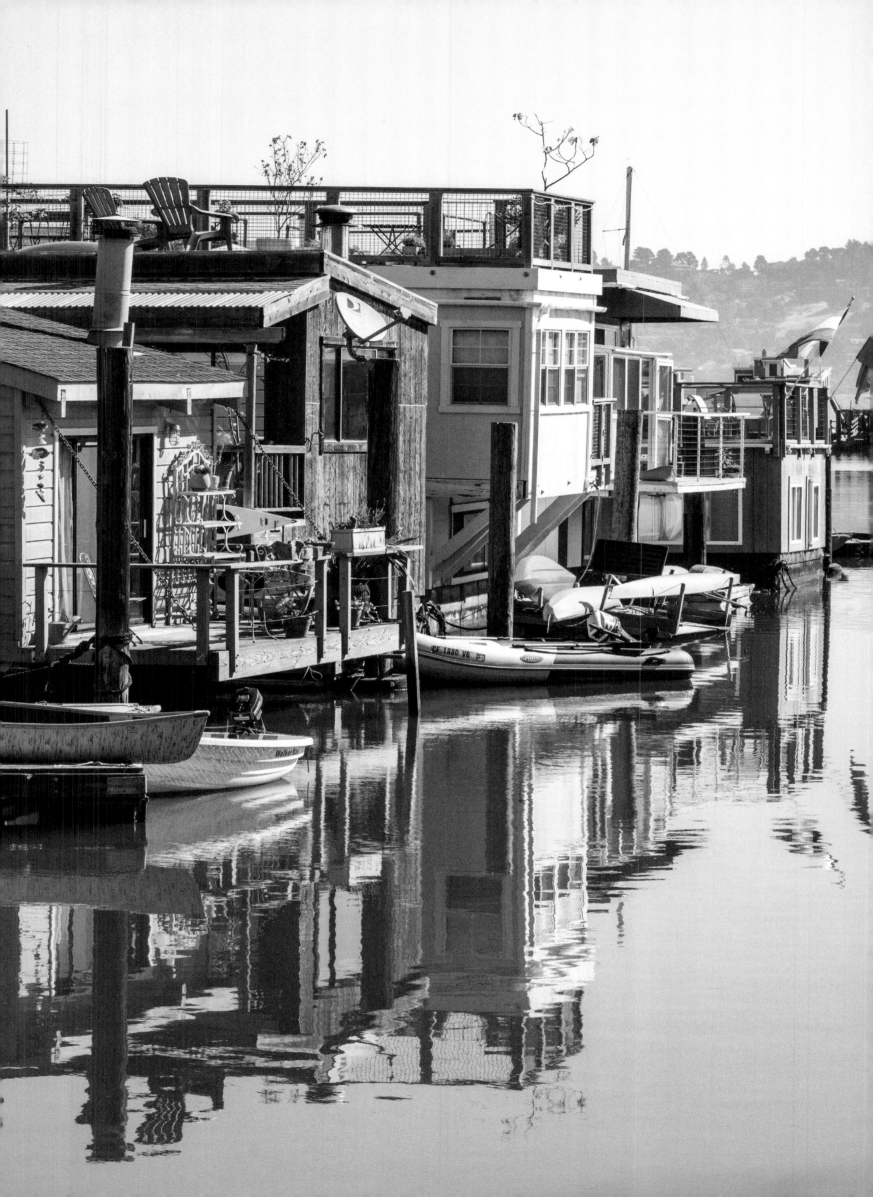

The Days of Astrology and Radicalism

She is in a black Code Pink t-shirt this morning, Janine Boneparth, as she rushes off to make her contribution toward a greener and less violent world. Her involvement has taken her to multiple places, to Kenya, to Canada, to fracking faults and picket lines and press conferences. Now, she bends over to pick up her first piece of plastic refuse for the day.

Soon we will meet one of Boneparth's predecessors in this peculiar world of maritime resistance and alternative arguments. The number of stories about Penny and Michael Woodstock knows no end. Dope seems to be a recurring topic. Acid made everything supernatural. People may have rejected capitalism, but they urgently needed money, all the time. The whole neighborhood was once described as a turned-on navy. However, Michael Woodstock was a man with a wandering mind.

"He was our shaman," says Larry Moyer.

That meant a combination of astrology and radicalism. During the Chicago Eight trial in the fall of 1969, when a group of well-known antiwar activists were charged with inciting violence during the Democratic National Convention the previous year, Abbie Hoffman famously tried to explain that he came from Woodstock Nation. When the judge, incidentally named Julius Hoffman, asked in what state that might be, the reply came fast as a whiplash: "It's a state of mind".

Michael Haas listened and picked a new last name for himself. When you look at photos of him he has long hair and beads. He looks familiar. That's what quite a lot of people looked like when everyone was young and turned to San Francisco for fresh ideas and new sounds.

Being part of a houseboat community makes for a certain lifestyle with both individualistic and collective streaks. It is a kind of living that needs to be nurtured and maintained. Penny Woodstock, who moved here with Michael in 1971, remembers how the tide in those days used to flush into the living room of The Starship, their family home full of red paint, psychedelic stature, and bookish overcrowding.

I'm English, I got married in London and our honeymoon was coming to America. I married an American. It was the late 60s, the best of times. I met Michael in 1969. That was the best year for music! I remember when the Stones played in Hyde Park. We moved to Oakland and came here to look at the mountains. Of course, everyone was

hitchhiking then and we got dropped off right there on the highway. My husband saw the ferryboat, The Charles Van Damme, this huge, beautiful ferrryboat, and said that this place looked interesting.

Michael was a big man who was a prophet. He used to prophesize everywhere. He pro-phesized about everything. Everything but religion. And we found a houseboat right here. A small one. That was the first boat we had. The Starship is the second.

When we first came here all of them living here looked like pirates! We didn't know anyone. They were scary. There was a big gang out where the parking lot is now.

We were hippies. They were mostly waterfront people. A different breed. They had boats, they ate different food. They didn't have long hair particularly, unless they wanted to.

How did they make a living?

Fishing mostly. There was a huge flea market across the road. That's how they made a living, buying and selling. Then I opened a shop on the Gate Five road, and that got really big and I employed half of the women here. It was called Waldo Works. It got pretty famous, people are still crying about it. Everybody had a booth in it, it was like an indoor market. I ran the place. I put the money in the bank. Well, that was a good thing.

You must have liked it here, despite the pirates?

Oh yeah. As soon as we got here - this is where we're gonna live. And I'm still here.

What have you enjoyed through the years?

All the babies. All of a sudden everyone that was here started having babies. We had a baby boom. There were twenty babies. They all keep in touch. It made it a lot different. The women were at home. We had a big nursery out there and then we had gardens.

See, everybody had to have a nice enough home to live in. People would come here with

nothing and then build a house. It was possible in those days. There were no inspectors coming. This house has never been inspected. Now I have to keep it up to code, and so has everyone.

Then, this was like the frontier. It was the last place you could build your own home, you know. I had four children. Aliss ran around with all the gang kids and they would run up and down the docks barefoot.

And she still lives here.
I know, she won't go away! She's forty, you know. It's time to get married and settled down!

How did this boat, The Starship, get its name?
It's from Jefferson Starship.

Were they around?
Oh yeah, lots of rock'n'roll people. They've been here. One of them lived in a house right there. A lot of famous people, I just don't remember their names. I've lived somewhere else, too, in the Dredge downtown. It was a huge place. We were there for four years and then my husband died, got murdered in Acapulco in 1986, so I had to move back here. I couldn't live out on the Dredge with three kids and him gone. That was too much. Been here ever since.

When we returned to The Starship our house was wrecked. It had a thousand beer cans in it. And all the electrical stuff... We had to start all over again with this place.

I had to get twenty men when we cemented it. That was a trip. They pushed this giant boat into the bay, and then it floated back to our spot here.

Did you build the ship yourself?
Yeah, most of it. It's why it's so funky. I keep trying to make it better and better. But now

they're gonna come in and rebuild the whole thing. There's a foundation that has promised us the money a long time ago and now they're gonna do it.

What will happen to you?

We're not gonna change. Too old to change. I'm gonna move to another dock, but I'm not gonna change.

What is it about this place that makes it different?

Memories, probably. All the fun we've had, all the parties. The children growing up. There's lots of things.

It's also a lifestyle that is not middle-of-the-road.

I know, and I look at people out there and they seem different than we are here. People are fascinated by this place. The big ferryboat over there used to hide us from the real world. All the anchor-outs in the bay were connected. A bunch of people still live there.

Now we have to be nice to the tourists. Sometimes you have to stop them, 'cause when a Japanese bus arrives twenty-five people get off and they're all starting to walk this way and you need to have the docks fixed. You don't want anyone falling over and breaking their legs.

What do you think about the waterfront development that is going on?

You can't stop it. We tried during the wars. Every time they bring in more mud I complain on Facebook! But nobody cares. Not any more. It's inevitable. I'm just glad to be alive to be still in it. I've still got my row boat over there, I've got three boats.

Inside, The Starship also looks like a boat.

It is a boat. I bought it like that. The water is why I like it. I don't think I could live without the water. I used to be at the end where I had the whole bay. Now it's crowded, so I'm actually glad to move to a new dock over here. I will have a really good spot.

The Rabbits and Children of Wonderland

The daughter of Penny and Michael Woodstock, Alissandre Haas is usually referred to as Aliss (as in Alice in Wonderland, as in Alice in Jefferson Airplane's "White Rabbit"). She occupies an unassuming houseboat next to her Mum. The Santa Maria is painted in white and blue like a Greek island cottage and there is something a little unstable about its position dipping into the water. The inside is tidy with the occasional Moby Grape poster on the wall.

I remember things from when I was two or three years old, because they were so incredible. Pretty amazing. If you lived on the Dredge, that'd be legendary on your mind. It's not there any more. We used to have to get to school in the morning so we would jump off the barge onto these pilings just lying on the sides, in the water, and we would have to kind of walk on these pilings all the way to this little island. It had to be low tide to go that way to get to school 'cause you'd cross through an area that's normally covered in water. Our cats used to take off for days, but they also had to use the same technique at the time of the tide to go catch mice in the park or whatever.

We were there until I was around five, my older sister was eight when we came back to Gate Six.

I also remember being a little girl and there was this little room up there and I would sit and watch the tide roll in through our Starship living room. Imagine this whole room filled with the bay! That's when we cemented the whole thing, and we lived in someone else's house for two months so I got to stay in this nice houseboat with all these toys. All their toys were for boys so we learned about dinosaurs and G.I. Joe. Lots of scientific stuff. I learned about bugs and all kinds of boys stuff.

You must have enjoyed life here since you've chosen to stay?

Yeah. That's my barge there, right behind you. That's gonna be my new home. I'm gonna build a brand new house. I was gonna call it Hotel California, but then I found out it actually means something else. I thought the name was cool, like in the song, but it turns out it's some hardcore insane asylum. You can check out, but you can never leave. I just found out.

You would love my birth certificate, because it says "Place of birth: Starship". I met Grace Slick once. I worked in the store and she came in with her credit card. We've seen Starship play a lot. And you know I'm Alice. Well, I'm Alissandre, but all my life I was Aliss, as a child, and of course I have photos of me with white rabbits.

There were a lot of kids here at the time. Like a pack. We all ran wild. We'd always swim. Our Dad used to make us go swimming off the back of the Dredge. I have some amazing memories of

swimming naked in the bay. When the herring swam by we just threw a net out.

Now, every day I go on the ferry to my job in the city. We enjoy lattes in the morning and have our beers in the afternoon. We work hard all day. I work at a design center in the city, designing tiles. Ceramics.

The drummer in Metallica lives in Marin. I've sold him beddings and tile. Right now I'm doing the bathroom for one of the Green Day guys. They live in Mill Valley. It's all striped. It's gonna be cool. See this floor here? I was painting it last summer. Turquoise. Spray paint. My Mum wanted a green, but I said no, I wanted it cool.

When you grow up like this it makes you even more appreciative about things. Other people may grow up with a lot of money and they may have every opportunity and they don't do anything. When you grow up like this, and you have the tide in your living room...

My boat is old, it was sinking on the corner. How much did I pay to get someone to fix it? He did a really good job. Sixty dollars for three hours. He lifted my boat about three inches in that corner and the hot water heater was falling through and he stabilized the whole thing. The guy I hired was kind of an expert 'cause he grew up here, too. He can fix any crazy situation properly.

We had a tsunami come once. The water rose three feet in what looked like a minute, and then down again. Imagine. I was sitting there riding the tsunami. It was pretty wild. We didn't know what was gonna come, but we wanted to watch it rolling in. It was the one from Japan. There's a lot of new sealife living here now. All kinds of new creatures came, all from the bay. A lot of it is still here.

I've tried to escape a few times, but now I've bought that barge for $20,000, with my own money, and I'll have to do something with it. It's a good price. You can create something amazing with that, your exact dream home.

I love it here in the spring and the summer and the fall. Winter? Awful. I've endured some pretty hardcore winters. The boats always leak. It's cold, thank you. It's depressing in the winter. And when the storms hit, we live it. We ride the storms. Sometimes we wrap ourselves in our blankets and it's so cold you can see our breath. But then spring arrives.

The Most Beautiful Day in The Universe

The woman in the wide, fluffy hat with breezy feathers sits herself down at the out door café table.

"How's it going?" asks one of her friends, already sipping a drink.

"Oh," she replies, "it's just another beautiful day in the universe."

We look around, and it is. It surely is.

Here's the wind, the sails, the sun. If you lean into the blue shades of water and sky and woody mountain ridges you will be absorbed by the natural beauty of it all. "Watching the ships roll in, and then I watch 'em roll away again." In the morning, you'll head up to Fred's Place once more to chat with the Chinese and the Mexicans and the regulars with their regular news.

Sausalito is one place where time halts; there really is no need to rush.

And yet things do change, and stories of vanishing breeds abound. They refer to tribal groups, endangered species of animals, occupations, traditions, free spirits, communities based on certain values and ideas. In a culture, where individualism routinely translates into consumerist conformism, a nagging question comes up: could we do it differently?

It has become easier to navigate, but somehow more difficult to find anything of real substance. Could there still be space left on the fringes?

The Sausalito houseboat community was certainly different and in some ways it remains an enclave where individuals can do their thing. The economy of the place has changed significantly, though. The times are no longer the same, they never are, and development is a word with many implications. But it is pretty obvious that this is yet another perfectly beautiful day in the universe of Sausalito.

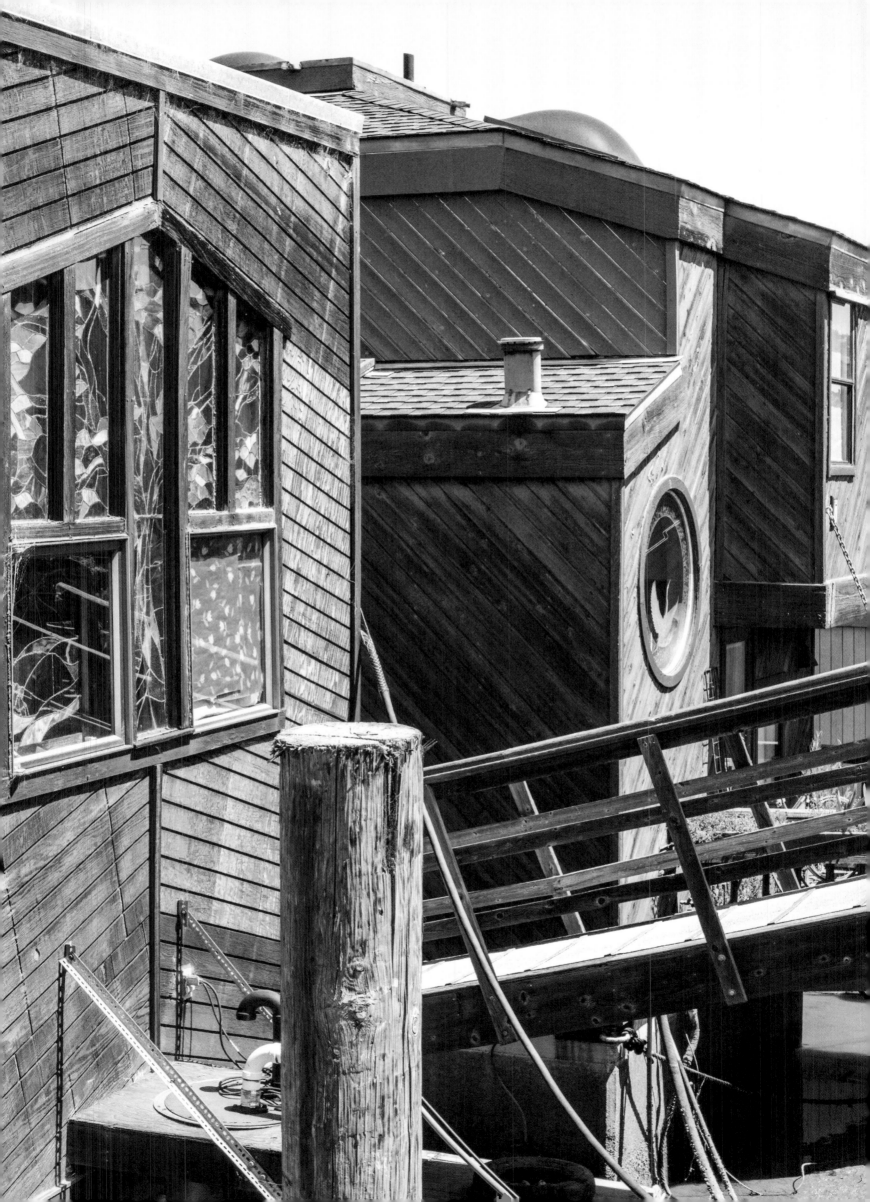

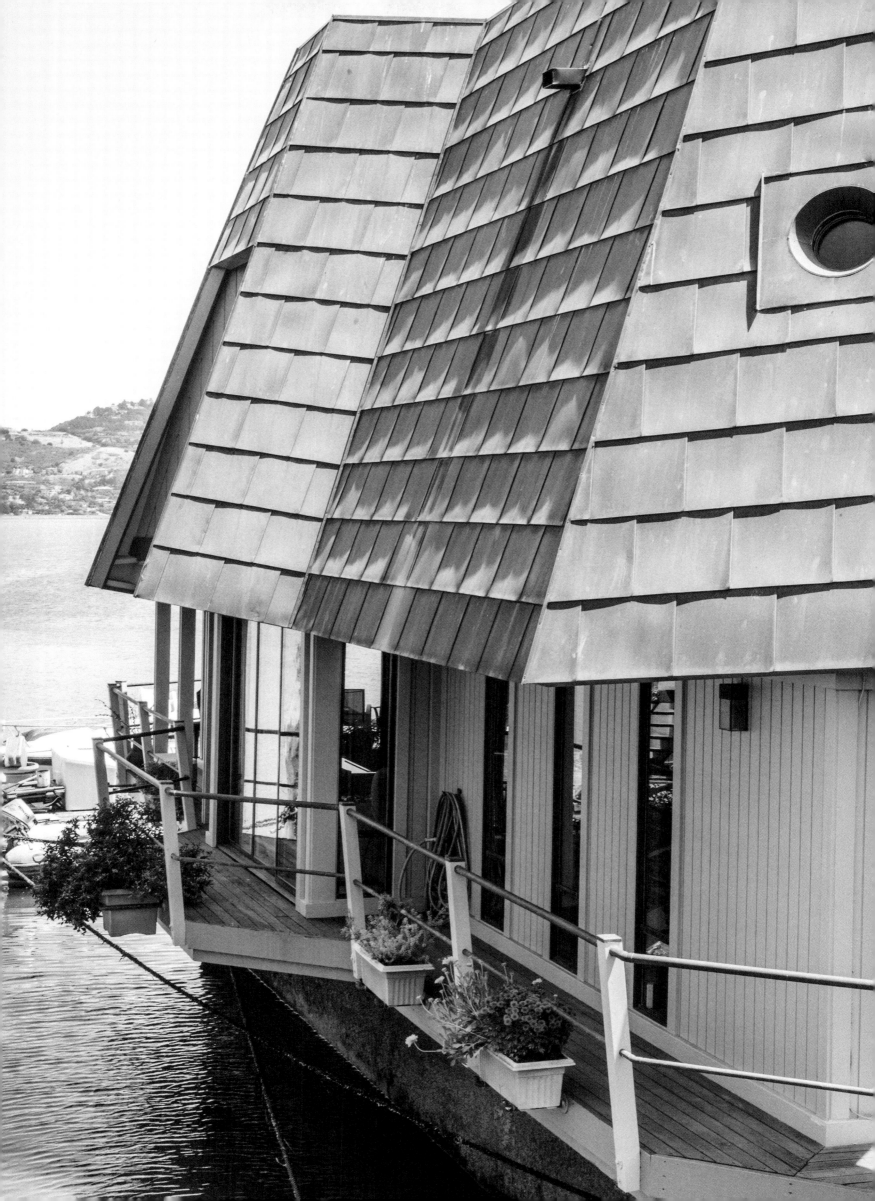

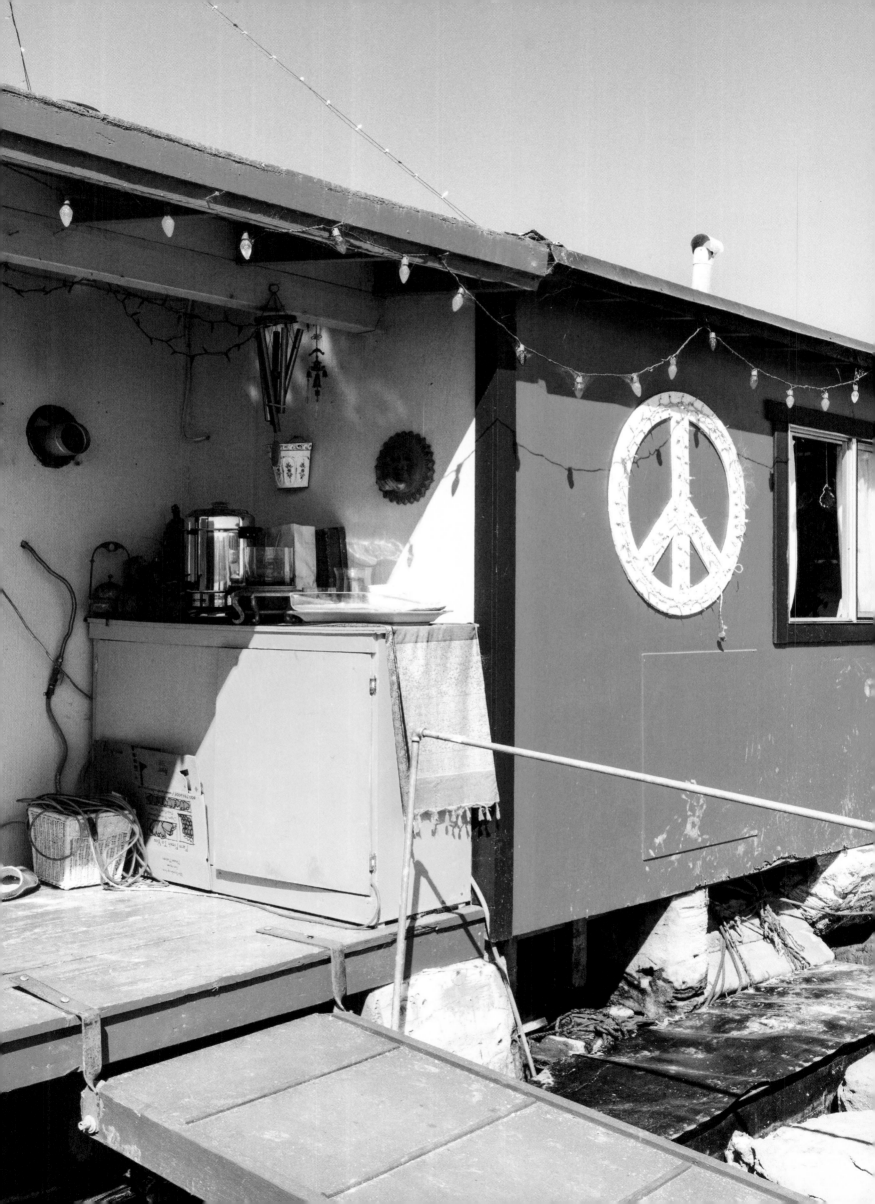

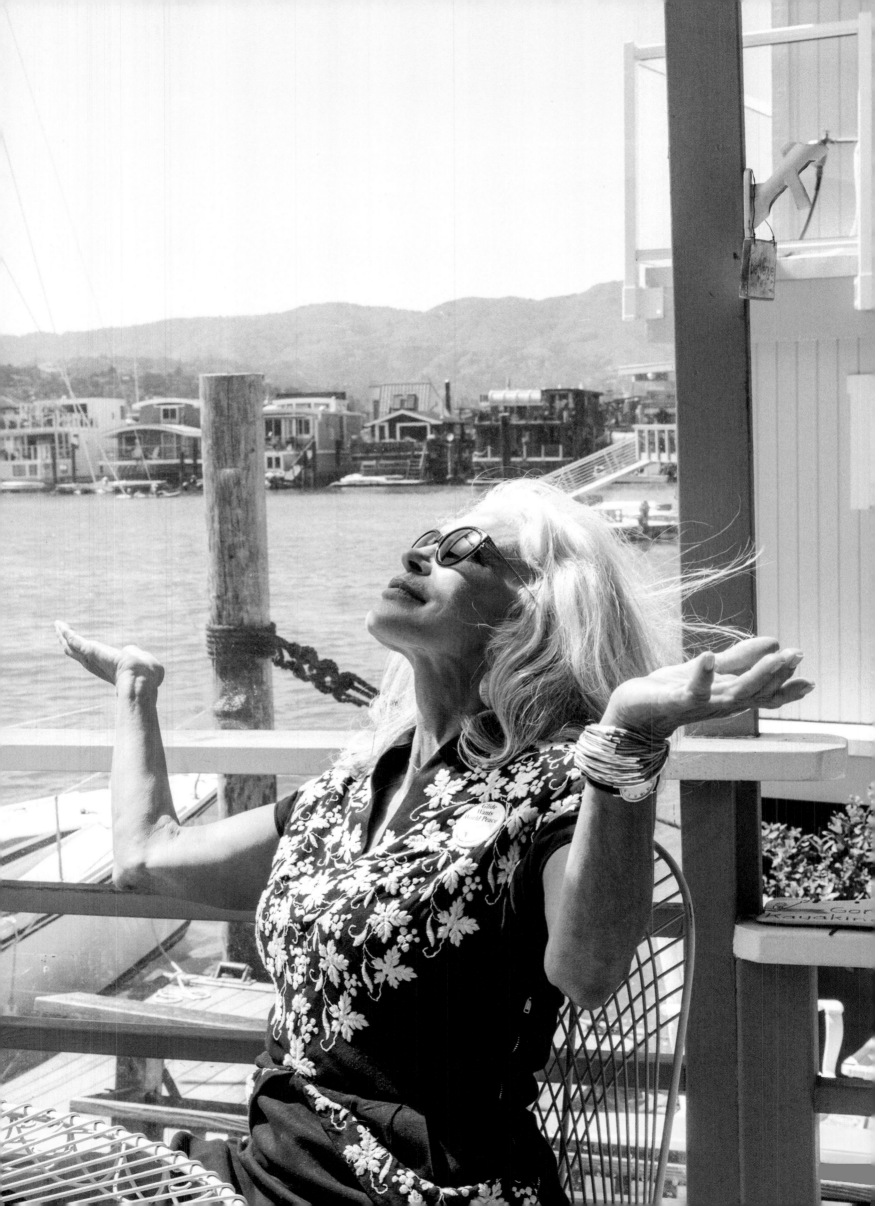

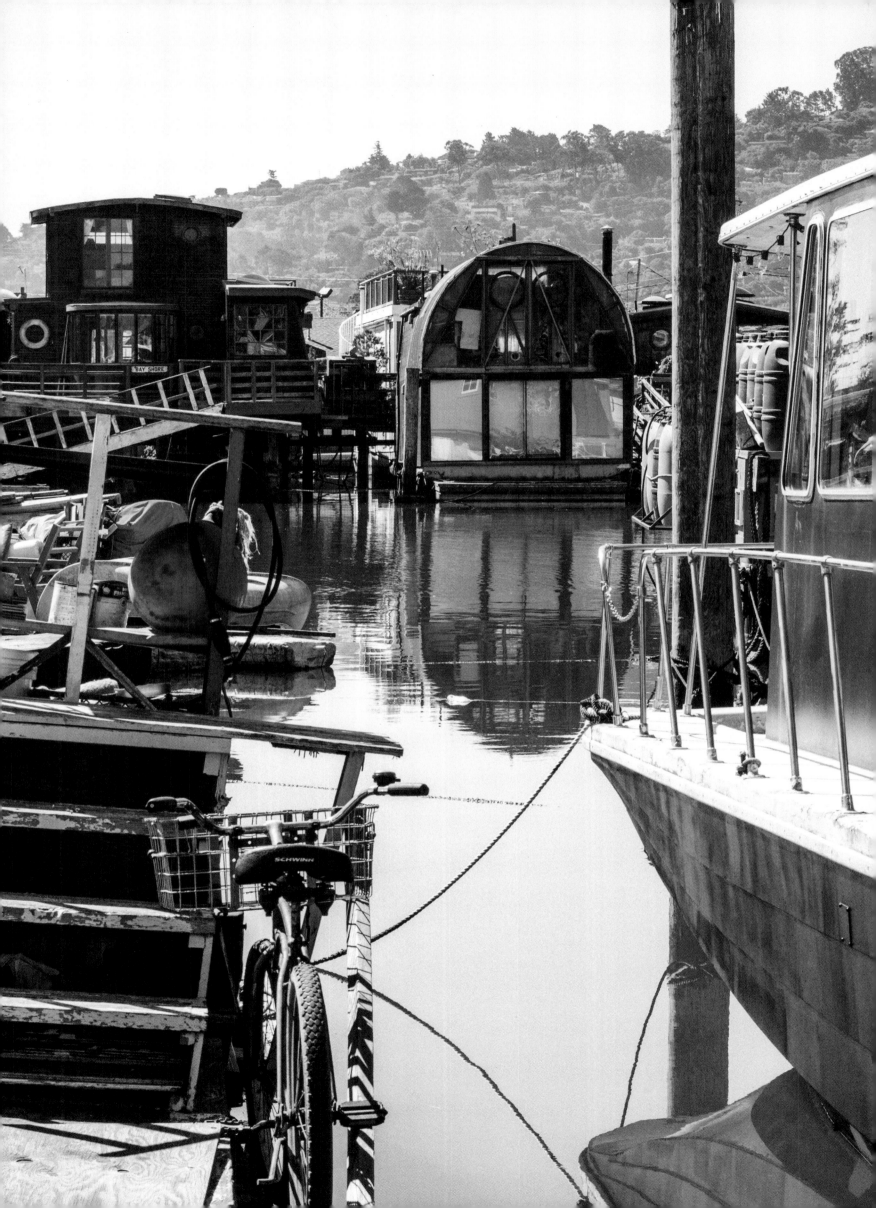

K

Published by:
Kerber Verlag, Bielefeld
Windelsbleicher Str. 166-170
33659 Bielefeld
Germany
Tel. +49 (0) 5 21/9 50 08-10
Fax +49 (0) 21/9 50 08-88
info@kerberverlag.com
www.kerberverlag.com

Kerber, US Distribution
D.A.P., Distributed Art Publishers, Inc.
155 Sixth Avenue, 2nd Floor
New York, NY 10013
Tel. +1 (212) 627-1999
Fax +1 (212) 627-9484

KERBER publications are available in selected bookstores and museum shops worldwide
(distributed in Europe, Asia, South and North America).

Text © Lars Åberg 2016
Photo © Lars Strandberg 2016

Designed by Krister Appelfeldt

Printed by Exakta Print, Malmö, Sweden

LARS ÅBERG
Swedish journalist
and the author of more than twenty non-fiction books
with Swedish or American themes.

LARS STRANDBERG
Swedish photographer
whose work is represented internationally in books, magazines,
newspapers, exhibitions, and advertising.

Åberg's and Strandberg´s previous book in English,
published in the U.S.,
was the award-winning and critically acclaimed "West",
about the modern American West.

KRISTER APPELFELDT
Swedish art director
with long experience from working
with American-style clothing and home design.

SPECIAL THANKS
Andrew Wright for generous financial suppport of the book project.
Patricia Berg for reviewing the text.
All the Sausalito houseboat residents who made this book possible.

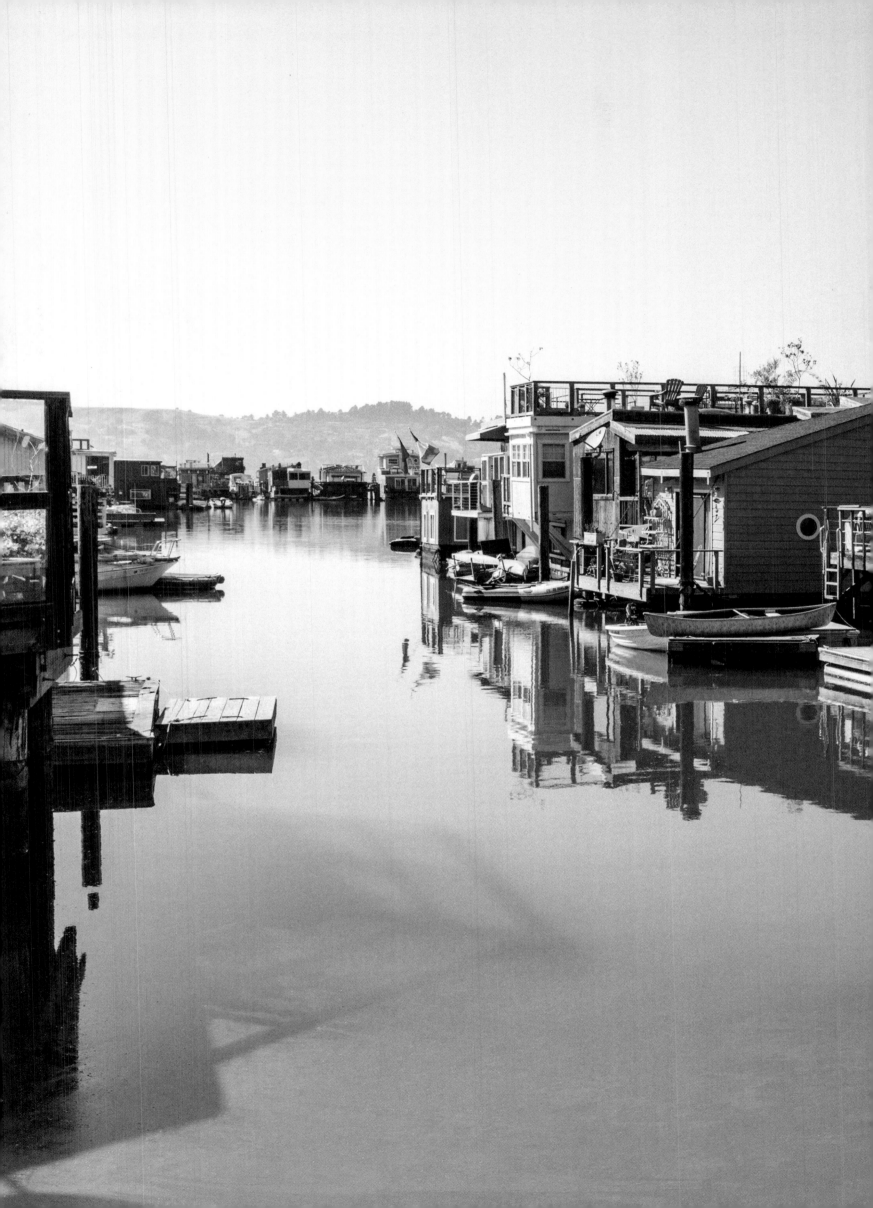

Reproduced from a Painting by the Author